Marcel Duchamp

Titles in the series Critical Lives present the work of leading cultural figures of the modern period. Each book explores the life of the artist, writer, philosopher or architect in question and relates it to their major works.

Marcel Duchamp

Caroline Cros

Translated by Vivian Rehberg

REAKTION BOOKS

Published by Reaktion Books Ltd
33 Great Sutton Street
London EC1V ODX, UK

www.reaktionbooks.co.uk

First published 2006

Copyright © Caroline Cros 2006

All rights reserved
No part of this publication may be reproduced, stored in a retrieval system,
or transmitted, in any form or by any means, electronic, mechanical,
photocopying, recording or otherwise, without the prior permission
of the publishers.

Printed and bound in Great Britain by
Biddles Ltd, King's Lynn

British Library Cataloguing in Publication Data
Cros, Caroline
 Marcel Duchamp – (Critical lives)
 1. Duchamp, Marcel, 1887-1968 2. Artists - France - Biography
 I. Title
 709.2

ISBN 1 86189 262 4

Contents

'Ed Paschke, my professor at the School of the Art Institute in Chicago, introduced me to the Readymade and to Marcel Duchamp's ideas. He had a great influence on me. He taught me to use my environment. Everything is already there. It is up to the artist to reorganize things, to put them together like a new chemical compound.'

Jeff Koons, in *Le Monde*, 31 August 2005

'We are now, in 2005, at a moment of aesthetic pause and reflection that is masked by activity and gallery growth patterns alongside the appearance and disappearance of artists in a constant flow of representation. In some ways this could be the perfect environment to play in. A situation encouraged by the so-called "dynamic" art market that always works to suppress the potential of sitting still in relation to what happens to be renegotiating itself in front of you. It is impossible to talk about the influence of Duchamp at the moment within the ongoing activated art world. Such an influence is hidden and veiled, but the ideas floating around make the potential of an obligation to de-code/re-code imminent and sloppy at the same time. We are in a moment of stasis and cultural battle simultaneously.'

Liam Gillick, 2005

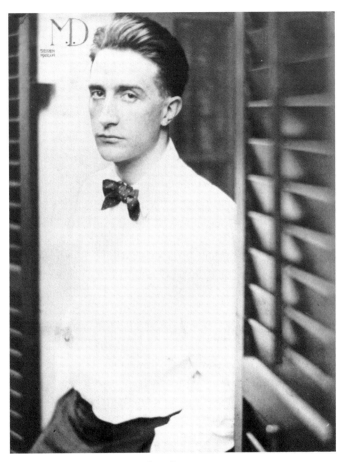
Duchamp photographed by Edward Steichen in 1917.

1

Introduction

When the Duchamp family of exceptional artists were living together in the Normandy countryside, the older brothers played chess, their parents and their visiting friends played cards, two of the daughters and Madame Duchamp played music, and the two middle children, Suzanne and Marcel, teased each other affectionately, sharing the secrets that would seal their bond. It was during his childhood that Duchamp developed his taste for chess and games involving hazard and chance. Games, then, in Jacques Villon's yard in Puteaux, became a subject for portraits painted during his teens (*The Chess Game*, 1910; Philadelphia Museum of Art), and when Duchamp liberated himself from the family circle during his American exile several years later, chess became his passion. Throughout his life he played on a daily basis, like a painter heading to work in the studio alone, every day.

Duchamp admitted it straight away: he much preferred playing chess with professionals, whom he considered the real artists, than keeping company in the art world and acting the part of the painter or 'cinematographer'. Even before he became a professional chess player himself, he encountered other chess fanatics, besides his brothers, like Walter Arensberg and Man Ray.

During his stay in Buenos Aires in 1919, where he joined a local chess club, he acquired his professional know-how by cutting out games from the newspaper and mastering the system developed by the extremely popular Cuban chess player José Raúl Capablanca.

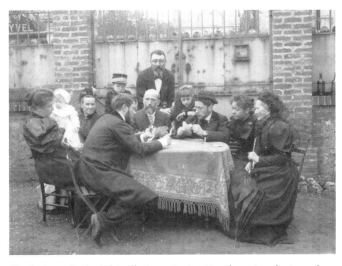

The Duchamp family at Blainville-Crevon in 1893. Marcel, wearing a kepi, was then aged six.

He also developed a method that allowed him to continue playing chess by correspondence with his patron Walter Arensberg in New York. If he sometimes played the dilettante where artistic practice was concerned, he was deadly serious about his engagement with chess: 'I am all set to become a chess maniac. I find all around me transformed into knight or queen, the outside world holds no other interest for me than in its transposition into winning or losing scenarios.'[1] When he returned to New York in 1922, his friend Henri-Pierre Roché encouraged him to continue his artistic research, but Duchamp responded quite firmly:

> No, I really don't feel like broadening my horizons. When I get a little money, I will do different things. But I don't think that the few hundred francs or whatever cash I would get out of it could make up for the hassle of seeing this reproduced for the public. I've had it up to here with becoming a painter

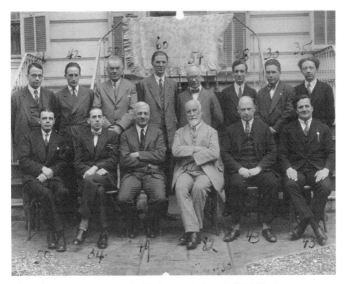

Chess players at a tournament in Nice in 1930. '42' on the left is Duchamp.

or a cinematographer. The only thing that could arouse my interest right now is a wonder drug that would make me play chess divinely. That would really turn me on.[2]

Indeed, less than one year later, in 1923, he spread the rumour that he had abandoned painting, leaving his major work, *The Bride Stripped Bare by her Bachelors, Even*, unfinished.

From the point of this rupture on, Duchamp officially placed his artistic adventures second; they were to distract him from his daily chess games only sporadically. A member of the French Chess Federation, Duchamp participated in professional tournaments in Brussels, Monte Carlo, Chamonix, Grenoble, Nice, Hamburg and Rouen, where he was a member of the local chess circle.[3] In these championships, he eagerly confronted internationally renowned professionals like Frank James Marshall, George Koltanowski and Savielly Tartakower: 'Koltanowski and I have a small office down-

town where he receives his mail and is playing about 50 matches at the moment.'[4] Up until 1939, Duchamp, who was a writing and publishing enthusiast, tended to the chess rubric in the newspaper *Ce Soir*, which was run by Louis Aragon. He also published a treatise on chess that he had written with the German master Viatli Halberstadt in 1932. After the French publishing house NRF turned down the manuscript, he sent it to a Brussels-based publisher, Edmond Lancel of the Editions de l'Echiquier, who agreed to publish it in French, German and English. Marcel worked on the book and cover design and selected the paper, and devised, as with his other publishing ventures, a de-luxe edition (of 30) and an ordinary one entitled *L'Opposition et les cases conjuguées réconciliées par M. Duchamp & V. Halberstadt (The Opposition and the Sister Squares are Reconciled by M. Duchamp & V. Halberstadt)*. While it was not a huge commercial success, the infinitely useless and absurd aspect of his initiative amused Duchamp: 'Even the chess champions don't read the book, since the problem it poses really only comes up once in a lifetime. They're end-game problems of possible games but so rare as to be nearly utopian.'[5]

In light of all this, what is the link between the artist's unfailing attraction for chess and his life as a 'professional' artist, which he almost always treated with disdain? Duchamp responded to that question himself by designing the poster for the 1925 chess championships in Nice, which he participated in, and by designing and creating chess pieces and miniature chess games. On 23 July 1944, he asked his friend Man Ray:

Did you get the pocket chess set? I'm making (myself) 50 or so of them and then the American market will be exhausted. Too much labour involved to want to launch a grand-scale production and chess players don't want to pay huge prices for a pocket chess set.[6]

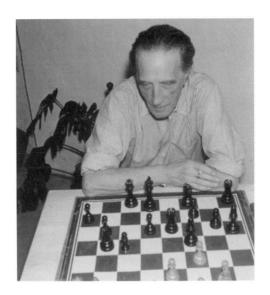

Duchamp in Cadaquès.

At the time, the Nice championships poster was plastered all over France and sold by the newspaper *L'Eclaireur du Soir* for 100 francs! Needless to say, today it is a highly sought-after object.

In 1951 Duchamp went even further and surprised his friends and disciples by welcoming a young historian and professor from Toronto, Michel Sanouillet, who had written a doctoral dissertation on Dada, into the fold. Once Sanouillet paid a visit to Duchamp's downtown New York studio and Marcel asked him to wait while he finished his chess game. The young historian, who would become Duchamp's friend, agreed, but was astounded to discover that Duchamp was playing against a naked woman. He immediately grasped the audacity of Duchamp's gesture and that this exceedingly Dada-esque greeting was a true demonstration of friendship and respect. In 1963 Duchamp reiterated the peformance in Pasadena on the occasion of his first retrospective exhibition. A well-known photograph shows Duchamp in deep concentration facing an entirely undressed Eve Babitz, her face hidden by her hair.

When Duchamp died in 1968, the American Chess Foundation, to which Duchamp and his wife Teeny belonged, printed an obituary in the *New York Times*:

> The officers and Board of Trustees of the American Chess Foundation record a deep sense of loss at the passing of Marcel Duchamp. A giant in the world of art, he was also an important influence in the world of chess and was for many years an irreplaceable member of our Board of Directors. We take immeasurable pride in his association with us.

The intellectual mastery inherent to chess, the passion for play and competition, and above all the apprehension of the world through the filter of relativity, which is symbolized by the black and white squares of the chessboard, matched Duchamp's frame of mind and offered him an abiding opportunity for satisfying his untiring quest for meaning. The rigour of the game, the concentration and detachment needed to face his tough opponents, all helped him to forge his trademark Duchampian temperament, which friends and historians have rightly related to alchemy, esotericism and Zen thought.

Duchamp was always sceptical about the occult sciences and paranormal phenomena such as hypnosis or the photographic revelation of immortal spirits.[7] And while he may have flirted with them, he said he preferred that these metaphysical dimensions and mysteries spring up spontaneously and remain invisible. Naturally, we are well aware that Duchamp favoured science, one of his other passions. But it is also clear that Duchamp, in his endless quest to define a new morality and firmly, but delicately, to break down prejudice, seems to have paid consistent attention to intimate and profound forces and resources of an eminently spiritual tenor.

To my mind, the Duchamp represented in the following pages – the 'Duchamp of with my Tongue in my Cheek' – fits with this vision

of life and creation. For in addition to his outstanding clear-sightedness and intelligence, his meticulous and precise gestures, the lightning rapidity of his eye as he seized his prey (the ready-mades), one must not forget his kindness, his love, his self-awareness and his awareness of others, and the humour he cultivated scrupulously, all of which fascinated those who crossed his path.

2

Marcel, this Sad Young Man on a Train[1]

The child who would become perhaps the most influential artist of the twentieth century, who would be recognized as early as the Armory Show of 1913 in New York, who would make an appearance in most of the century's artistic movements, from Fauvism and Cubism to Dadaism and Surrealism, and then anticipate its major artistic revolutions, was born on 28 July 1887 in Blainville-Crevon, France. This small town is located about 20 kilometres from Rouen, the city that burned Joan of Arc at the stake and served as the setting for Flaubert's novel *Madame Bovary*.[2] Marcel, the third boy in a family of six children, arrived after the death of a young daughter, Madeleine. He was raised with his two older brothers, Gaston (b. 1875) and Raymond (b. 1876), and his sister Suzanne (b. 1889) in a middle-class home, filled with paintings, that faced the village church. Their father Justin Isidore, known as Eugène, was a notary, then mayor of the village from 1895 to 1905.[3] At the turn of the century, M. Duchamp, who expected his sons to study law, could not have imagined that Marcel, Gaston, Raymond and Suzanne would become artists and remain acknowledged figures in the history of modern art. He provided them with regular financial support, deducting the money from their inheritance, until his death in 1925. Marcel's mother, Lucie Nicolle-Duchamp, had a complex, even distant, relationship with her sons. She is said to have preferred girls and probably struggled to overcome her disappointment over the

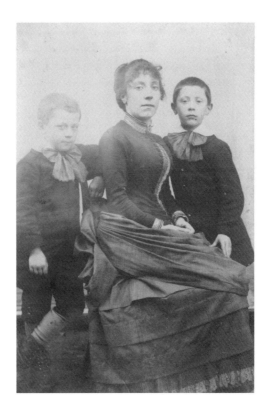

Mme Duchamp with her sons Raymond and Gaston ('Jacques Villon').

birth of a boy after her daughter Madeleine's premature death.

After studying law, Gaston, the eldest, devoted his life to painting and engraving, working under the pseudonym Jacques Villon, in homage to the fifteenth-century poet François Villon. According to Marcel Duchamp's first wife, Lydie Fischer Sarazin-Levassor,[4] the older brother owed his emancipation to a family friend, Mme Julia Bertrand (1868–1960). She was Marcel's godmother and a quite free-thinking and eccentric woman for the time, and she had an undeniable influence on the young Duchamp brothers. Mme Bertrand encouraged Gaston to turn his back on the 'path traced by the family by abandoning law and the notary profession', and to

change his name so as to distinguish himself within a family of strong personalities: 'Create a new individual out of yourself: a free, independent artist. By creating a new existence for yourself.'[5] Gaston turned to Villon, 'because of similarities in their situations and not because of a taste for the poet', Lydie specified. As for his choice of a first name, 'giving up law for the paintbrush was no doubt considered more foolish than wise, and in proper French one says of those who act stupidly that they "faire le Jacques ou le mariole"'. According to Lydie, 'that's how he came up with Jacques Villon'.[6] The younger Marcel's path to freedom would entail an ongoing process of self-initiation and an entire series of quite personal ruptures and decisions.

After studying medicine, Raymond became known in France and the United States as *the* authentic French Cubist sculptor, even though the First World War interrupted his career and took his life. Suzanne, who was only two years younger than Marcel, contributed to the development of Dada painting in Paris, with semi-abstract compositions in a language known as 'mechanomorphic', which her 'favourite' brother and certain of his friends, such as Francis Picabia, raised to its heights shortly before the war. With her second husband, the Swiss painter Jean Crotti, she founded the movement Tabu, a mystical branch of Paris Dada that advocated the expression of mystery, the articulation of that which cannot be seen or even touched, among other things. Suzanne and Marcel, who had been very close since their childhood, shared this fundamental trait: 'they wanted to protect their liberty at all costs, going so far as to raise a kind of barrier in order to keep out unwanted intruders'. Again, according to Lydie, 'Suzanne, like Marcel, had a secret, closed-off, side'.[7]

The Duchamp children's decision to become artists (three painters and a sculptor) was not an arbitrary one. Marcel asserted in 1949 that it was due to the influence of their maternal grandfather Emile Nicolle (1830–1894), who had been a shipping agent

Marcel and his younger sister Suzanne *c.* 1900.

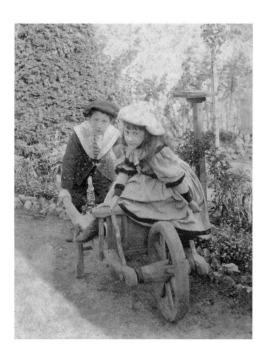

The Duchamp family *c.* 1900.

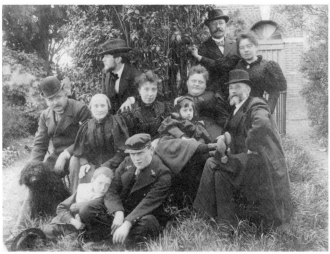

before becoming a renowned printmaker, specializing in views of his native Rouen. In the biographical note on Emile Nicolle in the Société Anonyme catalogue, Duchamp wrote:

> As children, we were surrounded by hundreds of his paintings on the walls at home and this detail may well have been an additional incentive to the atavistic and avocational careers of Jacques Villon, Raymond Duchamp-Villon, Suzanne and Marcel, his grandchildren.[8]

The grandfather also taught the two older brothers printmaking techniques and contributed to the grandchildren's visual education. Marcel's early interest in printing and publishing, which he later put to good use in his editorial projects, is a reflection of his grandfather's kind attention.

More than a decade after Suzanne was born two other sisters arrived, Yvonne and Magdeleine. Duchamp immortalized them in 1911 in a 'semi-Cubist' portrait with the strange title *Yvonne and Magdeleine Torn in Tatters* (Philadelphia Museum of Art), which may have been symptomatic of a hidden jealousy fed by Mme Duchamp's visceral attachment to her daughters. That same year in Rouen he also sketched Magdeleine in *Apropos of Little Sister* (The Solomon R. Guggenheim Museum, New York), a portrait in which the model's pose and the candle in the foreground 'parody' Georges de la Tour's dark compositions.

Before setting off on his own path, Marcel was a young man from a traditional and respectable family, from the Auvergne region on his father's side and from Normandy on his mother's, and marked by provincial bourgeois values. He was still part of a sibship, and, specifically, a sibship of artists, to whom he vowed a very filial respect. Yet, far from settling for this, Marcel continually distinguished himself from the Duchamp clan through strategies that enabled him to assert his individuality and to preserve his

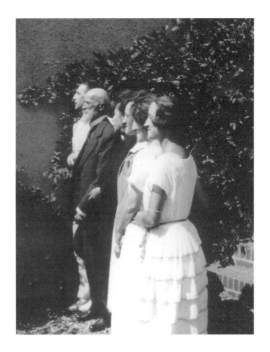

The Duchamps in profile at Veules-les-Roses, *c.* 1910: Suzanne, Yvonne, Magdeleine, Mme Duchamp, M. Duchamp and, finally, Marcel.

soul's 'unique' character from more pressing and limited ambitions. Equally influenced by Julia Bertrand and the philosophy of Max Stirner (1806–1856), which he discovered in the text *Der Einzige und sein Eigentum*,[9] Marcel kept the future in mind and sought to 'acquire wisdom, Knowledge, or Initiation' and 'to study the old fellow, and seek himself out in purity and the Absolute' above all.[10] Although he could not have known it then, he would gradually expand the artist's role in society and transform the definition of the work of art.

In autumn 1904, after completing his studies and passing his *baccalauréat* at the Lycée Corneille (Rouen's most reputable Jesuit high school, from which Gustave Flaubert and Guy de Maupassant graduated), Marcel, who had previously won several prizes for mathematics and drawing, joined his brothers in Paris. He first went to

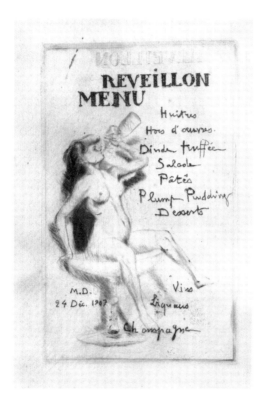

An annotated Christmas Eve menu, Paris 1907.

live with Jacques Villon on the rue Caulaincourt in Montmartre, and then enrolled in the Académie Julian. The following year he failed the entrance exam for the Paris Ecole des Beaux-Arts and opted for an arts trade training course at La Vicomte printers in Rouen. He obtained the title of 'art worker' from this apprenticeship, which allowed him to shorten his military service. Throughout his life he would strive to keep himself far away from that sort of discipline.

Marcel's first paintings belong to the tradition of Monet, Cézanne and the Impressionists. They evoke his childhood: the church in his home town, seascapes and landscapes from his Normandy vacations, or the portrait of his father seated in his

armchair. Family members or childhood friends served as models for his first academic studies, which he exhibited very early on at the Salon de Peinture Normande. During his first year in Paris he made a series of pencil drawings from life in his brother's studio or in his Montmartre neighbourhood. He made a living by drawing cartoons for publications such as *Le Rire* and *Le Courrier Français*, and exhibited regularly at the Salon des Artistes Humoristes at the Palais de Glace in Paris. These drawings include a little scene in the life of a couple, published in *Le Rire* on 10 August 1910. A man sits combing his hair in front of a mirror while a woman sits on the bed watching. She says: 'Ce que t'es long à te peigner'; to which he replies: 'La critique est aisée, mais la raie difficile!' These were almost premonitory words. Marcel was already playing on words, the phonetic proximity between the verbs *peigner* (to comb),[11] and *peindre* (to paint), but he was also making an oblique reference to a popular expression: 'It's easy to criticize, but it's hard to make art' (*la raie difficile* = *l'art est difficile*). This maxim would be particularly meaningful to him in 1912, when the Salon des Indépendants rejected his *Nude Descending a Staircase*.

Four years after he arrived in Paris, Duchamp was exhibiting his paintings at the Salon d'Automne at the Grand Palais, then at the Salon des Indépendants. The dancer Isadora Duncan purchased one of his works. She later became a close friend of the painter Francis Picabia, who was a member of the Groupe de Puteaux and exhibited with the Duchamp brothers at the Société Normande de Peinture Moderne. A strong friendship linked the two men until Picabia's death in 1953. Duchamp considered this a temporary separation and sent the deceased a telegram that read: 'Francis, see you soon, Marcel'.

Marcel's brothers quickly introduced him into the avant-garde circle of the Groupe de Puteaux and its weekly meetings on Sunday, known as the 'Dimanches de Puteaux', which brought together the most influential artists of the time: Fernand Léger and

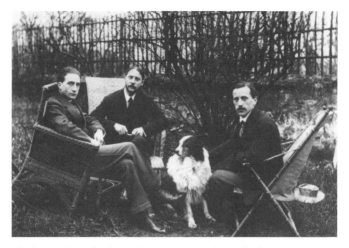

The three Duchamp brothers at Puteaux in 1912, with Pipe the dog.

František Kupka, and Albert Gleizes and Jean Metzinger, who co-wrote the first book on the Cubist movement, *Du cubisme*, in 1912, as well as Guillaume Apollinaire. Marcel was thus immersed in the artistic scene that founded and defended Cubism as well as Orphic Abstraction, thanks to Kupka's influence. He cultivated his future research at the heart of this circle of aesthetes, participating in discussions on such esoteric notions as the Golden Section, the fourth dimension and, in particular, the theories on perpetual life change of the young philosopher Henri Bergson. During these Sunday meetings, held in his brothers' yard, the artists also played chess, ball games and organized other outdoor activities, which Marcel remembered fondly in a letter to the American painter Walter Pach, who was organizing the Armory Show in New York: 'It's always fine in Puteaux on a Sunday, and you must miss playing games in the garden with us. Will you come back to us soon?'[12] Pach would play a crucial role in encouraging American collectors to acquire paintings and sculpture by the Duchamp brothers. From 1913 onwards he maintained a friendly and sincere correspondence

with Duchamp. Pach would also entertain Duchamp in New York in 1915 and introduce him to a circle of friends and benefactors that would be decisive for the recognition of his work in the United States.

Long before his Atlantic journey, however, which is still considered to be the starting point of his career, Marcel broke with pictorial tradition by painting a series of successful Cubo-Futurist works between 1911 and 1912. While the themes remained classical – chess players, nudes, family portraits – his friends in Puteaux judged the treatment as too iconoclastic. In truth, Marcel worried little about style and schools. He was interested in studying motion and speed, which also fascinated the Italian Futurists, who praised modernity and whose works Marcel may have seen at the Galerie Bernheim Jeune in Paris in 1912. Duchamp himself claimed that he was most interested in research being done in photography at the time by Eadweard Muybridge[13] and Jules-Etienne Marey.[14]

The shift from a post-Impressionist style to what Marcel referred to as 'Elementary Parallelism' took place in 1911 in such paintings as *Sad Young Man on a Train* (The Solomon R. Guggenheim Foundation, Venice), a self-portrait of the young Marcel travelling to Rouen to visit his parents, who were then living on rue Jeanne d'Arc across from the Musée des Beaux-Arts.[15] The fragments of his entirely unrecognizable face are spread across the width of the canvas so as to evoke the vibrations of the train in motion: 'First there's the idea of the movement of the train, and then that of the sad young man who is in a corridor and who is moving about; thus there are two parallel movements corresponding to each other.'[16] Marcel specified that it was above all a 'formal decomposition'. Yet, one may also see it as a metaphor for a transformation taking place in the young man, who is gradually discovering his path and his independent spirit.

In the title Marcel demonstrated his talent for word play, toying with the musical quality of the words 'triste' and 'train'. On the back

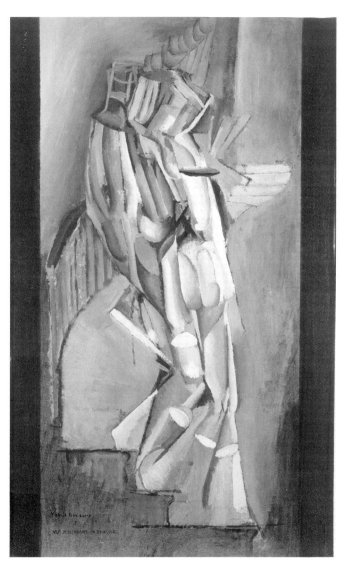

Nude Descending a Staircase, Nº1, 1911, oil on cardboard.

of the canvas, he wrote 'Marcel Duchamp nu (esquisse). Jeune homme triste dans un train' ('Marcel Duchamp nude (sketch). Sad Young Man on a Train'). This is a notable detail for it hints that the self-portrait is, in a way, a preparatory study for the *Nude Descending a Staircase*, the first version of which is dated December 1911. In this preliminary, still quite realist, version, one can make out the light-coloured wooden stairs in the family home in Blainville. A month later, Marcel submitted the final version to the Salon des Indépendants selection committee, composed of some of the Puteaux artists, including his brothers. The committee rejected the work on the pretext that the subject matter, while linked to pictorial traditions, deliberately ignored the representational canons that Cubist painters were still protectively relying on.

The painting is disturbing because it represents a totally dehumanized nude, neither female nor male, but a body in motion, likened to mechanical dynamics:

> it is not a typical nude, but an architectural nude. Imagine the different planes that begin to move; for example, the buildings of walls that begin to dance, to rise up, instead of remaining safely fixed in place, and this ballet is an aspect of the fourth dimension . . . the moving body contracts, it is an optical law.

Marcel then added that he 'was trying to render the impression that might be given off by one of these planar surfaces'. Yet, in wanting to represent a 'nude in motion' as if 'it was descending a staircase',[17] he took an academic subject that had previously only been painted standing, lying down or sometimes seated, and knocked it off its pedestal. Putting the nude into motion certainly shocked the committee. Several days before the Salon opened, his brothers, representing the committee, were charged with announcing their arbitrary decision and asking him to reconsider the painting's title. Without contesting the decision, but without giving in to their

request, Marcel immediately withdrew his work. This affront came as a real shock and he considered it a painful betrayal; from that day on he distanced himself from doctrines, renounced value judgements and carried on doing what counted most with careful determination: 'Reducing, reducing was my objective, but at the same time I aimed to turn myself inward rather than outward.' This attitude eventually led him to become the least disputed or, in André Breton's words, 'the most intelligent artist of his century'.

Apart from the title, there was a paradox in the painting's attempt to depict a body in motion in space on a two-dimensional surface using the classical procedure of oil painting. In fact, Marcel, who was attentive to Marey's investigations, understood the limits of easel painting. This canvas, which within just a few months would become the most notorious work of the decade, was in keeping with the most up-to-date experimental research: chronophotography, being used in science and medicine, and Italian Futurist painting and sculpture, introduced to the French, and to Duchamp's brother Raymond Duchamp-Villon, who was quite familiar with its precepts, through the publication of the Futurist Manifesto in *Le Figaro* in 1909. With unusual ease, young Marcel assimilated these different languages into a singular mode of expression without equal at the time, liberated from the constraints of realist representation and combining metaphysics and humour.

After enduring real humiliation at his brothers' inconceivable rejection, young Marcel forged on and created several preparatory drawings for one of his most enigmatic canvases, *The King and Queen Surrounded by Swift Nudes*. He cleverly set aside the theme of the solitary nude in motion for an even more unusual scene: two figures from a chess set, a king and a queen, are invaded by a rapid flow of secondary characters, 'the swift nudes'. He treated the king and queen like war machines: their various body parts are constructed from tubes, cylinders and sharply aggressive lances propelling

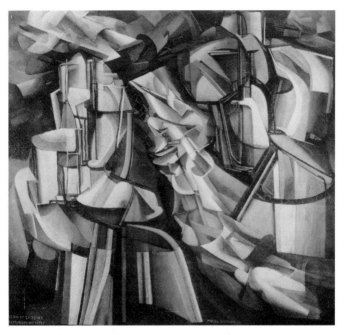

The King and Queen Surrounded by Swift Nudes, 1912, oil on canvas.

'energies' that connect the characters in a dizzying and constant flux. According to Marcel, the different versions of this painting attest to his interest in movement. During the same period the sculptures of Duchamp-Villon and Umberto Boccioni also testify to the metaphors of vital energy and perpetual life change visible in Duchamp's works.

Fernand Léger's paintings, particularly *Nudes in the Forest*, 1909–10 (Kröller-Müller Museum, Otterlo), also treat the human body in this mechanistic way. Marcel's greatest affinities at this time seem to have been with Léger and, especially, Picabia. Picabia's wife Gabrielle recalls the Marcel she first met as a reserved, slightly provincial, young man, who was very attached to his family and his brothers. But, with his revolutionary mindset, Marcel found true allies in the Picabias and in Apollinaire, who

enabled him to break away from the familial cocoon: 'Francis's influence on him was extraordinary, and mine, too, given the customs of the epoch: a woman who dared to have free ideas . . . I believe that it was I who extracted Marcel from his family.'[18]

Around this time Duchamp and the trio went to see Raymond Roussel's play *Impressions d'Afrique*. Marcel always recalled the importance of this episode, considering it an overwhelming and formative experience:

> One important point for you to know is how indebted I am to Raymond Roussel who, in 1912, delivered me from the whole 'physioplastic' past which I had been trying to get out of. A production at the Antoine theatre of *Impressions d'Afrique* . . . was a revelation for the three of us, for it really was about a new man at that time. To this day, I consider Raymond Roussel all the more important for having not built up a following.[19]

Duchamp was full of doubt during this period, but Roussel's iconoclasm and absurdity freed him from the past and led him in the right direction. About this time he was also reading Gaston Pawlowski's novel *Voyage to the Land of the Fourth Dimension*, first published in 1912.[20] This comforted him in his quest for independence, which was simply the progressive acquisition of a superior consciousness of reality. It allowed Duchamp to liberate himself definitively and irreparably from bias.

While living at his brother's house in Montmartre, Marcel became acquainted with a young German artist Max Bergmann (1884–1955), who had strayed into Pigalle, spoke little French, and with whom he spent enjoyable outings in the capital's livelier neighbourhoods. Quite naturally, Duchamp planned to meet up with him again in Germany by spending several months in Munich. 'I am off to find a cow painter', he told his family. He really wanted to distance himself from the 'Cubist straitjacket', of which

he was justifiably tired. Then, as a reassurance to the family he had never left so far behind, he added that he hoped his friend would meet him at the beginning of next week – 'and will show me "Berlin by night". It's a local speciality.'[21] Marcel's real motives for going to Munich and the details of his trip remain a mystery; there is little concrete information about them.

On 18 June 1912 he boarded the train for Munich, city of the *Blaue Reiter*, where Wassily Kandinsky, the founder of abstract painting and author of *Concerning the Spiritual in Art*, was the central figure.[22] Marcel made several detours to Basel and Lake Constance, then settled in for the summer in a small furnished room at 65 Barerstrasse. Because Bergmann lived in the country-side, Duchamp saw him infrequently. He did not seek out other artists based in the city, but regularly went to the Alte Pinakothek, where he admired Lucas Cranach's work: 'His large nudes. Nature and the materiality of his nudes have inspired me for the colour of flesh', he confided decades later. This solitary retreat, the first in a long series, was particularly beneficial to his research. Although Marcel had not been on very good terms with painting since the rejection of his nude, during his summer in Munich he painted and drew several of his most successful works on the theme of the virgin and the bride, and the passage from one state to the other, using a language described as 'Mechanical Symbolism'.

This is where Duchamp surpassed an increasingly offhand Picabia, whose two paintings dated 1913–14, *I See in Memory my Dear Udnie* and *Comical Marriage* (Museum of Modern Art, New York) echo the audacity of the Munich period. This is especially noticeable since Marcel offered him a work he painted there in 1912, *Bride* (*La mariée*). Given the rumours of Marcel's private passion for Gabrielle Picabia, with whom he had a clandestine assignation in the Jura mountains, this was a highly symbolic gift. Do the swift nudes surrounding the virgin or the bride represent the two friends taken with the same woman?

Whatever the private reasons for this turning point, his painting was increasingly abstract, despite his ongoing use of descriptive titles, and centred around the female figure as queen, virgin or bride. No longer represented in the form of an allegorical nude, as she had been throughout the history of painting, Marcel portrayed her as a reproductive machine with viscera and entrails, as a superior metaphysical being inciting desire and pleasure, excitement and *jouissance* in the swift nudes, these 'bachelors' who were trying to tame her. In Munich, Marcel wrote below a drawing for what would later become *The Large Glass*: 'Preliminary research for: *The Bride Stripped Bare by her Bachelors*'. Under the central figure he added a highly esoteric annotation, 'Mechanism of Modesty/ Mechanical Modesty',[23] which perhaps alludes to his undisclosed desire for Gabrielle Buffet-Picabia.

Dated July 1912, this drawing proves that it was precisely during his time in Munich that Marcel laid the foundations for one of his most important works, *The Bride Stripped Bare by her Bachelors, Even*. Also known as *The Large Glass*, this would occupy him for more than ten years, as he would claim, 'due to numerous new and unresolved technical problems'. In 1961 Duchamp said that the paintings of his Munich period corresponded to his artistic preoccupations at the time, movement and eroticism, but were really an attempt to translate his anti-romantic, distant and cold vision of such a subject:

> I was turning toward a form of expression that was totally divorced from absolute realism . . . this is not a realist interpretation of a bride, but my conception of a bride expressed through the juxtaposition of mechanical elements and visceral forms.

While still in Munich he learned from his family that his drawing from this series, *Virgin Nº1* (Philadelphia Museum of Art), was exhibited at the Salon d'Automne: 'I've been informed officially

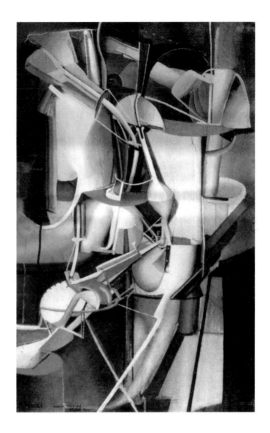

Bride, 1912, oil on canvas.

that the Jury at the Salon d'Automne liked my drawing. Much good it may do me!'[24] All his detachment as well as the progressive liberation he felt during his Munich exile are present in this response.

When he returned to Paris in October he joined his friends Picabia, Gabrielle and Apollinaire on a car trip to the Jura mountains;[25] several years later Duchamp would make a drawing from his recollections.[26] He also participated in the *Section d'Or* exhibition on the rue de la Boétie in Paris. Marcel was a member of the planning committee, which gathered regularly at Picabia's, who played a

pioneering role in this project. Exceptionally for a salon, each artist had his own room. Marcel presented some six paintings, including *Nude Descending a Staircase*, which he had withdrawn several months earlier following his brothers' objections, urged on by Henri Le Fauconnier and Gleizes, as well as *The Chess Players, The King and Queen Surrounded by Swift Nudes* and drawings completed during his stay in Munich. Nevertheless, Duchamp's correspondence from this period shows that he was not very involved in Parisian artistic life and that only one idea obsessed him: leaving Paris and doing something besides making art. 'No more painting, look for work!', he told himself. With little delay, shortly after his return to Paris, and thanks to Picabia, he was employed as a librarian at the Bibliothèque Sainte-Geneviève. His job provided ample spare time and he filled the two years before his departure for New York by reading scientific and artistic texts and treatises. In January 1915 he wrote to Walter Pach on the library letterhead, telling him of his boredom and especially his lack of motivation with regard to his own work:

> So I carry on working regularly, but few hours a day, weary at the moment. I still haven't finished my red thing on glass. I expect to finish it end of February . . . I am writing to you from the Library where life is even more extravagant than in peacetime. By which I mean how little we have to do.[27]

Once again, with the greatest discretion, Marcel continued thinking about his projects and methodically accumulating notes and ideas that were the result of an incessant inner dialogue and the basis for future projects.

Marcel had renounced easel painting after his return from Munich and the period that followed was marked by research in two different directions. First, he was elaborating different parts of the lower section of *The Large Glass*. Works related to this include

The Chocolate Grinder, a replica of a 'machine for grinding chocolate' he had glimpsed in a confectioner's shop window on rue Beauvoisine in Rouen; *Glider Containing a Watermill in Neighbouring Metals*; and the *Nine Malic Moulds*, or the nine bachelors in uniform. Duchamp confirmed this: 'from 1913 on, I was concentrating on developing the *Large Glass* and made a study of every detail'.[28] The notes held in the *Boîte de 1914* (*Box of 1914*), an edition of five, which brought together his initial reflections on the *Large Glass*, testify to this activity. Secondly, he was working on his first three-dimensional works resulting from chance: *Bicycle Wheel* in 1913 and *Bottle Rack* in 1914, although he had not yet named them 'ready-mades', nor had he shown them to anyone.

He worked on his reflections in the utmost secrecy and, as he intended, nobody suspected that the young Marcel, who was officially a librarian and had even enrolled in a library science course at the Ecole des Chartes on 4 November 1912, was devising some of the most iconoclastic works of the century. To all intents and purposes he had changed his profession and so he was left in peace to concentrate on his work, freed of obligations to play any social role. He maintained his correspondence with Walter Pach,[29] quietly preparing for his departure to New York: 'I have told nobody about this plan. Could you please, therefore, reply to these questions on a separate sheet of paper so that my brothers don't find out until my plans have been finalized.'[30] Marcel had truly decided to change continents and this exile would last a long time and put a substantial distance between him and his family, as well as his country of origin:

As for my time in New York, that's altogether different. I am not looking for anything there but individuals . . . I am not going to New York, I am leaving Paris. That's quite different. Long before the war, I already had a distaste for the artistic life I was involved in. It's quite the opposite of what I'm looking for. And

so I tried, through the Library, to escape from artists somewhat
. . . My only option was New York where I knew you and where
I hope to be able to escape leading the artistic life, if need be
through a job which will keep me very busy.[31]

Before leaving he gave his sister Suzanne, who had just married
a pharmacist, a commercial print of a landscape onto which he
added one small green and one small red splotch of gouache on the
horizon line; he titled this *Pharmacy.* Suzanne, who could not yet
have realized that she held one of the first 'rectified ready-mades',
would continue to be surprised by her brother. Several months
after settling in New York he secretly made her a partner, albeit
from a distance, in his latest undertaking: the reappropriation of
everyday objects stripped of any apparent originality.

3

All Aboard for New York, 1915–18

After nine days at sea aboard the *Rochambeau*, Marcel Duchamp
arrived in New York on 15 June 1915 with a section of the bottom
half of his 'glass', *The Nine Malic Moulds*,[1] and his notes for the
Large Glass packed in his suitcases. Walter Pach, from the Armory
Show organizing committee and whom he had already met at his
brothers' home in Puteaux, met him at the dockside. Duchamp
lived for a time with Pach and his wife before settling in the duplex
apartment of Walter and Louise Arensberg, collectors from Boston
who had recently moved to New York and whom Pach asked if
Duchamp might use their empty apartment during their holiday
in Connecticut.

As soon as Duchamp crossed the threshold into the Arensbergs'
world he entered a particularly rich period in his life – full of *joie de
vivre*, scattered with 'platonic' love affairs and lasting friendships,
Dadaist jokes and pranks, all of which captivated his entourage.

It was one of the most carefree times he would ever know:
'I think of you often and the three good years I spent with you', he
wrote to his benefactors in 1918.[2] Duchamp later recalled the relative
ease of his bohemian lifestyle at that time, and especially the
strong camaraderie that existed between artists; he even compared
this moment of total freedom to 'swimming in a calm sea'.
A bohemian life such as this clearly suited him: he invented
the ready-mades and produced his last painting, *Tu m'*, over the
course of these years.

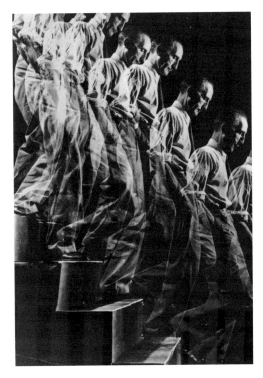

'Marcel Duchamp Descending a Staircase', a photograph published in *Life* magazine in 1952.

New York had not yet attained the prestige of Paris, Berlin or Munich as an artistic centre. The International Exhibition of Modern Art, however, known as the Armory Show because it was held at the 69th Regiment Armory on Lexington Avenue, would soon change all that. The result of more than a year's planning by the Association of American Painters and Sculptors (AAPS), the Armory Show included more than a thousand examples of the most advanced art, European for the most part. In fact, there were so many French artists that one of the organizers exclaimed 'all Modern art speaks French!'

The Armory Show was an unprecedented success in New York, with approximately 88,000 visitors, and had shorter runs in

Chicago and Boston. The men behind it, Arthur Davies and Walter Kuhn, accompanied by their interpreter Walter Pach, had travelled to Paris in 1912 to explore the studios and galleries. They also went to the Section d'Or exhibit and admired Duchamp's *Nude Descending a Staircase.* During their visit to the Duchamp brothers in Puteaux they chose nine of Villon's canvases for the Armory Show, as well as four sculptures by Duchamp-Villon, which were later purchased by the collector John Quinn, and four of Marcel Duchamp's works, including the notorious *Nude Descending a Staircase.* On the way back to New York the painting was shown briefly at the Galería Dalmau in Barcelona and was finally acquired by the San Francisco dealer Frederick C. Torrey for $324. When Duchamp arrived in New York in June 1915, the painting was already surrounded by an aura; he had become a living legend before even stepping foot on American soil. American journalists eagerly sought out this young painter who had dared to paint 'an explosion in a tile factory'[3] and provoked such a *succès de scandale*. Everybody wanted to meet him.

The Armory Show included such historically recognized French and European artists as Van Gogh, Gauguin and Matisse, as well as those who would become the pillars of the avant-garde, such as Constantin Brancusi and Francis Picabia, who attended the opening reception before leaving for the Caribbean with his wife Gabrielle. Picabia, who had been in New York since 1913, moved in the circle of Alfred Stieglitz, the photographer and owner of Gallery 291 at 291 Fifth Avenue, where Picabia exhibited his watercolours. A year later, on the advice of the American photographer Edward Steichen, Stieglitz also gave Brancusi his first exhibition in the United States.

Duchamp left France and the early stages of the First World War in order to flee the pervasive gloom. Most of his friends left Paris, too. His sister Suzanne signed up as a nurse and his brother Raymond went to fight at the front. Duchamp hoped to find

'individuals' in New York and, especially, the intellectual and artistic freedom that would safeguard his independence and keep him at a distance from Parisian quarrels. He expressed sheer indifference to painting and its 'isms'; in fact, he declared that he had finished with painting altogether. Instead, when he arrived in New York Duchamp played the role of a *passeur*; he 'brought modern art to New York', for which the Americans were eternally grateful. When questioned by the press, he unfailingly offered his individual opinions on subjects as diverse as the emancipation of American women, Cubism and the promising future of American art.[4] He quickly won over the Americans, and there began a veritable love affair between Duchamp and the United States, where he lived on and off for years, eventually acquiring American citizenship in the 1950s.

Duchamp's first acquaintances included the American artist Man Ray, who later recalled Duchamp entering his cabin in Ridgefield, New Jersey, for the first time in 1915.[5] The story goes that the two men started playing tennis without a net, which immediately sealed their friendship and led to countless associations over the years. Walter Arensberg, who would soon become Duchamp's main sponsor, was passionate about literature and cryptography, wrote poetry and edited a review, and also shared Duchamp's interest in chess and nineteenth-century Symbolist literature. His wife Lou (short for Louise) was a musician who liked to play Schoenberg for her guests. Man Ray and his wife, the writer Adon Lacroix, were regulars at the Arensbergs' 'salon'. These soirées brought together the exiled European avant-garde – Picabia, Edgard Varèse, Henri-Pierre Roché, Mina Loy, Baroness Elsa von Freytag-Loringhoven and Arthur Cravan – as well as Americans like Charles Demuth and John Covert, who were rightly considered the first American Dada artists. It was not long before Duchamp became the most desirable member of the circle.

The salon evenings often lasted far into the night and were captured in sketches by the actress Beatrice Wood, who was in love

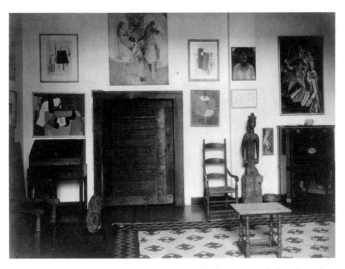

The Arensberg apartment in New York, *c.* 1918, displaying several of Duchamp's paintings. *The Sonata* (1911), centre, *The Chocolate Grinder Nº1* (1914), above the chair on the right and far right, *Nude Descending a Staircase Nº3* (1916).

with Marcel. Lou would regularly offer her guests gourmet treats like chocolate éclairs and pudding, filling up these 'bachelors', with their tastes for whisky and libertine behaviour. According to Roché, Duchamp was the best-known French person in America, apart from 'Napoleon and Sarah Bernhardt', and his handsome good looks were reminiscent of 'young Bonaparte, adolescent Alexander the Great and Praxiteles's *Hermes*.'[6] Some of the guests played chess, others commented on the modern paintings that surrounded them: Matisse's *Mademoiselle Yvonne Landsberg*, Duchamp's *King and Queen Surrounded by Swift Nudes, Sonata, Dulcinea, Yvonne and Magdeleine Torn in Tatters, The Chocolate Grinder*, and a true-to-size reproduction of his 1912 masterpiece, *Nude Descending a Staircase*, which Walter had missed buying at the Armory Show.

Since the original painting was in California, Duchamp decided to appease Walter with a black and white photographic copy of the

original. He hand-coloured the copy, rejecting its original 'Cubist colours' for black, white and turquoise tones that were more in tune with Manhattan's urban landscape and architecture, and which further dehumanized the nude. Then he signed the reproduction, and added the word 'fils' (meaning 'son of Duchamp') next to his signature. Most of his pre-New York paintings already decorated the walls of the Arensberg home, along with Cubist compositions by Braque and Picasso, and the African and Pre-Columbian objects that the couple also collected.

The Arensbergs' salons were privileged moments between friends, a time and place for debating sophisticated subjects like the fourth dimension or the extreme modernity of Brancusi's sculptures, and for transgressing the middle-class taboos and codes of a still quite puritanical America. These salons, the first of their kind in the United States, also reflected the passage of a European culture from one continent to another, which would contribute to the emergence of contemporary art in the United States decades later. The unwavering support provided by the Arensbergs and their circle helped Duchamp to establish a firm footing in New York, and he would maintain his almost familial ties to them all his life.

Obviously, Duchamp did not only attend soirées. In his quest to preserve his independence, he kept his word and set out to make a living from something other than art. He decided to teach French, but only to students who already knew some, and recruited many from the Arensberg circle. The lawyer and collector John Quinn was among the first to sign up. After the lesson Quinn invited Marcel to dinner, and Marcel translated Quinn's correspondence with European artists. In November 1915 Quinn introduced Duchamp to Bella Greene, who recommended him to the head of the French Institute, who then hired him as a librarian. Duchamp worked there for four hours every afternoon and earned a salary of $100 a month, which was his fixed income for two years.

Most of his other students were women, who inevitably grew to idolize him. These included the Stettheimer sisters: Caroline, called Carrie, with her doll's house; Florine, a painter, whom Duchamp called the 'King's Painteress';[7] and Henrietta, nicknamed Ettie, a writer. The adult Stettheimer sisters lived with their mother, to whom they were entirely devoted, in a refined setting where they received such guests as Henry McBride, critic for the *New York Sun*, Francis Picabia, Henri-Pierre Roché and others from the Arensberg salon. Marcel, whom they nicknamed Duche, became their French professor in autumn 1916 for the sum of $2 per hour, even though they had lived for many years in Europe and spoke French almost fluently. Mostly Duchamp lavished this house full of women with conversation and special attention. He was courteous and gallant, and took care to flatter their feminine sensibilities, giving Carrie a 10-centimetre-high version of his *Nude Descending a Staircase* for her doll's house as a birthday present, and maintaining an ambiguous, flirtatious relationship with Ettie.

After a brief visit with Ettie in 1922, Duchamp wrote to her: 'I had tears in my eyes when I left (Why not?). Though, as you do not like men that cry I did not want to show it.'[8] Ettie, who was also involved with the sculptor Elie Nadelman, published a novel called *Love Days*, under the pseudonym Henrie Waste, in 1923. In it, Marcel plays the minor role of the painter Pierre Delaire ('Stone of Air'), friend to Susanna Moore, the author's stand-in. When Duchamp received Ettie's newly published novel, he dashed off an ironic letter from Rouen:

I have not read your book, just the part about me. It's always adorable to have a portrait of oneself, even if one is only there as a backdrop. I'm not the right person to tell you whether it's accurate or not. (You say you didn't treat me very kindly: it's not important.) But I suppose you're using Susanna as an imperfect double or one that's deliberately misleading to make your real

self seem all the more mysterious. What odd confessions you are inclined to make in your writing![9]

Duchamp played a more protective role with the poet and painter Florine, encouraging her to exhibit and publish her work, even offering to publish her poems in Parisian Dada magazines under her first name Florine, so as not to 'compromise the family'. In 1946 he also organized a memorial exhibition of her work at the Museum of Modern Art in New York.

The Stettheimer sisters entertained at their summerhouse Tarry, surely short for Tarrytown, located on the Hudson River. Their most elaborate party, the 'Fête à Duchamp', was given in honour of Duchamp's thirtieth birthday on 28 July 1917. Florine captured this evening in a well-known painting.[10] Executed in her naive style, she shows Marcel and Picabia arriving in a car, then Duchamp crossing into the yard and the area where his friends are gathered. Their faces lit by Japanese lanterns, the guests appear engrossed playing chess and in intimate conversations, which Duchamp interrupts to make a speech. In 1923 Florine also painted two particularly enigmatic portraits of her French professor.[11] The first shows Marcel's face, surrounded by a halo, saint-like, floating on a white ground. The second shows Duchamp and his female alter ego, Rose Sélavy: Duchamp is comfortably seated in an armchair that resembles a throne and turns a wheel crank that lifts the stool on which Rose, dressed in a fuchsia tunic, sits and stares at her 'parent'.

Duchamp also taught French to Beatrice Wood, a young actress in the French National Theatre, who trained for several years at the Académie Julian in Paris and whom he met at the hospital bedside of the composer Edgard Varèse in 1916. The 'young girl', as Marcel called her, fell in love with her professor; 'except for the physical act we were lovers', she claimed, and she indeed became his student in several different subjects: 'Victor polished up my French', she said.[12] Marcel encouraged her to

draw by occasionally lending her his studio and tried to console her by introducing her to Henri-Pierre Roché, who had just arrived in New York on a diplomatic mission that would eventually last three years. According to rumour, their trio turned into a sort of *ménage à trois*, which Roché magnificently described in his novel *Victor*. The main character, Victor (Duchamp), is almost entirely absent throughout the book, yet Patricia (Beatrice) and Pierre (Henri-Pierre) are both utterly fascinated by him – 'There is no danger since we both love him' – and speak of him incessantly.[13] Duchamp gave them permission to go to his studio and look at his works in progress, as long as he was not there. In the novel, Patricia and Pierre vaunt their friend's charisma: 'He has a friendly smile, but he is really a dictator. He does what he wants when he wants. Whatever happens, he ends up the centre of attention; he is the leader. His imagination knows no bounds.'[14]

Duchamp, alias Victor, Duche or Pierre Delaire/Stone of Air, fascinated his friends: according to Man Ray, 'While few understood his enigmatic personality and above all his abstinence from painting, his charm and simplicity made him very popular with everyone who came in contact with him, especially women.'[15] As Roché wrote in *Victor*: 'He needs women. He does not need a woman. Nor children. He must be alone; he is solitary, meditative, a thinker. He's a preacher, in his own way. He is working for a new morality.'[16] Duchamp (whom Roché always called 'Totor', short for Victor), Beatrice and Roché worked together on two Dadaist magazines, *The Blind Man* and *RongWrong*. The cover of the first issue of *The Blind Man* was a cartoon by Alfred Frueh of a dog dragging a blind man to a modern art exhibition.

The mysterious and independent Duchamp was extremely sought after during these three New York years. Yet, with his gentle and courteous French manners, he took care not to hurt the feelings of his female friends and, with his ability to disappear elegantly at a moment's notice, he remained untouchable.

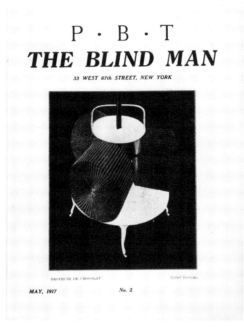

P · B · T

THE BLIND MAN

33 WEST 67th STREET, NEW YORK

BROYEUSE DE CHOCOLAT Marcel Duchamp

MAY, 1917 No. 2

Duchamp's *Chocolate Grinder N°2* (1914) on the cover of the second issue of *The Blind Man* (May 1917), a magazine published by Beatrice Wood in association with Duchamp and Roché.

In autumn 1916 Duchamp met Katherine Dreier (1877–1952), who would end up playing as crucial a role as Walter and Lou Arensberg in Duchamp's career. The daughter of wealthy German immigrants, Dreier had travelled all over Europe, especially to London, Paris and Munich, and although she had some French language skills she decided to perfect them with Duchamp. Dreier was decidedly less feminine and delicate than Beatrice, Lou or the Stettheimer sisters, but she was no less fascinated by Marcel's intelligence and charm. She soon considered him her 'adopted son', her 'Dee', her 'other self', and even a 'modern Leonardo'.[17]

Having exhibited her own painting at the 1913 Armory Show, Dreier was a frequent guest of the Arensbergs and was named one of the founding directors of the Society of Independent Artists exhibition of 1917 by the American painter John Covert, Pach's cousin. She was also in charge of organizing conferences and

educational activities in conjunction with this ambitious show, which had no jury and gave no prizes. Marcel was named head of the Hanging Committee to deal with more than 2,000 works sent by some 1,200 artists, ranging from such prestigious names as Brancusi to a crowd of amateur artists, including Richard Mutt!

Although it was he who submitted the most discussed and debated work, Duchamp does not appear listed in the Independents exhibition catalogue. Several days prior to the opening, on 6 April 1917, he suggested that the works be hung in alphabetical order, by order of the artists' last names, the first letter of which would be drawn from a hat. In a Dadaist gesture and by pure chance, he pulled out the letter R and from there decided how to proceed with the hanging. When the committee arrived at the letter M, it found itself in front of a white porcelain urinal signed and dated on the bottom left 'R. Mutt, 1917'. The committee immediately censored the provocative work on 'non-artistic' grounds.

In truth, several days earlier Duchamp, Walter Arensberg and Joseph Stella had gone to the J. L. Mott Iron Works and purchased a 'Bedfordshire' model urinal – Duchamp signed it R. Mutt and titled it *Fountain* – in order to test the democratic principles of the Society of Independent Artists, which claimed that any artist who paid the six-dollar fee had the right to show their work. This prank turned into an event, a *coup de théâtre* within the small circle of intimates around Duchamp and Arensberg. In the face of the committee's narrow-mindedness, they both immediately resigned. In a letter to Katherine Dreier, Duchamp outlined his reasons for quitting: 'As you know, I have resigned from the board of Directors on account of a serious disagreement with the ruling spirit of the Society'.[18] Duchamp and Arensberg gleefully managed to cover the tracks of the true author of this scandalous sculpture for a month. Then, the American painter Charles Demuth (1883–1935), who was close to both the Arensberg and Stieglitz circles, sent a letter to the directors' committee with two 'anonymous' telephone numbers

(those of Marcel Duchamp and Louise Norton) that, when called, would reveal Richard Mutt's true identity. But nobody rang and the mystery remained intact.

Proud of having provoked yet another scandal, Duchamp sent off a detailed letter to Suzanne in Paris, but he told her that the work was submitted by a woman:

> Tell the family this snippet: the Independents opened here to enormous success. A female friend of mine, using a male pseud-onym, Richard Mutt, submitted a porcelain urinal as a sculpture. It wasn't at all indecent. No reason to refuse it. The committee decided to refuse to exhibit this thing. I handed in my resignation and it will be a juicy piece of gossip in New York.[19]

Fountain soon disappeared, but not before Stieglitz had photo-graphed it, placed on a pedestal in front of Marsden Hartley's 1913 painting *The Warriors*.[20] Stieglitz's photograph, now titled *Marcel Duchamp Fountain 1917*, appeared in *The Blind Man* and the image has since circulated as the most subversive icon of modernity. From this point on, Duchamp would continuously explore the boundaries between original and copy, collapsing any hierarchical value distinctions between and expanding the notion of authorship.

In the wake of this very 'Duchampian' episode, Duchamp, who was feeling slightly put out by some of his friends' biases, reasserted his lack of interest in art and in artists. In October 1917 he joined the French Military Mission and reported to his cherished students, the Stettheimer sisters:

> A great change from this morning on. As from tomorrow, I will be working at a French war mission – downtown, from 9:30 in the morning till 5 in the afternoon every day . . . They've offered me the position of personal secretary of a captain, for a modest

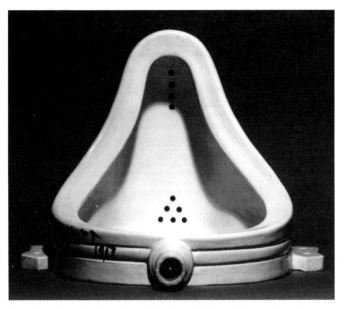

One of an edition of eight authorized replicas of Duchamp's *Fountain* (1917) made in 1964.

salary to begin but which will increase if I prove to be the man
for the job,

adding, in conclusion,

My apologies for Wednesday. My apologies for no longer being
worthy of your hospitality, a wretched bureaucrat who has been
forsaking all he had loved and loves in NY for two years now.[21]

The Independents episode, while comical on the surface, stirred
Duchamp's chronic weariness where the value of art and its reception
were concerned. In the meantime the Arensbergs had left New
York and the United States had declared war. Confronted with this
hardly festive atmosphere, Duchamp decided to depart for Buenos

Aires 'with no particular goal, without knowing a soul over there'[22] and without speaking the language. 'So I'll say my adieus. Perhaps the mission will send you to Argentina and it'll be there that we'll meet up. Off I go again, it's getting to be a habit', he wrote to his friend Roché on 11 August 1918.[23] Shortly before his departure he asked the 'King's Painteress', Florine Stettheimer, to join him. But on 13 August 1918 he sent her a drawing with the handwritten dedication 'Adieu à Florine'. The sketch shows North and South America joined by a sinuous line along which he has written '27 days + 2 years', and the word 'coal'. On the east coast of the United States, Duchamp drew a large house, surely the Stettheimer home where he had celebrated his thirtieth birthday, and on the centre of the South American continent he placed a large question mark, and the word 'hot'.[24]

In the end Duchamp left New York on 14 August with Yvonne Chastel, the first wife of the painter Jean Crotti, and after 27 days at sea they arrived in Buenos Aires. A few months later he received a cable with news of his brother Raymond's death on 9 October, from typhoid fever contracted during the war. Although he maintained his correspondence with Francis Picabia and Walter Arensberg, Duchamp devoted his exile of nearly a year to 'the part of his life that he enjoys most': chess. In January 1919 he sent Lou Arensberg some news:

> As you can see from my letters, I am doing some work here as there isn't much in the way of entertainment. Apart from a few tango bars, there's nothing at all, or else the theatre with its foreign companies, often French . . . I play chess alone for the time being: I came across some magazines and cut out about 40 of Capablanca's games that I'm going to play over. I will probably also join the Chess Club here, to try my hand again.[25]

It was also during this stay in Buenos Aires that he began thinking about optical issues, which would turn up in his work about a year after his return.

In reality, during his three years in New York Duchamp had not simply settled for giving French lessons, for being courted by tireless female admirers, or for leading an unsettled life and 'getting drunk' until all hours. 'Victor', or 'Totor', spent his days and nights doing more than meeting friends and playing games (such as teaching his American friends how to swear in French), going to the movies with Miss Florine or attending costume balls at the Vanderbilt Hotel with Roché. He did more than take trips out to Staten Island to console 'Bea' over her troubled love life, or go on nocturnal outings that led to breakfast at Lou and Walter's, or eat Sunday roast at Gleizes's, which ended with all the guests signing the bone. Duchamp, with his pet names 'French Man', 'Floating Atom' or even 'Immune Baby', played many different roles for many different devotees. However, he was still busy with the conception and creation of *The Large Glass*, the primary elements of which he left with the Arensbergs before leaving for Argentina. During this seemingly carefree period, Duchamp also produced most of his ready-mades. Yet, he made only one public: *Fountain*, released under the name of the infamous, anonymous Richard Mutt.

4
Ready-mades, 1914–64

After the Paris Salon des Indépendants rejected his *Nude Descending a Staircase* in 1912, Duchamp officially turned his back on painting. He understood better than anyone that he had to control access to his works, and knew that their reception by even the most discerning public – that is, the twenty or so people he frequented at the time – strongly depended on the context in which the work appeared and, especially, on the commentary it generated. As a result, during his first New York stay Duchamp kept his new production, which he had secretly been developing in Paris, to himself. These works were neither painting nor sculpture, but an entirely new form he would start to refer to as 'ready-mades' in 1915. Today, the English term 'ready-made' is indisputably linked to his name; the ready-mades have become Duchamp's formal alter ego, regardless of the countless artists and artworks they have inspired.

Duchamp started thinking about the 'ready-mades' in 1913, when he jotted a note to himself about making 'works of art that are not art'. A year before, while visiting the Salon de la Locomotion Aérienne with Léger and Brancusi, he challenged Brancusi: 'Who could do any better than this propeller? Tell me, can you do that?'[1] In retrospect it is tempting to think that Duchamp was, in fact, asking himself this question. Shortly thereafter, using a procedure not unlike Picasso's and Braque's approach to Cubist collage, he fitted together two utterly different, utilitarian objects: he attached an upside-down bicycle wheel, fork and all, to the top

of a stool. Duchamp recalled the moment: 'The first one is a bicycle wheel that I simply placed on a stool and watched it spin. So, in this case, in addition to the ready-made, there was the fact that it was spinning.'[2] A year later, he purchased a mass-produced bottle rack, commonly used in French wine cellars, at a Paris department store, the Bazar de l'Hôtel de Ville. Here Duchamp's gesture was even less perceptible than it had been with the *Bicycle Wheel*; he just selected an object at a given place and time. He reduced his gesture to purchasing the object, using it in a different context, and adding an inscription that would not describe it, but was instead a pun or play on words. This new approach, which challenged contemporary assumptions about the very nature and value of art, provided an ordinary thing with 'another destination'.[3] Reappropriating an everyday object also stripped it of its initial value and its anonymity, transforming it over time into a modern sculpture that possesses a 'beauty of indifference' able to withstand such industrial inventions as the perfect propeller that made such an impression on Duchamp.

Duchamp later referred to the *Bottle Rack* and the *Bicycle Wheel* as ready-mades *avant la lettre* ('before the term had been coined'). According to his correspondence at this ground-breaking moment in modern and contemporary art history, the two objects stayed behind in his studio on the rue Hippolyte, which he asked his sister Suzanne to empty after his departure for New York. In a letter thanking her for dealing with this chore, he mentioned them for the first time:

Now, if you have been up to my place, you will have seen, in the studio, a bicycle wheel and a bottle rack. I bought this as a ready-made sculpture. And I have a plan concerning this so-called bottle rack. Listen to this: here in NY, I have bought various objects in the same taste and I treat them as 'ready-mades'. You know enough English to understand the meaning of 'ready-made' that I give these objects. I sign them and I think of an inscription

for them in English. I'll give you a few examples. I have, for example, a large snow shovel on which I have inscribed at the bottom: *In advance of the broken arm*, French translation: En avance du bras cassé. Don't tear your hair out trying to understand this in the Romantic or Impressionist or Cubist sense – it has nothing to do with all that.[4]

Duchamp clearly stated his objective here: he was inventing another category of artwork, 'works of art that are not art', from wholly functional everyday objects devoid of any apparent aesthetic qualities that he purchased in hardware stores or, sometimes, assembled with one or more of his closest friends. The English word 'ready-made' suited Duchamp perfectly and he made it his own in 1915; he could think of no better name for these now infamous 'objects with inscriptions' that have since generated countless interpretations.[5]

Duchamp took his own detachment and indifference to the beauty of an artwork even further. Not only did his straightforward gesture of naming radically undermine traditional assumptions about works of art, his next step would challenge the role of the artist: he asked his sister to sign the object in his place:

This long preamble just to say: take this bottle rack for yourself. I'm making it a 'Ready-made', remotely. You are to inscribe it at the bottom and on the inside of the bottom circle, in small letters painted with a brush in oil, silver white colour, with an inscription that I will give you herewith, and then sign it, in the same hand-writing, as follows [after] Marcel Duchamp.[6]

He did not, however, include the inscription in the letter, even though he wrote and asked his sister again: 'Did you write the inscription on the ready-made? Do it. And send it to me (the inscription) and let me know exactly what you did.'[7]

Duchamp's long-distance instructions were very specific and demonstrated that, even if the artist's gesture seemed immeasurably small, it was nonetheless well aimed and courageous. Towards the end of his life, Duchamp recalled:

> It's very difficult to choose an object because at the end of fifteen days you begin to like it or hate it. You have to approach something with indifference, as if you had no aesthetic emotion. The choice of ready-mades is always based on visual indifference and, at the same time, on the total absence of good or bad taste.[8]

Duchamp thus invented a new definition for the artwork: no longer a pale copy of reality, it was now taken directly from reality. At the time it may have seemed surprising or even absurd, but Duchamp's method was didactic and clear. He demonstrated that the work of art had been conceptualized according to two distinctive and independent axes: its conception, or idea, and its material realization. His method showed that the artist did not have to be present for its creation; all one needed was a pre-defined 'user's manual'. He summarized his position in 1963: 'a ready-made is a work of art without the artist to make it'. The physical creation of an artwork without the artist's intervention was simply inconceivable at the time, except in photography and cinema, which, in any case, were not considered as fine arts. Applying these criteria to traditional media like painting and sculpture was unheard of. Yet, once Duchamp set the process in motion, it followed that questions pertaining to the status of the original and the copy, which had long served as paradigms for recognizing and judging the value of art, would gradually become obsolete.

There is no trace of Suzanne's reaction to her brother's letter urging her to avoid considering this kind of object as she would an Impressionist or Cubist painting and arguing that she was looking at

something entirely different. Duchamp was very cautious about showing these objects. He knew he had to orchestrate their appearance and keep their origin a mystery. Unbeknownst to his friends, who thought him inactive and inoffensive, he was actually preparing to unveil his ready-mades. As Man Ray recalled, Duchamp, who had made rapid progress in English, felt quite at ease in New York and, although he gave the impression that he was just a dandy who had left painting behind, he was actually preparing several great surprises for his friends.[9] He wrote to Suzanne at around the same time that he was choosing other objects for ready-mades, which he would soon reveal to the public in a most theatrical way. But first, for his own enjoyment, he installed a replica of *Bicycle Wheel* in his Beekman Place studio. Many years later, and with more than a hint of irony, he said he enjoyed looking at this perpetually moving object because it was 'very calming, very comforting. I took pleasure in watching it, just as I take pleasure in looking at the flames dancing in a fireplace.'[10] And he added: 'I probably accepted the movement of the wheel very gladly as an antidote to the habitual movement of the individual around the contemplated object.'[11] Later, when he shared a different studio with his sister Suzanne's second husband, the Swiss painter Jean Crotti,[12] he spread his ready-mades 'made in USA' throughout the space (on the floor, the ceiling, in the space, but rarely on the walls, like paintings). Several years later, he recounted their origins and the context of their first public appearance.

Duchamp and Crotti had their studio in the Lincoln Arcade Building, which was mainly rented to artists, located on Broadway and 66th Street, close to the Arensbergs' duplex. In November 1915 he dragged Crotti to a hardware store on Columbus Avenue, where he purchased a snow shovel, a perfectly ordinary object for any New Yorker used to east coast snowstorms. The shovel nonetheless intrigued Duchamp and Crotti for, on the contrary, it was rather uncommon in France. Duchamp carried it back to their studio on

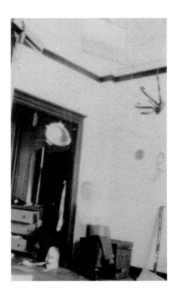

Duchamp's studio on 67th Street, New York, in 1917. We can see Duchamp's shadow as if seated in the corner, and we can also see several ready-mades, including, suspended on the ceiling, an initial version of *In Advance of the Broken Arm* (1915), on the right *Hat Rack* (1917) and *Fountain* (1917), suspended from the door-frame.

his shoulder, and wrote the inscription 'In advance of the broken arm' along its handle before hanging it from the ceiling. Of course, his friendly accomplice Crotti never suspected that Duchamp would mention his name whenever this ready-made came up in conversation. Yet Duchamp relied on the collaboration, even minimal, of one or more of his friends for most of the ready-mades from this period. He surrounded these mass-produced objects with personal anecdotes and memories in order to emphasize their anonymous and unaesthetic nature and to capture better the viewer's attention. For Duchamp, the ready-made was above all a 'rendez-vous', a fortuitous encounter with an object that he plucked from its habitual context and promoted to the status of an artwork. It was not, strictly speaking, an idea, but a 'revolution' in the conception and the definition of the artwork.

What is even more remarkable is that Duchamp achieved this revolution through indifference and humility in the face of chance. The creative act resides solely in his decision to recognize a

particular object, to divest it of its usual function and to give it a different trajectory. In addition, by inviting his friends to participate in these encounters, Duchamp was touching on issues of intellectual property that have only gained in importance as the constant flow of images and signs has accelerated over the course of the last century.

Once again, he made Crotti his accomplice. In a letter dating from July 1918, just prior to his stay in Buenos Aires, he told Crotti about an even more sophisticated ready-made, *Sculpture for Travelling*:[13]

> Do you remember those rubber bathing caps that come in all colours? I bought some, cut them up into uneven little strips, stuck them together, not flat, in the middle of my studio (in the air) and attached them with string to the various walls and nails in my studio. It looks like a kind of multicoloured spider's web.[14]

In 1917 Duchamp installed in his studio two other humorous and poetic ready-mades, similar in kind to the aluminium snow shovel. *Trap* (*Trébuchet*) and *Hat Rack* are objects that have similar uses in everyday life (hanging up coats and hats in an entry), but their design differs, so Duchamp experimented with their placement. He hung *Hat Rack* on the ceiling, like a Calder mobile before the fact. He thought about hanging the coat rack *Trap* on the wall, but instead he left it on the floor: 'It was on the floor and I kept walking into it. It was making me crazy so I finally said: okay, if it is going to stay on the floor I will nail it there.'[15] Given his predilection for wordplay, Duchamp was naturally aware that the verb *trébucher* means to lose one's balance and also means to move one's pawn in the game of chess.

Between 1916 and 1917, then, Duchamp's studio was home to four ready-mades: the American version of the *Bicycle Wheel*, *Snow*

Shovel, *Trap* and *Hat Rack*. While he had not revealed his new
objects in Paris, friends and journalists who visited his New York
studio either did not notice, preferred to ignore, or did not take too
seriously the objects hanging from the ceiling or placed on the
floor. Henri-Pierre Roché, however, mentions them in *Victor*: 'In
the entryway he stretched out a multi-coloured rubber sculpture
for travelling. He fixed coat hooks to the floor. A bicycle wheel
standing on its fork and a big snow shovel stood in for artworks.'[16]
For the time being Duchamp preferred to withhold commentary
on this new 'form of manifestation', in part because he had more
surprises up his sleeve. These four objects would soon be joined by a
fifth: the genuine white porcelain urinal he purchased at a bathroom
supply store in 1917 and titled *Fountain*.

Fountain was one of the rare ready-mades to pass directly from
the shop to the exhibition space. Using the pseudonym Richard
Mutt, Duchamp submitted it to the Society of Independent Artists
exhibition in New York under the pseudonym Richard Mutt, only
to have it rejected on the grounds that 'this object is very useful
in its place, but its place is not in an art exhibit!' Hidden behind
a curtain for the length of the show, Duchamp brought *Fountain*
to Alfred Stieglitz on 9 April 1917 to be photographed. He then
defended the urinal on aesthetic and ethical grounds in an unsigned
editorial titled 'The Case of R. Mutt', which, accompanied by
Stieglitz's photograph, appeared in the second issue of *The Blind
Man*, followed by Louise Norton's essay 'The Buddha of the
Bathroom'. The work was next returned to Duchamp's studio,
where photographs taken by Roché in 1917 show it hanging above
a door-frame. Although rumour held that Arensberg bought the
object, it never turned up in his collection. Yet *Fountain* would
resurface thirty years later in other circumstances.[17]

After relying on Suzanne and her husband for help with his
ready-mades, Duchamp turned to his principal American benefactor,
Walter Arensberg. We know that Arensberg was with Duchamp

when he bought *Fountain* and that he supported Duchamp's desire to shock the Independents committee.[18] However, even then Arensberg was not new to Duchamp's readymades. A year before, during the Easter holidays, Duchamp asked him to hide an object of his choice in a roll of twine that was to be clamped between two brass plates held by large wing nuts. *With Hidden Noise* (1916) may well poke fun at the Easter tradition of hiding eggs with mysterious objects tucked in them. Arensberg, however, waited until New Year's Eve to seal the object. Duchamp made three slightly different versions of this 'assisted' ready-made: the first for his collector, who was flattered that only he knew what the ball of twine contained, a second version for himself, and a third for his friend, the journalist and playwright Sophie Treadwell, whom he had probably met at one of the Arensbergs' soirées. Beatrice Wood even played a secondary role in one of her plays at the Lenox Little Theater in 1918, and some of Treadwell's texts appeared in *The Blind Man*. Once again, the playfully indifferent Duchamp took artistic collaboration to another level: he shared authorship, entrusted someone else to 'finish' the piece and, since the contents were a secret, left the final results entirely up to chance.

A few years later he had Walter Arensberg in mind again when he produced especially for him a ready-made 'made in Paris', called *Paris Air* (1919). Again, how it came into being has contributed to its aura, as well as its charm. Duchamp bought a glass ampoule at a Paris chemist's located 'on the corner of the rue Blomet and the rue de Vaugirard', which he subsequently emptied and filled with the air of the capital. *Paris Air* is one of Duchamp's most precious and nomadic ready-mades; it fits in the palm of the hand like a talisman. And due to its extreme fragility it is also one of the first ready-mades that Duchamp had to reproduce:

> May I ask you the following favour. Walter Arensberg has broken his ampoule, 'Paris Air.' I've promised him I'd replace it. Could

you go into the pharmacy . . . and buy an ampoule like this one: 125 cc and the same measurements as the drawing. Ask the pharmacist to empty it of its contents and seal the glass with a blowtorch. Then wrap it up and send it to me here. If not rue Blomet, somewhere else – but, as far as possible, the same shape and size.[19]

Other ready-mades include an Underwood typewriter cover he titled *Traveller's Folding Item* (1916):

I thought it would be a good idea to introduce some flexibility into the readymade, in other words, instead of hardness, porcelain, iron, things like that, why not use something flexible as a new form; that's how the typewriter cover came into being.[20]

Duchamp has in fact created a visual pun by playing with the word 'Underwood' and the object's function to cover another object protectively.

Duchamp's initial intentions for the ready-mades were linked to his desire for 'complete anaesthesia' with regard to 'good' and 'bad' taste. He sought to disqualify aesthetic judgements permanently by introducing the 'hoax' as a demystifying artistic principle. Nevertheless, all these objects, none of which displays any obvious intervention on the part of the artist, have stood the test of time for almost a century. In truth, Duchamp's interventions were more substantial than he would admit – firstly, through the inscriptions he hoped would carry 'the mind of the spectator toward other regions more verbal'.[21] He especially wanted do away with the descriptive function of the title and demonstrated this in a ready-made of 1916 , a dog comb he inscribed with the nonsensical phrase 'three or four drops of height have nothing to do with savagery' ('*Trois ou quatre gouttes de hauteur n'ont rien à voir avec la sauvagerie*').[22] Secondly, he placed his objects in space in an

entirely new way, anticipating the principal concerns of modern and contemporary sculpture: the abolition of the pedestal, of volume and of noble materials in favour of the exploration of scale. Finally, he limited their production:

> I realized very soon the danger of repeating indiscriminately this form of expression and decided to limit the production of ready-mades to a small number yearly. I was aware at that time, that for the spectator even more than for the artist, art is a habit-forming drug and I wanted to protect my ready-mades against such contamination.'[23]

Apart from the 'objects with inscriptions', Duchamp also created 'rectified' or 'assisted' ready-mades, primarily two-dimensional objects that he altered in the most discrete, almost invisible, but remarkably targeted way, so as to solicit the viewer's attentive participation. These were often initially copies or reproductions, such as *Pharmacy*, which he gave to Suzanne in 1914: 'a little ready-made which is a reproduction used by artists to make little landscapes. They are given models and they copy them.'[24] Several decades later Duchamp recounted how he threw this reproduction off-kilter by integrating the image of a pharmacist's sign, in reference to his sister's marriage to a pharmacist. In effect, bringing his sentiments to bear on his chance encounter with the landscape:

> Look at *Pharmacy*. I did it on a train, in half-darkness, at dusk; I was on my way to Rouen in January 1914. There were two little lights in the background of the reproduction of a landscape. By making one red and one green, it resembled a pharmacy. This is the kind of distraction I had in mind.[25]

These 'rectified' or 'assisted' ready-mades also testify to Duchamp's interest, sometimes ironic, in the commercial prints he

purchased at art supply shops for their weak visual qualities and because they symbolized the very tradition he was challenging. By retouching them in small measures he intended to confront the viewer with his or her own critical capacity and attention to detail, as well as his or her ability to distinguish the real (the original) from the fake. His best-known example is *L.H.O.O.Q*, a cheap reproduction of the *Mona Lisa* onto which he pencilled a moustache and goatee and the sequence of letters that, when pronounced like initials in French, sound out the phrase 'Elle a chaud au cul' ('she is hot to trot' is a polite translation). The viewer is free to play with the five letters and invent other verbal combinations.

In a less provocative way, Duchamp transformed another found image into a tribute to his friend Apollinaire. *Apolinère Enameled* (*sic*) was originally an advertisement for Sapolin brand enamel paint. He changed the lettering and added the reflection of the little girl's hair in the mirror, a detail that would escape all but the most observant viewer. Then, in December 1919, he presented his dentist, Dr Tzanck, with an enlarged facsimile of a cheque as payment for dental work: 'I asked for the sum and I made the cheque entirely by hand, I spent a long time making the little letters, making something that looked printed; it was not a little cheque.'[26]

The Parisian Dadaists, in particular Tristan Tzara, Louis Aragon and Picabia, greeted these two-dimensional, slightly modified ready-mades with appreciation and enthusiasm, but the three-dimensional ready-mades like *Bottle Rack*, *Fountain* or *With Hidden Noise* were more difficult to grasp. Even Duchamp's most fervent admirers, Katherine Dreier and Walter Arensberg, did not take them very seriously and rightly imagined that they would disappear. The three-dimensional ready-mades were generally considered as another of Duchamp's jokes, or were received with the same cool distance that lay behind their conception.

Sometimes the ready-mades went practically unnoticed. In April 1916 the Montross Gallery in New York invited Duchamp,

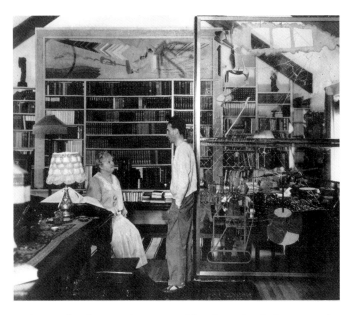

Duchamp with Katherine Dreier at West Redding, Connecticut, in the summer of 1936. Visible are *Tu m'* (1918) and the original of *The Large Glass* (1915–23), just repaired by Duchamp.

Jean Crotti, Albert Gleizes and Jean Metzinger to exhibit their work. Duchamp decided to show *Pharmacy*, which the catalogue referred to as a 'drawing'. That same year he agreed to participate in another exhibition, at the Bourgeois Gallery, called *Modern Art after Cézanne,* on condition that he was allowed to show two ready-mades. Along with the paintings *The Chocolate Grinder* and *King and Queen Surrounded by Swift Nudes,* Duchamp displayed his *Trap* and *Hat Rack* as 'sculpture', installing them in the gallery entrance exactly where visitors would leave their coats, hats and umbrellas – in any case, not where they expected to find sculpture. His wager paid off: the two ready-mades shocked no one, because no one saw them. An American journalist who visited the studio, however, wrote an article for the *Evening World* on 4 April 1916 (the day after

the exhibition opened) that mentioned the snow shovel hanging from the ceiling, although when Crotti pointed it out he failed to mention the title written in white paint on the wooden handle. News of the ready-mades did not really circulate among Duchamp's friends. Duchamp wrote to Ettie Stettheimer: 'Have you heard about the "ready mades"? If not, ask Roché about them. That very funny article in the *Tribune* that you mention is a "readymade". I signed it, but didn't write it.'[27] Just a few of them were in on the secret: Crotti, of course, then Roché, Arensberg and Man Ray.

In 1918 Katherine Dreier commissioned a painting for her library. She offered Duchamp free rein and $1,000. The urinal had shocked her as much as it had the other members of the Independents' committee and she was wary of acquiring one of his 'objects with inscriptions'. Duchamp accepted the commission and decided to use his last painting to pay homage to his ready-mades. *Tu m'* (it is up to the viewer to complete its title)[28] winks at painting and 'documents'[29] a selection of ready-mades:

> I executed the cast shadow of the bicycle wheel, the cast shadow of the hat rack . . . and the cast shadow of the corkscrew. I had found a sort of projector which made shadows rather well enough, and I projected each shadow, which I traced by hand, onto the canvas. Also, right in the middle, I put a hand painted by a sign painter, and I had the good fellow sign it.[30]

Duchamp fell upon the idea of using shadows in his studio, where he had replaced the window curtains, which he detested, with oiled newspaper that stuck nicely to the smooth glass surface. When he worked or played chess late into the night, the hanging ready-mades cast reflections on the walls and the windows covered in newspaper. In 1918 he also executed a note he dated 1914, which he reproduced for the *Green Box* and in which he described the projection of cast shadows of most of the ready-mades found in his studio:

shadows cast by 2. 3. 4. Readymades. 'brought together'
(Perhaps use enlargement of that so as to
extract from it a figure formed by
an equal [length] (for example) taken in each Readymade
and becoming by the projection a part of the cast
shadow

 for example 10 cm in the first Rdymade each
 10 cm — 2nd — of these 10 cm
 etc. having become
 a part of
 the cast shadow

Take these having become and from them make a tracing
without of course changing their position in relation to
each other in the original projection.[31]

This might be interpreted as a metaphor for his quest for the
fourth dimension: the ideal of a transformed consciousness of reality
that modern and civilized man should strive to achieve.

Shortly afterwards Duchamp left for Buenos Aires with
Sculpture for Travelling, initially destined for Katherine Dreier, who
joined him there for four months in order to write a study of the
Argentinian way of life and the condition of women in Argentinian
society.[32] In 1918 Duchamp wrote to Arensberg: 'Miss Dreier has
been here for a month. She takes care of articles for the Studio
and various other things but this town is very hard for her, I mean
women on their own are not accepted in Buenos Aires. It is crazy,
the insolence and stupidity of the men here.'[33]

Duchamp's ready-mades started to turn up in various group
exhibitions in which he participated during the 1930s.[34] The
Surrealists appreciated their affective and subversive dimension
and were among the first to show them in Paris. Duchamp lent
Pharmacy and *L.H.O.O.Q.* to an exhibition of collage, *La Peinture
au défi*, organized by Louis Aragon at the Galerie Goëmans in 1930.
The first replica of his *Bottle Rack*, along with *Why Not Sneeze, Rrose
Sélavy* and *Bagarre d'Austerlitz* were shown with objects by Picasso
and a sculpture by Giacometti at the *Exposition surréaliste d'objets*

mathématiques, naturels, trouvés, et interprétés, organized by André Breton and Charles Ratton in 1936. When American museums started to mount exhibitions of Dada and Surrealist art, Duchamp was always represented by his Cubist or mechanomorphic canvases from the 1910s. One such exhibition, *Fantastic Art, Dada, Surrealism,* organized by the Museum of Modern Art in 1937, displayed eleven of Duchamp's works in two rooms at the beginning of the exhibition. The only mention of the ready-mades was Man Ray's photograph of the *Bottle Rack,* which he had taken so that it could be included in one of Duchamp's projects at the time, an edition of more than 300 called the *Boîte-en-valise (Box in a Valise* or *Travelling Box).* Similarly, the Arts Club in Chicago organized Duchamp's solo show in 1937, but it was exclusively a painting one. The first concrete definition of the ready-made appeared in the catalogue for Duchamp's and Breton's *Exposition internationale du surréalisme,* organized that year in Paris with the help of their 'special advisers' Salvador Dalí and Max Ernst. Although they did not include any ready-mades in the exhibition, the catalogue defines them for the first time as 'manufactured objects promoted to the dignity of art objects through the choice of the artist'.[35]

The ready-mades disappeared for many years until the 1950s, when the American dealer Sidney Janis organized several encounters between replicas and the public without any Duchampian detours or ruses. Duchamp recalled in 1967 that 'for more than thirty years nobody spoke of them and neither did I',[36] then Janis asked for permission to make a copy of the long-lost *Fountain* for the exhibition *Challenge and Defy: Extreme Examples by xx Century Artists, French and American,* which opened in September 1950.

In the exhibition at the Janis Gallery, *Fountain* was attached to the wall almost at ground level, unlike the works by Delvaux, Dalí and Magritte, which were hung at eye level. Three years later, *Fountain* reappeared in the Janis Gallery exhibition *Dada, 1916–1926,* which was entirely organized by Duchamp and included most of

his ready-mades: *La Joconde*, *Dr Tzanck*, *Apolinère Enameled*, *With Hidden Noise*, *L.H.O.O.Q.*, *50 cc Air de Paris*, *Traveller's Folding Item* and Katherine Dreier's commission, the painting *Tu m'*. This time Duchamp installed *Fountain* above a doorway, as he had in his own studio in 1917. He attached a branch of mistletoe to the replica as 'a graphic detail' that distinguished it from the original. Duchamp worked on this first Dada retrospective in the United States for almost a year, gathering together works, documents and manifestos from different collectors, working like a historian to reconstitute the memory of the European movement he helped to bring to New York between 1915 and 1918. He designed vitrines for the documents, including one he suspended from the ceiling, rendering it as inaccessible to the viewer as he had his urinal. Finally, he designed and printed the catalogue, made out of tissue paper. Duchamp's layout played on contrasting black and white characters cascading down the page, like the stairs in his famous *Nude*. As a final gesture for the opening reception, he placed the catalogues in a paper bin full of wrinkled paper balls!

In 1959 a replica of *Bottle Rack* appeared in the *Art and the Found Object* exhibition organized by the American Federation of the Arts at the Rockefeller Center, New York. The American artist Robert Rauschenberg purchased Duchamp's most mythical ready-made for $3 and then asked him to sign it. Naturally Duchamp accepted with a malicious grin: next to his signature, *after Marcel Duchamp* (*D'aprés Marcel Duchamp*), he wrote: 'Impossible to remember the original sentence'. With his infallible logic and absolute serenity, Duchamp brought the trajectory of these 'objects with inscriptions' to a conclusion, having brilliantly orchestrated their appearance and disappearance according to his own personal path.

5

Collaborations

Marcel Duchamp and his sister Suzanne were quite similar in character and forged a special bond during their Normandy childhood that never faltered, despite the geographical distance that frequently separated them. After relying on her help to pull off his first 'remote' ready-made, *Bottle Rack*, he involved her in another long-distance collaboration: he offered her a ready-made as a gift in celebration of her second wedding to his former studio-mate Jean Crotti. Duchamp described the gift: 'It was a geometry book . . . to be hung by strings on the balcony of [their] apartment on the rue de Condamine; the wind had to go through the book, choose its own problems, turn and tear out the pages'. The choice of the book was anything but neutral: 'It amused me to bring the idea of happy and unhappy into ready-mades, and then the rain, the pages flying, it was an amusing idea.'[1] Suzanne, equally amused by her brother's unexpected propositions, went along with the game. She took a black and white photograph of the ready-made, from which she did a painting in which she reversed the forms, just as her brother had overturned the bicycle wheel on the stool in 1913 or had hung objects upside down from his ceiling. True to her own Duchampian spirit, she called the painting of 1920 *Marcel's Unhappy Ready-made* and sent him the photograph. He responded: 'I really liked the photo of the Ready Made getting bored on the balcony. If it's completely torn to shreds you can replace it (Ah! It's true, you've moved!).'[2] Of course, this notion of the 'Ready Made getting bored' could very well apply to Duchamp himself.

Their playful collaboration encapsulated perfectly the camaraderie he generously and faithfully cultivated throughout his life. In fact, Duchamp's ready-mades from 1916 and 1917 – the famous urinal signed Richard Mutt, *With Hidden Noise*, as well as *Rendez-vous du 6 février 1916 à 1 h après-midi* (four postcards typed with cryptic texts setting up an appointment with the Arensbergs at his beloved Breevort Hotel on Lower Fifth Avenue) – should be considered in the light of these collaborations since they demonstrate the obsolete nature of the original, unique artwork and, as a result, of authorship.

Duchamp's collaborations extended to his publishing 'firm', P.B.T. (P for Pierre, alias Roché, B for Beatrice Wood and T for 'Totor', Roché's lifelong nickname for Duchamp). This admittedly short-lived and clandestine association led to the publication of two Dada magazines, *The Blind Man* in April 1917 during the Independents exhibition and *RongWrong*, the single issue of which appeared in July 1917. The first issue of *The Blind Man* tried to establish a link between the paintings in the Independents exhibition and the public, addressing its readers questions such as: Which work in the exhibition do you like best, which do you like least, which do you find the funniest, the most absurd? The trio went even further by suggesting that its readers, presumably all habitués of the Arensberg salon, 'write a funny story' using the form of a 'quatrain' or a 'song', or even a 'dramatic story in less than two hundred words', based on a work of their choice. In exchange, they would publish the texts by the anonymous authors in the next, and final, issue. They also organized a costume ball to celebrate the arrival of the second issue, as well as printing a poster with a drawing by Wood chosen by Duchamp. That same year Duchamp and Roché had their pictures taken on Broadway, not far from Duchamp's home, with a trick camera that used a hinged mirror to repeat the model's image in sequence. The resemblance between Duchamp and Roché is striking and effective in their two photos.

Multiple portrait with Roché in 1917, Broadway, New York.

Considered as the first photographic ready-mades,[3] these portraits again challenge notions of authorship, but they especially reassert that the artist's choice matters more than the objects he or she produces. These playful and flirtatious collaborations were completely in line with the Dadaist spirit that Duchamp and his friends were importing onto American soil, and one that was hardly disposed to its provocative, and even slightly fraudulent, tendencies.

Duchamp instituted another form of stable and long-term collaboration with the photographer Man Ray that lasted almost thirty years. Walter Arensberg had introduced Duchamp to Man Ray and his wife, the poet Adon Lacroix, in 1915. Man Ray was then associated with Alfred Stieglitz's gallery and his magazine *291*. Immediately taken with Duchamp's charisma, Man Ray began making regular visits to Duchamp's studio:

> Once in awhile I'd run up to visit Duchamp, who was installed in a ground-floor apartment which looked as if he had been moving out and leaving some unwanted debris behind. There was absolutely nothing in his place that could remind one of a painter's studio.'[4]

Their friendship intensified around 1920: 'He was making rapid progress in English and we could exchange ideas. His proficiency no doubt was due to the fact that he had taken on some pupils to teach them French; I'm sure he learned much more English than they did French.'[5] This led to an entire series of crucial works and projects. Duchamp appreciated his easy-going nature, which distinguished him from the elegant, but seemingly haughty and rigid Arensberg. He immediately recognized his new friend's talent as a photographer, a talent that would blossom in 1921 when Man Ray went to Paris: 'He took up photography and it was his achievement to treat the camera as he treated the paint brush, a mere instrument in the service of the mind.'[6] Man Ray could easily relate to Duchamp's ideas, and they quickly began working on a series of 'four-handed' projects, which include Man Ray's photographs of Duchamp's works. Stieglitz had been the first to photograph one of Duchamp's ready-mades, *Fountain*, which he placed on a pedestal in front of a painting, as if to prove that the urinal was as much a work of art as its backdrop. Man Ray's vision of his works was equally subtle and telling. In 1920, while Duchamp was secretly working on his *Large Glass*, Man Ray photographed the dust accumulating on the glass plates stored in his studio. He tightly framed the shot on the bachelors' domain and used special lighting and a long exposure to make the dust appear thicker. Both artists signed this black and white aerial view, which resembles a lunar landscape or a microscopic image, and Duchamp added his touch by calling it *Dust Breeding*. It is one of the first, though certainly abstract, representations of the *Large Glass*.

When he was finishing his *Large Glass* and had started playing regularly at the Marshall Chess Club, Duchamp, who owned a hand-held ciné camera, rigged up a motorized optical machine that he called *Rotary Glass Plates (Precision Optics)*. In Man Ray's 1920 photograph of the object, a pipe-smoking Duchamp stands next to his latest invention and stares at the camera: 'I've made a "monocle".

Duchamp with *Rotary Glass Plates* (1920) and behind him, *The Chess Game* (1910), in a photograph by Man Ray.

It's a thing that rotates at top speed driven by an electric motor – highly dangerous – I almost killed Man Ray with it. I hope to take some photos of it and send them to you', he wrote to Suzanne and Jean Crotti.[7] Then, in 1936, Man Ray photographed the *Bottle Rack* on an entirely black background, isolating it from its usual context to make a modern sculptural icon out of it.

At approximately the same time, Duchamp effected another total modification of the work of art. His ready-mades had already caused one transformation, but they hardly ever left his studio. When they were shown to the public, they were censored (*Fountain*), ignored, or confused with everyday objects (*Trap* and *Hat Rack*). Yet Duchamp never stopped his playful and provocative questioning of the relationship between the hand of the artist and the artwork. He used his own talent to show effectively that art is a

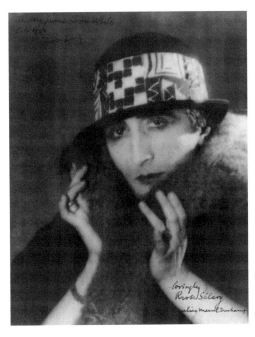

Rrose Sélavy by Man Ray, Paris, 1921, a photograph by Man Ray retouched by Duchamp with himself as Rrose Sélavy.

'fabrication' of the mind and, especially, a question of attitude, of spirit and freedom in the face of conventions.[8]

Once Duchamp had elevated the manufactured object to the status of the artwork, he then raised the artist's behaviour to the same level with the birth of his female alter ego, Rrose Sélavy, in 1920. The public appearance of this *femme savante* (intellectual woman) of questionable morals called for a certain *mise-en-scène* that required Man Ray's cooperation. Man Ray began by taking portrait photographs of Rrose (Duchamp disguised as a middle-aged woman) posed against a neutral background and dressed to the nines in a fur collar, pearl necklace, rings and a hat.[9] Man Ray's pictures serve as the birth certificate of this 'daughter born without a mother' – or Duchamp in drag. Man Ray and Duchamp accentuated her peculiar femininity by touching up the photos with ink and pencil.

In 1921 Duchamp decided to launch a perfume, to be distributed in Paris and New York. His perfume bottle would be a 'false' replica of a real Rigaud brand perfume bottle available in shops; a kind of 'reversed' ready-made, in sum. He modified the original label by adding Rrose's emblematic face, photographed by Man Ray. There was no better ambassadress than Rrose for publicizing this new brand of perfume. After cutting his portrait of Rrose into the form of a medallion, Man Ray, following Duchamp's instructions, created a photomontage for the label, which read: 'BELLE HALEINE/Eau de Voilette' (translated as Beautiful Breath: Veil Water, but Duchamp is also playing on the terms Belle Hélène and Eau de Toilette). Although he originally intended to flood the two continents with his perfume, Duchamp gave up his idea to mass-produce the bottle, and today it stands as one of the most precious ready-mades from this period, simultaneously authored by Duchamp and Man Ray.

Immediately after this episode, Duchamp, who was in contact with the Parisian Dadaists Tzara and Picabia, considered importing Dada to New York through the publication of a magazine. He wrote to Picabia on 22 January 1921: 'Man Ray and a friend of ours, Bessie Breuer, are going to bring out a New York Dada. Would you be kind enough to ask Tzara for a short publishing authorization that we could put on the magazine? Here, Nothing, eternally, Nothing, very Dada.'[10] Man Ray recalled that Duchamp designed the cover but left him to do the layout and choose the contents, which included a poem by the painter Marsden Hartley, a caricature signed by a newspaper cartoonist named Goldberg, and several banal slogans as well as a photograph taken by Stieglitz representing a woman's leg wearing a too-small shoe. Man Ray added several ambiguous photographs to all of this, taken from his own files.

The sole issue of *New York Dada* came out in 1921 with, on its cover, a reproduction of the perfume bottle, its cap slightly open as

if to let out Rrose's 'beautiful breath'. The typed title, 'new york dada april 1921', ran all over the page in upside-down lower-case letters; Duchamp ignored the traditional margins, as he had with *Rendez-vous* in 1916. The distribution of this magazine was quite low key: 'The distribution was just as haphazard and the paper attracted very little attention. There was only one issue. The effort was as futile as trying to grow lilies in the desert.'[11]

Soon after, Duchamp, who made regular trips between Paris and New York in order to renew his residency permit, decided to return to France temporarily. Man Ray joined him in 1921. Duchamp was there to greet him, and also arranged for his lodging in Paris. He introduced Man Ray into the Dada circle, which warmly welcomed him, thanks to Duchamp's recommendation. Philippe Soupault's *Librairie Six* organized an exhibition of his work in December 1921. Duchamp helped with the invitation card: a small yellow triangle with the phrase 'UNE BONNE NOUVELLE' (Good News). In a caption he wrote for the 1949 Société Anonyme catalogue, Duchamp described Man Ray's arrival in France:

> He arrived in Paris in 1921, already known as a Dadaist, and joined the ranks of this active group with Breton, Aragon, Eluard, Tzara and Max Ernst, the founders of Surrealism three years later. The change of milieu gave new impetus to Man Ray's activities.[12]

Man Ray and his lover Kiki settled in the Hôtel Istria on rue Campagne-Première, not far from Montparnasse. Word spread gradually and Man Ray became the most sought-after portrait photographer in Paris. He photographed the couturier Paul Poiret's dress models and works in Jacques Doucet's collection. He also took a portrait photograph of Peggy Guggenheim in a magnificent Poiret gown, as well as one of Gertrude Stein,[13] whom Picasso had painted in 1906.[14]

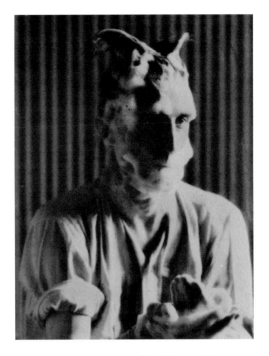

Duchamp when lodging at the Hôtel Istria in Paris in 1924, in a photograph by Man Ray.

This recognition did nothing to alter his friendship with Duchamp and the two accomplices continued to collaborate in a friendly and jovial way, such as when Duchamp also took lodgings at the Hôtel Istria: 'I was living in a frightfully cold studio which I have forsaken for a small but very comfortable hotel, 29 rue Campagne Première', he wrote to Ettie Stettheimer on 1 January 1924.[15] There, Man Ray took several portraits of his neighbour in his bathtub, completely dressed, his hair and face covered with white shaving foam and shampoo.

Meanwhile Duchamp started a new project based on the founding principles of games and chance: 'In this case, I believe I have eliminated the word chance. I would like to think I have forced roulette to become a game of chess', he wrote to Jacques Doucet in 1925.[16] The *Monte Carlo Bond*, as it came to be known, combined a

vain hope in financial speculation and the meticulous fabrication of a fake casino bond, which Duchamp painstakingly strived to make appear as real as the original. Man Ray recalled: 'so he took up roulette. He studied the monthly sheets of all the numbers that came up, published by Monte Carlo, and worked out a system of placing his money that would infallibly bring in a return profit.'[17]

As with the perfume bottle label, Duchamp once again relied on techniques of photomontage. He superimposed that photograph Man Ray had taken of him in the Hôtel Istria bathroom (his hair sculpted in shampoo or shaving suds into bull's or devil's horns) onto the centre of the roulette wheel, implying that the little devil thinks he can 'break the bank' of the Monte Carlo Casino. He placed this image on a background printed repeatedly with another of his plays on words 'domestic mosquitoes half stock' ('*moustiques domestiques demi-stock*'), in a manner somewhat reminiscent of his cover for *New York Dada*. He printed the rules of the game on the back of the document and asked friends and patrons to invest in the 30 bonds he issued at a going rate of 500 francs per bond. Some purchased them, including Jacques Doucet. Duchamp wrote to him in January 1925: 'I posted earlier the gambling obligation we discussed yesterday. It is self-explanatory. I've done a lot of work on the system'.[18] The bonds were signed M. Duchamp, administrator, Rrose Sélavy, President of the Administrative Council.[19] In order to get the ball rolling, Duchamp went to Monaco on several occasions, though he hoped to stay there for three full months. Man Ray recalled that he stuck to his system and won a little, but not enough to reimburse his sponsors.[20] In truth, since he had sold only a dozen bonds he could go to Monte Carlo only for very short periods; then, because 'slow progress was trying his patience', he abandoned the project. Nevertheless, he told Ettie Stettheimer that he planned to return there in September 1926: 'Before leaving I am going to spend a month in Monte Carlo which I love for its lack of mosquitoes and its architecture.'[21]

Jacques Doucet's financial support was essential during these two years in France. Doucet purchased *Rotary Demisphere*, the second optical machine he and Man Ray built, this time with the help of an engineer. Then in 1926 Man Ray, the cinematographer Marc Allégret and Duchamp made a stereoscopic film from the dozen discs designed for the globe of that new machine. Black discs printed with white optical patterns alternated with other discs on which spirals of white letters spelt out erotic puns on black velvet backgrounds. Duchamp insisted that the dark surface of the discs exactly match the 'totally matte backgrounds in cinema studios'. He titled the work *Anemic Cinema*, an anagram of the word cinema but also an allusion to the anaemic state caused by the hypnotic effect of the rotating spirals, and to sexuality. Duchamp's projection of the film (copyrighted by Rrose Sélavy) went unnoticed: 'We learned today that the Dadaists are organizing 17 exhibitions in Paris, 14 in Spain, 12 in London . . . A single film will be projected in America, then in France', read an announcement the Dada artists sent to the Paris press on 1 December 1926.

Meanwhile Man Ray was taking photographs of the paintings by Picabia that Duchamp purchased with money he inherited from his parents. The collaboration between Duchamp and Man Ray resulted in a crucial body of work and photographs that Man Ray did not just execute, but authored. In 1920 Duchamp involved him in another quite different project, and once again Man Ray had proved to be an audacious and inventive artistic ally. Katherine Dreier, who had been collecting Duchamp's work since 1918 and who followed him as he travelled from Buenos Aires to Paris, from Paris to Rouen, where she met his parents in 1919, decided to establish a museum of modern art. She asked Duchamp for his advice and he immediately brought Man Ray into this new venture:

While eating he informed that he had met a lady who collected contemporary works of art, and was planning to found a museum

of modern art . . . she had asked Duchamp to be the honorary president. He had proposed me for the vice-presidency. I was thrilled . . . I accepted his offer wholeheartedly.[22]

Several days later, Miss Dreier organized a meeting with Man Ray:

When I arrived I was ushered by a maid into a room lined with books and modern paintings, mostly Expressionists. Here and there stood a piece of sculpture on a pedestal. Presently, Duchamp arrived; shortly after, the hostess entered: Katherine S. Dreier . . . Miss Dreier opened the session by declaring that first a name had to be given to the new venture. After a few suggestions, I had an idea – I had come across a phrase in a French magazine that had intrigued me: Société Anonyme – which I thought meant Anonymous Society. Duchamp laughed and explained that it was an expression used in connection with certain large firms of limited responsibility – the equivalent of incorporated. He further added that he thought it was the perfect name for a modern museum . . . The name was adopted unanimously.[23]

During this meeting Miss Dreier informed her two friends that she had 'already rented the floor of a brownstone near Fifth Avenue' and asked them to take charge of fitting out the space, which was actually an apartment, and transforming it into an art gallery. Then the trio began to conceive what was in fact the first museum of modern art. Duchamp took inspiration from a chess knight for the Société Anonyme logo, while Dreier insisted that they print flyers inviting people to join the museum and to contribute financially. Man Ray took on the roles of public relations agent and photographer of the museum's artworks. Man Ray and Duchamp combined their talents and quickly devised the museography for the first modern art museum, a predecessor to the

Museum of Modern Art in New York, which opened its doors in 1929. They used glossy white oilcloth on the walls and blue tinted lighting to avoid distorting the colours of the paintings. Their conception of the space and their hanging of the artworks, which was quite radical for the time, is still used in most art museums specializing in twentieth- and twenty-first-century art.

Man Ray moved to Hollywood in 1940. Lou and Walter Arensberg also lived there, but they were not well acquainted. The friendship between Duchamp and Man Ray was steadfast, despite the geographical distance. Duchamp continued to write to his cohort, signing off with a friendly 'Yours forever, Marcel' (*Marcel à vie* or Marcelavy, in reference to Rrose Sélavy), or inviting him to Cadaquès, where Duchamp started spending summers in the 1930s. Duchamp also gave him a reproduction of *L.H.O.O.Q.* and the erotic sculpture *Female Fig Leaf* (1950), which he had asked Man Ray to produce and distribute.

Duchamp never lost sight of this privileged and long-standing friendship. Throughout their lives, Man Ray and Duchamp worked together without ever defining things in advance, remaining attentive to the sincerity of their dialogues and the laws of chance.[24] When the American magazine *View* was putting together a special issue on his work, Duchamp again turned to Man Ray for assistance:

View is preparing a 'Duchamp number' and I would like to have your collaboration. Can you send any documents (photographic or other) retracing our relationship over the last thirty years that you managed to bring back from France? For example, do you have a photo of your portrait of Rrose Sélavy?'[25]

The issue appeared in 1945, its cover a black and white photograph that Man Ray took of a dusty bottle of wine on a dark background, which Duchamp transformed into a starry sky. The

label, just about legible, is a montage that Duchamp made out of his military service record. An inked-red puff of air escapes like fog from the mouth of the bottle. The same year Man Ray asked Duchamp for a favour in kind: to design the cover of the catalogue for his exhibition at the Julien Levy Gallery in New York, entitled 'Object of my Affection'. Duchamp produced a silhouetted movie-still close-up of a couple kissing, its enlarged Benday dot surface looking ahead to Roy Lichtenstein's Pop Art in the US and Alain Jacquet's Mec Art in France.

Whereas Duchamp's collaborations with Man Ray extended over a 30-year period, his collaborations with the American artist Joseph Cornell were of a different sort. Although still cordial and respectful, they worked together less frequently and for just over a decade.[26] Their personalities were quite distinct (and Duchamp was sixteen years older than Cornell), yet they were both amiable and attentive, and they shared a passion for Mallarmé and cinema. Both were also deeply interested in typography and had an obsession for compiling and creating miniature objects and images – often very personal, cherished mementos. Duchamp stumbled across their common ground when he saw Cornell's signature boxes, 'coups d'oeil' and 'surrealist toys' at the Julien Levy Gallery,[27] where his works were sharing the stage with Picasso's engravings on the theme of the 'unknown masterpiece'. The same year that Cornell met Duchamp he became friends with the beautiful and talented war photographer Lee Miller, who had worked with Man Ray and had been his lover. Cornell harboured a secret affection for her while she was photographing his works and shooting some of the most striking portrait photographs ever taken of him. Most of Cornell's amorous passions, however, remained strictly platonic; after a difficult childhood with an authoritarian mother and sickly brother, he was wary of others and preferred solitude.

Duchamp and Cornell met in person for the first time in 1933 at the Brummer Gallery in New York, where Duchamp had organized

a Brancusi exhibition. Duchamp was already a living legend who fascinated everyone he met; Cornell was little known, extremely reserved and shy. He did not have the support network or the friends that Duchamp had. Over the course of the year that transpired between their first meeting and their first collaboration (1942), the two men learned to appreciate one another and even exchanged gifts. Duchamp dedicated his as follows: 'Marcel Duchamp/For Joseph Cornell'; Cornell's dedications were more formal: 'To Marcel Duchamp/In homage/In memory of friendship/ Joseph Cornell'. Cornell kept every trace of their exchanges and encounters in a photographic archive box, building a kind of 'portrait' of his true friend.[28]

Cornell was also one of the first artists to acquire an edition of the *Rotoreliefs*, which Duchamp put up for sale in 1935. Duchamp advised Peggy Guggenheim to purchase works by Cornell in June 1942, when he finally arrived in New York after endless negotiations concerning his immigration papers, which had required the intervention of Alfred Barr, director of the Museum of Modern Art. Duchamp moved temporarily into Peggy Guggenheim's home, where John and Xenia Cage were also living. One day when Duchamp picked up the telephone he heard Cornell's voice on the other end of the line. Cornell was pleasantly surprised: 'It was one of the most delightful and strangest experiences I've ever had', he noted in his diary.[29] They immediately set up a meeting at Cornell's house in Queens, where they ate lunch with his younger brother.

All this time Duchamp was looking for help with one of current projects, the *Boîte-en-valise*, a portable museum containing 60 or so miniature reproductions of his works. He wanted to produce an 'ordinary' edition of 300 and 20 de-luxe boxes. Shortly after their lunch, Duchamp showed Cornell a model of the *Boîte-en-valise* and asked if he would assemble them, for a fee of roughly $20 for every two de-luxe boxes finished. From that point on, they usually met in restaurants like Pappas, Le Moal French Restaurant on 3rd Avenue,

The Box in a Valise, series A, de-luxe, inscribed no. XIV/XX 1941, a sample offered to Teeny Duchamp. The box contains an original work of art: *Two Characters and a Car (study)*, 1912, charcoal on paper.

or the famous self-service diner, the Automat. During these meals Duchamp gave him print reproductions of his works as well as the miniature replicas of ready-mades like *Fountain*; Cornell ordered the necessary materials and submitted the bills to Duchamp. And so the 'waltz of the valises' began.

Between 1942 and 1946 Cornell assembled approximately eleven de-luxe boxes and thirty ordinary ones. The de-luxe versions were meant for collectors like Peggy Guggenheim or the Arensbergs, the art historian and curator James Johnson Sweeney, the artist Roberto Matta, and the Museum of Modern Art, which purchased one for $200. Duchamp and Cornell continued exchanging gifts, which Cornell called 'sanctuary loans': hand-written notes like 'Delay included, New Year's intentions', written by Duchamp on an envelope. For Christmas 1942 Duchamp offered Cornell a ready-made: packaging for a brand of glue, which he altered to read 'gimme strength' – a hint at the importance this material played in the fabrication of the boxes, and in their collaboration.

In 1943 Duchamp, Cornell and Tanguy exhibited together in *Through the Big End of the Looking Glass* at the Julien Levy Gallery. Cornell and Duchamp designed the invitation and Duchamp

purchased one of Cornell's *Pharmacies* for his personal collection. Then in 1946 Duchamp asked Cornell to return all of the remaining elements so that he could take them with him on his upcoming trip to France. They shared a meal at Pappas and ended their working relationship.[30] On 30 April 1946 Duchamp sent him a postcard signed 'Goodbye, Affectionately, Marcel'. After their collaboration ended, Duchamp continued to send him friendly notes on a regular basis, while Mary Reynolds, Duchamp's companion since the mid-1920s, purchased his works and wrote to him as 'Dear Admiral'. Later, Duchamp's wife Teeny, whom he married in 1954, would meet Cornell in teashops to eat typically American pastries whenever she and her (now famous) husband were in New York. After Cornell's death, the file of documents he had compiled between 1942 and 1953, bearing witness to his relationship with Duchamp, was discovered and entirely emptied of its contents. It is now part of the Philadelphia Museum of Art's archive, a complement to the Lou and Walter Arensberg collection.[31]

6

'Exhibiting – it's like getting married'

Duchamp participated in Salons in Rouen and Paris, such as the Salon des Artistes Humoristes, as early as 1906. As a *sociétaire* of one or another of these Parisian salons, he started helping with the organization of group exhibitions, such as the Section d'Or, initiated by Picabia in 1912. Then he went through the painful experience of the 1912 Salon des Indépendants; this had a deep and irreparable impact on his involvement in the history of exhibitions. He became more than just careful; he almost systematically refused to exhibit, preferring instead to play a different role. With his legendary discretion, he adopted the roles of benevolent 'arbitrator' and bold adviser, organizing, from a distance, approximately thirty group exhibitions that are of historical importance today because they have significantly modified our definition of the exhibition. Just as he had overturned all the established categories for judging the origins and values of artworks when he invented the ready-made, he was also questioning the artwork's circulation, market, reception and distribution. Although he claimed to keep his distance from the public domain, he understood that such issues were crucial for any artist of influence. And, as in all the other realms of his exist-ence, he reinvented codes and conventions by using publications, sales and exhibitions to pose questions of value and context cleverly and effectively. In 1968 the artist Daniel Dezeuze remarked: 'With Marcel Duchamp, this [artistic creation] refers at any given moment to the established cultural system and no longer brings

mechanisms of creation up to date, but rather those of valorisation, circulation and the consumption of these values through this system.'[1] Today, young artists such as Liam Gillick, Philippe Parreno and Pierre Huyghe use this strategy to handle the art system.

In 1917 the organizers of the Society of Independent Artists exhibition, Duchamp's friends, voted against the usual custom of having a jury decide on the works included and of awarding prizes. After numerous meetings at the Arensbergs' contemporary art-filled duplex, the committee named Duchamp fundraiser for the event and responsible for hanging the works submitted – more than 2,000 items.[2] Three days before the opening reception on 9 April 1917, Duchamp opted for an unconventional solution, yet one that suited him perfectly. He let the laws of chance decide; he hung the works in an alphabetical order chosen at random by drawing letters from a hat, in the presence of two witnesses, Roché and Beatrice Wood. He pulled out the letter 'ʀ' first. Documents from the exhibition show the paintings hanging in two rows, frame against frame, with the corresponding letter of the alphabet serving as a guide. The organizers made 'wheelchairs' available for moving along the long hallways filled to capacity with artworks.[3] Duchamp escaped his perilous mission by relying on a quintessentially Dada gesture to organize the democratic and eclectic Salon. The episode ended with his *Fountain* rejected and his departure for Buenos Aires.

Upon arrival in Argentina, he wrote to Lou and Walter Arensberg that he intended to organize a Cubist exhibition there: 'I would really like to get together thirty good things. I have found galleries here which, because of the newness of the thing, would be prepared to let us have the rooms for free.'[4] He then reassured them that he was not asking them to send their paintings, as he wanted only saleable items, and added: 'I will not exhibit anything myself, as is my principle.'[5] He abandoned the project in the end, but stood his ground when it came to exhibiting his own work. In 1921,

when his own brother-in-law Jean Crotti asked him, on Tristan Tzara's behalf, to participate in the Salon Dada at the Galerie Montaigne in Paris, Duchamp responded: 'You know very well that I have nothing to exhibit – that the word exhibit is like the word marriage for me.'[6] This was Duchamp's elegant way of saying that he did not want to be associated with any movement or group, not Cubism, Dadaism or, later, Surrealism.[7] In a letter of 1925 to his benefactor, Jacques Doucet, Duchamp wrote:

> Desnos has asked me, on behalf of Breton, to exhibit the globe you have, saying that you have agreed to lend it. To tell you the truth, I'm not keen on the idea and I'll only do it if you really want to. All painting and sculpture exhibitions make me sick. And I would like to avoid being associated with them. I would also be sorry if people saw in this globe anything other than 'the optical'.[8]

Despite his refusal to participate or even to see exhibitions, he managed to stay abreast of developments in European and American contemporary art. As a founding member of the Société Anonyme, he exhibited and acted as an advocate for contemporary European art. In fact, during the 1920s Duchamp complemented his artistic activities, and countless chess games, by initiating and raising funds for a number of museum projects, exhibitions, public sales and publications of great significance. At the same time, he cultivated relationships with and advised some of the most import-ant collectors. Although he did not want to exhibit his 'things' in group shows, he often agreed to organize exhibitions to promote the works of his siblings or friends, such as Picabia and Brancusi. Initially his role in what he called the 'art game', which has come to light over the past decade, provided him with all expenses-paid travel between Paris and New York, and with a more substantial income than the $2 per hour he earned giving French lessons.

Nevertheless, he was still teaching French in 1921, as he wrote to his sister Suzanne: 'have a lot of lessons, winter season is starting again'; or to Man Ray: 'I'm giving my French lessons and making just enough to get by.' Once, during a quick trip through France, he thought about finding another job. He considered becoming an assistant cameraman or businessman, as he told Man Ray in 1922, and also thought the art market might be a lucrative pursuit. He contacted the Arensbergs in this respect on 15 November 1921: 'Perhaps I could be of service to you with the sale of the Picassos. I know Rosenberg and could talk to him if you write and tell me to.'[9]

Then, in 1922, he accepted an assignment that he approached with an eagerness and an audacity that distinguished him from the 'simple technician' he liked to call himself. Henry McBride, art editor and critic for the *New York Sun*, who championed French art and would later support Cornell's work, asked Duchamp to compile and design a collection of his essays. Duchamp selected the texts and found the perfect title in *Some French Moderns Says McBride*. Next, he designed the maquette and published the 'book' through the Société Anonyme, with 'Copyright Rrose Sélavy, 1922' in place of his signature. As he informed McBride, 'This last sentence is my signature. Rrose Sélavy, in case you didn't know, was born in 1920.'[10]

In a letter of 14 June 1922 Duchamp explained what he had in mind: 'Now – This is my idea for the cover . . . which would be creamy yellow . . .'; he included a drawing. As usual, Duchamp sought a unifying idea for the publication. Instead of placing the title in the centre or on the upper half of the cover, he spelled it out in upper-case letters on individual file tabs along the outer edge of the page, set up like commonly used page dividers in 'dust proof files', or in address books and agendas. The letters in the title may be pronounced singularly or read as an inscription, similarly to Duchamp's titles for 'Some French' ready-mades. The back functioned according to the same system, but the tabs spelled out the name of the editor in a single line: SociétéAnonymeIncorporated.

His 'typographical ideas' for the inside of the book came next:

> As you can see, the brochure would have 26 or 27 pages (front–back) since each letter is on a page of its own. Now, if I have enough room, I propose the following: Set off on the first page with minute characters, ending up on the last page with big characters, making the characters progressively larger with each page . . . tell me what you think of the idea overall.[11]

Duchamp wanted to play with the size of the typeface as a means of breaking with traditional approaches to page layouts:

> I have already chosen the typeface ranging from 5 pt for the first page to 12 or more for the last page which will have 5 words (I think). With each page, the typeface, from the same family, will gradually increase in size. The first two articles on Cézanne will have to be read with a magnifying glass.[12]

This quite unorthodox proposal echoed his ongoing speculations on optics, since these variations in typeface radically alter the reader's relationship to the white page.

Lastly, he presented his ideas about the illustrations: 'My idea is to incorporate them into the text by gluing them onto the binding strip. I think it will be better to spread them out. I could, if you want, put Brancusi on the first page.'[13] Their correspondence indicates that Duchamp worked seriously on this project for almost a month, regularly informing his client of his progress:

> If you are here, I would like you to come to the printer's with me one day and I'll show you your brochure – almost done. Everything's printed. We've almost finished gluing in the illustrations, just to satisfy our curiosity, we're going to finish the first 50 copies, so that we can start to distribute them.[14]

Just as Duchamp had invented an alternative way of hanging artworks for the Society of Independent Artists some five years earlier, his liberal approach to typography allowed him to sweep away the past. While the two projects are quite different, their common experimental points of departure are the alphabet and language. Both reveal Duchamp's innate sense for publicity and communication, and correspond to his concern for optics and the viewer's relationship to the artwork. Two years later, in September 1925, he would use the same inventive spirit in his design of the poster for the French chess championships in Nice, in which he also participated.

Then the unfortunate deaths of his parents disrupted his life: 'And now to something more serious. My mother and my father died in the month of February, only one week apart. It really is a horrific thing to go through especially when events decide to accumulate.'[15] He would use a large portion of his inheritance money to purchase art by Picabia and Brancusi. In addition to the respect he had for his two friends, he was aware of the investment potential his acquisitions represented. In 1926 he purchased a group of 80 paintings, watercolours and drawings directly from Picabia, which he put up for sale at the Drouot auction house on 8 March. Given Jacques Doucet's interest in the painter, Duchamp first informed him of his intentions: 'I've started negotiations with Maître Bellier about organizing a sale of Picabias at the Salle Drouot in March. I've gathered them all together at the Istria, back from framing, and I would like to show them to you.'[16] Duchamp's frequently expressed, vaguely speculative desires were bolstered by a sales catalogue, edited by Rrose Sélavy, titled *Catalogue des tableaux, aquarelles et dessins par Francis Picabia appartenant à M. Marcel Duchamp*. Man Ray was in charge of photographing the works and Rrose wrote an introductory text. Duchamp worked out 'typographical ideas' similar to those he developed for McBride's brochure, despite the commercial stakes involved here. He changed

A group at Golfe Juan that includes Suzanne, Crotti, Picabia and Duchamp, *c.* 1927.

Duchamp with Mary Reynolds and Brancusi in the summer of 1931 at Villefranche-sur-Mer. Marcel is handling the 'detonator' for the camera.

the size of the typeface on each page and alternated different type-
faces according to each section. The pages unconventionally recall
opticians' alphabetical charts. His financial investment met with
'moderate success, producing a 10 per cent profit over what
Duchamp had paid for the group of works.'[17] He asked Jacques
Doucet, who was present at the sale, to help him find buyers for
five unsold canvases from the *Espagnoles* series.

Duchamp then initiated a showing of some of these paintings at
The Intimate Gallery in New York in March 1928. He sent a letter
to Stieglitz from Nice with a price list for the dozen or so works
still available, ranging from $200 to $600 per canvas. With the
help of a wealthy heiress, Madame Rumsey, and his friend Roché,
who had returned to Paris, Duchamp purchased, for the sum of
$8,500, about 30 sculptures by Brancusi that the heirs of John
Quinn, the American collector, had put up for sale. He understood
immediately that this was a rare opportunity, as he declared to the
American press: 'sculptures by this artist can only be found in his
studio'.[18] And, he added, Brancusi, who was obsessed with forms,
materials, molecules and atoms, trusts only those who appreciate
his sculpture.

This obviously applied to Duchamp. The two were very close
and had great respect for one another. In 1919 Duchamp had intro-
duced collectors, including Katherine Dreier, to Brancusi's studio.
The two men called each other 'Morice',[19] which was apparently
an immense measure of trust and likemindedness. Duchamp's first
wife, Lydie Fischer Sarazin-Levassor, who dined at Brancusi's studio
on several occasions, recounted: 'Brancusi and his close friends
referred to each other as Maurice. Not just anyone could be Maurice;
one had to devote oneself heart and soul, a very pure heart and
soul, to be a Maurice.' During one of these close-knit soirées,
Brancusi explained to her the meaning of 'Morice': 'Morices are a
very particular kind of person . . . they cannot be defined. They
exist in the world and recognize each other when they meet . . . It's

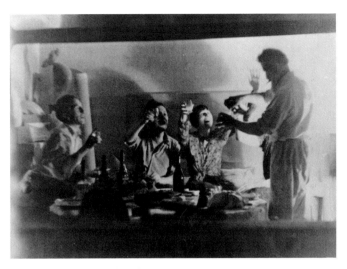

Dinner in Paris at Brancusi's studio, *c.* 1923–4.

Duchamp who has found them',[20] as he had with the ready-mades.
Uncertain of her young and mysterious husband's love for her,
Brancusi tried to reassure her: 'Heart and intelligence; that's what
is needed and, above all, be yourself . . . Do not settle. Be a free
thinker. Ignore doctrines. Never indoctrinate. Always act through
instinct and not through reason. Yes, Yes, you could be a Maurice',
he said.[21]

During this rather speculative operation, Duchamp also
acquired one of his own paintings, *The Chess Game*, from 1911.
Then, with Brancusi's help, he organized three exhibitions for the
sculptor, who had been discovered in New York at the 1913 Armory
Show. One of these took place at the Chicago Arts Club and two
others at the Brummer Gallery in New York. Duchamp left for New
York in 1926, bringing along twenty or so sculptures and drawings,
to supervise the installation at the gallery, where he had the walls
covered with grey cloth. He also oversaw the publication of the
catalogue, with a preface by Paul Morand, and hired a Japanese

photographer named Kunioshi to take pictures of the exhibition, at the cost of $20 per hour. He then left for Chicago to install that exhibition. Photographs show that he opted for a spacious arrangement of the works. In February 1927 Duchamp returned to Paris with the unsold sculptures and tried to sell them through Doucet:

> In the evening, we were to meet for dinner at Brancusi's. Marcel had rented a neighbouring studio to show the sculptures he had brought back from the United States – calling them 'stones' in order to avoid paying customs charges. I knew he had spent his entire inheritance on these works and it was very important for him to recuperate his investment.[22]

In 1928 Katherine Dreier advised the dealer Joseph Brummer to hire Duchamp as his gallery director, offering to pay him $150 per month, to cover the cost of his trips between New York and Paris, and to pay for his rooms in New York. Duchamp wrote to Dreier [in English]: 'It is verbally understood that Brummer would pay my expenses (ocean trip and stay in NY for 2 months about). But please don't see him about this because I want him to realise by himself whether he wants me or not. I don't care personally one way or the other.'[23] Duchamp offered to organize an exhibition of 27 works by his late brother Raymond Duchamp-Villon, as well as a Pascin exhibition.[24] Then in 1933 he suggested a Brancusi show, keeping in mind the sculptures he still had in his possession. He arrived in New York with a group of works, including the most recent sculptures, and immediately contacted American collectors, including the Arensbergs, Dreier and Stephen C. Clark (heir to the Singer Sewing Machine Company), to borrow others. Duchamp informed Brancusi: 'You'll see from the catalogue which things I've been able to obtain from various collections and that finishes off the group.' Duchamp supervised the installation, which called for certain, delicate adjustments he did not hesitate to implement:

'The columns were 2 cm too long for the gallery because of the lack of levelling (old house) and we took the liberty of shortening them by 2 cm at the top.'[25]

This second installation was much less conventional than the first. Duchamp sent a sketch to Brancusi, who stayed in Paris, in order to reassure him that he was doing everything in his power to reconcile Brancusi's demands – he did not want the sculptures to be placed against the walls – with the architectural limits of the space. He attempted to approximate Brancusi's Paris studio as well as he could: 'the 58 pieces are floating with the greatest of ease in the three galleries. The gallery has been completely whitewashed and the dewaxed parquet gives a quite good neutral tone without the polish (rubbed down with sandpaper and acid!).'[26] In another letter Duchamp sketched his ideas for the fold-out catalogue: 58 pieces, no foreword by Brummer, and texts by the French Surrealist author Roger Vitrac. The final page contained just one aphorism, 'behind the catalogue', written by Brancusi and published as a facsimile. During the run of the exhibition Duchamp contacted potential collectors, including Albert Barnes in Philadelphia: 'In a few days, I'll write to Barnes to ask him to go and see his collection and, at the same time, will try to get him to come and see the exhibition.'[27] He expressed his hopes that the works would sell, naming the most important collectors of the times, such as Gallatin, who 'asked for all the prices', or Peggy Guggenheim's mother, who 'came before the opening and is to come back'. He congratulated himself on the large number of visitors, despite the lack of press coverage, although *Art News* did publish an article titled 'Marcel Duchamp, Back in America. The Famous Artist, who has organized a Brancusi exhibition at the Brummer Gallery, offers his spiritual analyses of art'.[28]

Duchamp returned to Paris in January 1934 and decided to sell Brancusi's *Prometheus* (1911) to his associate Roché because he needed money to invest in another project that concerned him directly:

Can you make up the 1,000 francs needed for the book now, as I'm afraid that my famous inheritance won't be coming in for 2 months and all the bills for the book have to be paid as we go along . . . As I'm worried about being short, could you send me a check for 5,000 in the name of Rrose Sélavy?[29]

The 'book' Duchamp mentioned in this letter is actually *La Boîte verte* (*The Green Box*), which he made available via subscription in 1934, although he offered a copy to Brancusi once it was finished. That same year Breton published an article on *The Bride Stripped Bare by her Bachelors, Even* in the magazine *Minotaure*, for which Duchamp designed the cover: a reproduction of *Corolles*, the final optical disc from his *Anemic Cinema*, superimposed onto a detail of *Dust Breeding*:[30] 'I am going to send you next week the last issue of "Minotaure" in which Breton writes a long article about the "Mariée" – your library panel also illustrates the article. The cover of the magazine is by your friend M. D.'[31]

While he was at it, Duchamp initiated several editions, such as the *Rotoreliefs*, which he presented at the Concours Lépine, an inventors' competition held near the Porte de Versailles, and the *Boîtes-en-valises*, which he first sold via mail order. Although the editions were always limited, these projects constituted small sources of income for Duchamp, who did not always have access to the material comforts that other well-known artists enjoyed.

In 1938 Peggy Guggenheim entrusted him with the exhibition schedule for her London gallery Guggenheim Jeune. That same year, one of his most genuine and charismatic admirers, André Breton, asked him to design the *Exposition Internationale du surréalisme* at the Galerie des Beaux-Arts on the rue Saint Honoré in Paris. Salvador Dalí and Max Ernst served as 'special advisers'.

Breton and Duchamp first met through Picabia in 1919 at the Café Certa, where the Dadaists were then holding court. They instantly established a relationship based on mutual respect. Some

recalled that Breton, the 'pope' of Surrealism, underwent a change of attitude in Marcel's presence:

> Breton became strangely smaller. He was as naturally in the centre as Duchamp was naturally peripheral. But when Duchamp was present, Breton refused to take his place. All the others looked and listened to Breton, whereas he looked to Duchamp and listened to him. A strange humility.[32]

Even though Duchamp always maintained his independence from Breton's Surrealist circle, Breton managed to associate him in the installation design and hanging of the principal Surrealist exhibitions held in Paris and New York between 1938 and 1960. Whereas Duchamp had a rather classical, modernist approach to monographic exhibitions, he used entirely different tactics in the Surrealist group shows. He responded to Breton's invitations by imagining theatrical productions and *tableaux vivants*, using sound, smells and darkness to create ritualistic and troubling atmospheres of heightened extravagance.

Duchamp's stance, a total rupture with the minimal aesthetic of the 'white cube' that he and Man Ray invented for the opening of the Société Anonyme, fitted Breton's expectations that these exhibitions should be 'collective artworks'. According to Marcel Jean,

> the Surrealists had long wanted to organize a creative event that would also break with the secular, anonymous displays on the walls of a gallery, a salon or a museum. They dreamt of integrating their works into a décor that was, like them, both metaphoric and absolutely concrete.

Duchamp succeeded in fulfilling their wishes in the first exhibition of this sort in Paris in 1938. First, he transformed the gallery entrance into a Parisian street lined with clothes mannequins. Man

The *Exposition Internationale du surréalisme* in 1938 at the Galerie des Beaux-Arts in Paris. Note the coal sacks hanging from the ceiling and Man Ray's *Orator* at the centre.

Ray described them in his *Self-Portrait*: 'Sixteen artists were invited to adorn rented store mannequins. I left mine nude, with glass tears on the face and glass soap bubbles in the hair. Duchamp simply removed his jacket and hat and placed it on the mannequin as if was a coat rack.'[33] Behind each mannequin they hung tracts, invitations and posters from their previous exhibitions. Duchamp installed a street sign that read 'rue des lèvres' (Street of Lips), some reproductions of the *Rotoreliefs* and signed the bottom of his mannequin's belly Rrose Sélavy. He also slipped a red light bulb in her pocket, which lit the corridor and which some saw as a mocking gesture.

Then Breton asked Duchamp to create a ceiling for the main gallery. Duchamp had initially thought about using open umbrellas. Instead, he blocked out the overhead lighting and covered the ceiling with *1,200 Coal Sacks*, which plunged the viewers into darkness,

forcing them to use the electric torches provided and get very close to the works they wanted to see.[34] For security reasons he filled the sacks with newspaper. Underneath this installation, which Breton called *Ciel des Rousettes*,[35] Dalí installed an artificial pool with waterlilies and reeds surrounded by an undulating carpet of dead leaves. Off to the side was a coal brazier, like those found in Parisian café terraces, and four gigantic beds with embroidered satin quilts that resembled beds in bordellos; in other words, on the one hand the collective spirit so dear to the Surrealists, and on the other a symbol of eroticism, collective too!

The invitation card shows that Duchamp suggested hanging works on swinging doors, thus modifying the viewer's frontal perception of them. In his role as 'generator-arbitrator', Duchamp asked Man Ray to design the lighting. It was the 'lighting master' who had the idea to give each visitor a torch 'in case they wanted to see something'.[36] Man Ray also recounted that on the opening night the visitors spent more time shining the torches in each other's faces than toward the art, which hardly interested most of them. Lastly, and this was the wildest idea for a gallery exhibition at that time, they decided to grill coffee beans on an electric heating element in a corner of the room, so as to fill the room with the aroma. This final extravagance, as well as the others, was announced in a brochure distributed during the exhibition: 'Ceiling loaded with 1200 coal sacks, Mazda torches, swinging doors, echoes, Odours of Brazil and all the rest'. Although Duchamp was absent on the opening night, ostensibly because he had to attend the opening of a Jean Cocteau exhibition he organized at the Guggenheim Jeune gallery in London, he nonetheless included five of his works, including *Pharmacy*, *Nine Malic Moulds* (which he had offered to Roché) and *Brawl at Austerlitz*.

The Surrealists were very enthusiastic about the installation but the press was more reserved. Behind this abundance of eccentric provocations there was an allusion to the terror and anxiety caused

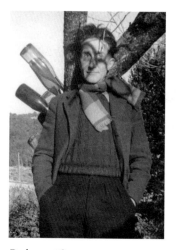

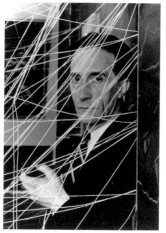

Duchamp at Sanary, *c.* 1941–2.

Duchamp behind *Sixteen Miles of String* (detail) for the exhibition *First Papers of Surrealism* organized with Breton in New York in 1942.

by the war that would soon envelop Europe. Although Duchamp has often been reproached for his distance from historical events, certain of his activities may be seen as veiled, yet critical, references to contemporary conflicts. Witnesses remember the smell of coffee, but they also remember a speaker sounding out 'the lockstep of a German army procession' and a phonograph playing 'hysterical laughter recorded in a psychiatric asylum'.[37] Breton confirmed this ten years later during the inauguration of the third *International Surrealist Exhibition* in 1947, saying that the previous one had tried to render the 'spiritual climate of 1938'. It is entirely probable that Duchamp was quite affected by this period of uncertainty; his long-standing companion, Mary Reynolds, joined the Resistance and had difficulty leaving occupied France; they were finally reunited in New York in January 1943.

Indeed, not long after the 1938 exhibition most of the Surrealists left for New York, which became their home in exile for the entire

duration of the war. Administrative difficulties prevented Duchamp from reaching New York until 25 June 1942: 'After leaving Paris in June 41 myself, I have spent 9 months in Sanary, between Toulon and Marseilles, waiting for my American visa.'[38] Breton, who arrived in New York in 1941, continued to lead the movement and spoke on the radio several times per day, as Duchamp informed his brother Jacques Villon in a letter dated December 1941. Breton hoped to widen the Surrealist movement with 'American recruits' and asked Duchamp to help out with the first Surrealist exhibition in New York, which took place at Whitelaw Reid Mansion. 'Nothing much new here', Duchamp wrote to Man Ray in October 1942, 'I'm taking care of the Surrealist Show which will be nothing like the Paris one.'[39] The famous 'Surrealist Show' opened in October 1942: its title, *First Papers of Surrealism*, made reference to American immigration and naturalization procedures. The French designer Elsa Schiaparelli financed the exhibition but let Breton choose the works. As Breton's 'twine', or better yet, his 'ambiance maker', Duchamp made an original and inexpensive suggestion. He stretched approximately eight kilometres of string throughout the space: from the floor to ceiling, onto the chandeliers, mouldings and temporary partition walls.[40] The paintings were hung on large white panels that resembled the wooden structure of *The Large Glass*, while the twists and turns of the string recalled the accidental breakages that transformed this work forever.

Exhibition views give the impression that Duchamp sought to create a space altered by time, invaded by 'spiders' webs', the kind of morbid jungle one might find when entering into an abandoned house. This 'dusty' atmosphere evoked death, which might have been effective had it not prevented direct access to the works, which were partially hidden behind a dense labyrinth of string. Duchamp had implied this would be the case, but Breton had not fully grasped his intentions.[41] Again absent for the opening, Duchamp had orchestrated another unusual event in advance. He

asked a group of six children, including the dealer Sidney Janis's son Carroll Janis, to arrive at 8 p.m. and play during the opening reception. The kids were dressed in baseball and football uniforms and followed Duchamp's instructions. One of them recalled this joyous game: 'we were encouraged to run about and I remember feeling somewhat uncomfortable, both because I didn't think it was proper behaviour and also because I sensed that some of the guests were of the same opinion!' Duchamp also instructed them that, if they were chastised, they should say they were playing on his behalf: 'we had all the huge rooms to ourselves and we started throwing balls. Just kept on through the whole evening and it got so crowded and we kept playing. Our instructions were to ignore everybody and just play to our heart's content. We just loved it!'[42]

Apart from this, the morbidity of his project, perhaps a reference to the continuing war, comes across even more forcefully in Duchamp's catalogue for the show. He chose an almost abstract, black and white photograph for the cover. A closer look reveals a fragment of a wall riddled with bullet holes (Duchamp went to Kurt Seligmann's country house to fire at his barn). On the back cover Duchamp printed a false replica of this wall; in truth, a yellowing photograph of the random holes and hollows in a piece of Swiss cheese. Apart from the dark humour evident in the association of these two images, the artist's interest in the creative processes of imprinting and moulding is also visible here. Duchamp's concept of 'infra-mince' (infra-thin), first mentioned in his notes from 1930, stems from his careful observation of these processes. Indeed, the two images, which seem to have nothing in common, are joined by the 'infra-thin', just as 'when the tobacco smoke smells also of the mouth that exhales it, the two odours are joined by infra-thin'.[43] Duchamp proposed another surprising idea that surely referred to Europe's darkest period. Using the name *Compensation Portrait*, he asked artists to send a representative image of their choice. Duchamp chose a photograph of an elderly woman who appears

to have escaped from a concentration camp. Breton returned to Paris in 1946 and stayed in contact with Duchamp, who had covertly started a project that would remain secret until his death. Its subject, eroticism, was familiar to the Surrealist universe.

While Duchamp was busying himself with this *tableau vivant*, to which he ended up devoting two decades, he agreed to participate in the Surrealists' latest adventure at the Galerie Maeght, Paris. Duchamp asked Man Ray to loan his painting by Arcimboldo:

> There's going to be a Surrealist exhibition in Paris in '47 (March or April) – and Breton is planning to invite you, but I also had this idea that we could exhibit several old paintings from XVII/XVIII Century in tune with Surrealism. And I think your Arcimboldo would be a good example.[44]

Duchamp wanted to hang paintings by Hieronymus Bosch, Arcimboldo and William Blake in a ground-floor room, which was to be called 'Surrealists despite themselves', at the entrance to the exhibition. The invitation to the artists participating in *Surrealism in 1947* declared that it was conceived as a 'surpassing':

> the exhibition's general structure will respond to the primordial concern to retrace the successive phases of an initiation; the passage from one room to the next will imply graduation. The upper rooms will be accessed by a staircase signifying the 21 major arcana of the Tarot . . . At the top of the stairs, the Hall of Superstitions, which opens the theoretical cycle of the trials, should synthesize the primary existing superstitions and force the viewer to overcome them so as to continue visiting the exhibition.

The letter then specified that the 'architectural configuration has been entrusted to Kiesler, Matta and Duchamp', who created a strange anxiety-producing space with walls covered in green cloth

and a 'large yellow form descending from the ceiling, threatening a schematic white figure of a man' that stands before the 'black lake' painted by Man Ray. The fears were organized around it, watching and waiting: Marcel Duchamp's 'Green Ray', the beautiful 'Grand Totem of Religions', the 'Vampire', the 'Evil Eye'. Duchamp's 'Green Ray', a porthole the size of a woman's breast or small circular mirror, produced the optical illusion of a view of a maritime horizon at night, dimly lit by a mysterious source of light.

Duchamp prepared this new 'exhibition manifesto' from New York and asked the Viennese architect Frederick Kiesler to supervise the Paris installation according to his specifications. Curated by 'Duchamp and Breton', the exhibition brought together 88 participants from 24 different nationalities. It reserved quite a few surprises for the visitor, including:

> a room that made them pass by several curtains of multi-coloured rain in order to reach, without disturbing those playing billiards on the table provided, the room divided into octagonal recesses. Each of the twelve recesses contained an altar like those used in pagan cults (Indian or Voodoo, for example) dedicated to a being, a category of beings, or an object endowed with a mythical life.[45]

Duchamp also designed the cover of the catalogue, a rubber breast in relief entitled *Please Touch*, which equally served as a *cache-sexe* (g-string) for a live female model in the exhibition, and as a reference to his secret project. Breton sent a word of thanks to Duchamp, who responded: 'Have you had time to do the "despite themselves" room and the kitchen?' Although Breton did not follow through with the 'despite themselves' room, he did mention the artists he considered obvious sources for the Surrealists – Giorgio Di Chirico, Antonin Artaud and his friend Marcel Duchamp, naturally – in the catalogue. The press was hardly enthusiastic,

and Duchamp, true to himself, did not mind: 'It's rather nice to be treated with contempt like youngsters "AT OUR AGE"', as he wrote to Breton from New York.

Duchamp's involvement in these three Surrealist exhibitions in New York and in Paris, even from a distance, is now considered to be as fully intentional and as important as his other creative projects. Duchamp never simply settled for arranging artworks and inviting artists. Each exhibition was an invention, a novel and thought-provoking proposition for initiating the viewer. These quite experimental exhibitions anticipated the emergence of *in situ* works or installation art in the 1960s and '70s, which are indebted to their theatricality, as well as their desire to transform the public's relationship to art. By appropriating provocative methods derived from theatre, dance, magic or games, Duchamp more than attained his goal. In turn, by wisely agreeing to play the role of 'idea giver' or 'ambiance maker', Duchamp kept to his strategy of renouncing and waiting, which did not prevent him from expressing himself, however minimally.

During these two decades of collaborations with Breton and the Surrealist circle, Duchamp was seriously working on his *tableau vivant*, entitled *Etant donnés: 1° La chute d'eau, 2° Le gaz d'éclairage*, founded on illusion, eroticism and mystery, and associated with the impromptu universe of the Surrealists.

7

La Mariée mise à nu par ses célibataires, même

A brief study of Duchamp's most monumental and mysterious work[1] takes us back several years in the artist's life – specifically to Duchamp's stay in Munich in summer 1912. This Munich episode was decisive. It was there that he finished a crucial group of paintings on the theme of the virgin: on the passage from virgin to bride and of the bride on her own. These paintings, along with the mechanomorphic anatomical drawings that focus on certain details in them, serve as the basis for *The Large Glass*, a tableau measuring 2.75 metres high, made out of 'two large pieces of plate glass above one another', the title and deeper meaning of which remain puzzles still only partially deciphered by the work's author, as well as the countless historians, poets and critics that have studied it.

The top part of this glass panel painted in oils is entirely devoted to the bride, who is not represented at the centre of the blank and transparent surface, but at the far left. Duchamp took the motif for representing his bride directly from the eponymous painting he had completed in Munich in 1912, which he offered to his friend Picabia upon his return. Specifically, the motif in question is a fragment of the bride's body analogous to the most buried, the most enigmatic part: her entrails, as detailed in medical handbooks. Duchamp might have come across such handbooks through his brother Raymond Duchamp-Villon, who had studied medicine before becoming a sculptor. In order to represent what he called

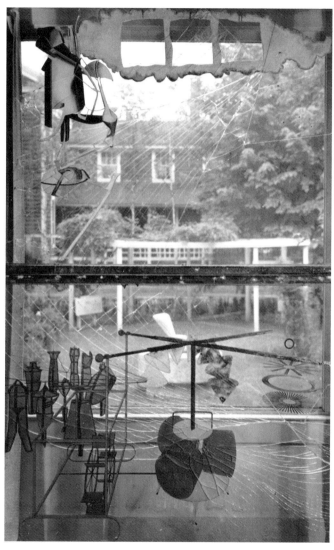

The Large Glass (1915–23) photographed in Katherine Dreier's house. On the other side of the glass is the Brancusi sculpture *Leda*, displayed in Dreier's garden.

'Eros's matrix', the bride's most intimate and concealed part, he likened her to a very sophisticated machine, something between a gynaecological instrument and a motor. He represented her in profile, as in an anatomical cross-section; this dissociates her from any temporality and any anecdotal attachment to reality. The bride is so dehumanized that it was long impossible to link her to actual elements of Duchamp's life at the moment of her creation. Only decades later would certain historians establish a quite probable link between the subject of this painting, *The Bride Stripped Bare by her Bachelors, Even* and the artist's personal life – that is, his affair with a married woman, Jeanne Serre, which led to the birth of a child, Yo, in 1911, about a year before his conception of the tableau and his stay in Munich.[2]

Any biographical interpretation of *The Large Glass*, however, should not overshadow its entirely novel and fascinating aspects, which occupied a central place in the artist's work and life. By representing the bride as an 'arbour-type', an 'agricultural machine' endowed with powerful and infallible mechanics in perpetual motion, trundling along the 'sparks of her constant life', Duchamp evoked the 'origin of the world' and touched on a truly universal question that, while intelligible to all, remains buried and unfathomable nonetheless. Once again, he incites our interest by masking the universal dimension of the subject and inventing, almost as an engineer might, an entire grammar that stems more from treatises on engineering and mechanics than from human and romantic concerns. He confirmed this many years later when a journalist asked him about the work's meaning and mystery: 'something that would not be anecdotal . . . something else where the grey matter would come in as an instrument of measure'.[3]

The bride's state of grace is rendered with just as much mystery. This 'timid power' – hung female, without legs – no longer bears any relation to reality. She shoots up toward the sky with a 'touch of malice', feigning ignorance of desire, releasing an aspiring energy, a

breath of pleasure signified by a suspended cloud: a 'halo', an illuminated veil that stretches in space and time across several repetitive sequences, represented by three empty squares placed next to each other at regular intervals. With striking precision and a wondrous and loving regard, Duchamp was the first twentieth-century artist who dared to decipher the divine moment of female orgasm and to represent it in a dry, wilfully non-visual language that leaves room for the imagination.

The painting's lower half is devoted, as one might expect, to the bride's pendant: the domain of the bachelors. He broadly conceived it around 1913, as is attested by a drawing from the same year, *The Bride Stripped Bare by her Bachelors, Even* (Musée National d'Art Moderne, Centre Pompidou, Paris), which shows the different elements of the bachelor machine already in place. Yet, it was in 1915 that Duchamp would start to assemble and technically realize the different elements of the *Glass*, only to abandon them in 1923, as if he suddenly found them to be of less immediate interest than before!

When Duchamp returned to Paris from Munich in autumn 1912 he met up with friends, including Picabia and his brothers, who were still living in Puteaux. He visited his parents in Rouen and, contrary to appearances, continued thinking about the bachelors' domain, which proved in the end to be more complex because, while the 'bride has a life centre', the bachelors wander from 'eccentricities' to 'countless eccentricities'. In his notes on *The Large Glass*, Duchamp specified that 'the principal forms of the Bachelor-Machine are imperfect: rectangle, circles, parallelepiped, symmetrical handle, demi-sphere.'[4]

Over the course of the following decade, between approximately 1913 and 1923, Duchamp worked out the bachelors' domain – which was, as it happens, his own, since he categorically refused any long-term relationship. Then later, between 1923 and 1926, life, which Duchamp placed under the law of chance, but in reality is

subject to the power of the unconscious (hasn't Duchamp been repeatedly referred to as the 'father', even the 'grandfather', of the unconscious and, in fact, of psychoanalysis?), seemed to reconcile these indisputably complementary realms that still, in his own words, know no 'solution of continuity'. It seems clear that the glass is the mirror of the bachelor, alias Marcel Duchamp, and his relations with the bride. Certain historians, notably Ulf Linde, author of the first replica of *The Large Glass*, have noted the conjunction of the syllables 'Mar' (Mariée) and 'Cel' (Célibataire) that make up the artist's name.

Duchamp was 'collecting different ideas in order to put them together' as early as 1912.[5] Like its author, *The Large Glass* became a 'sum of experiments' on the encounter between two opposed domains: the bride's, evoked in a 'visceral' mode, and the bachelors', in a concrete, and therefore detached, mode.

Just below the 'arbour type', symbol of the life of the Bride, Duchamp placed the *nine bachelors*, who appear to be gigantic hooks (the bachelors, perhaps like Madame Duchamp's six children, clutch onto the bride). In truth, these almost identical figures, all of which bear a filial resemblance, are portraits:

> the idea is amusing because they are moulds. And for moulding what? Gas. That is, one sends the gas through the moulds where it takes on the form of the gendarme, the department store delivery boy, the *cuirassier*, the priest, and the stationmaster, etc., which are found on my drawing. Each of them is built on a common horizontal plane, the lines of which cut off at the point of the sex.[6]

Duchamp is particularly precise about their trajectory: 'At the top of the glass a sort of fork must fall astride the axles going from the glider to the grinder. This fork will be an ordinary hook considerably enlarged.'[7]

The glider Duchamp refers to here came from a small painted sign, *Coffee Mill* (Tate Modern, London), that he offered to his brother Raymond Duchamp-Villon in 1911. Executed in a mechanomorphic idiom and Cubist chromatic tones, this little painting hung for several years in his brother's kitchen along with others offered by artists from Puteaux and the Section d'Or. The *Coffee Mill* turned into a sophisticated chariot, entitled *Glider Containing a Water-Mill in Neighbouring Metals*. He painted this motif on glass between 1913 and 1915, prior to his departure for New York. In his notes Duchamp alludes to the 'litanies of the chariot', in other words, to its 'back and forth motion' and, above all, to the emancipation of its metals. There again, Duchamp could not evoke the natural flows of love more clearly. But, in order to delay their interpretation, as was his custom, he described and represented them as chemical precipitates activated by a studied mechanics.

In the *Bride's Lighthouse*, one of the first essays on *The Large Glass*, which appeared in the review *Minotaure* in 1935, Breton mentioned, among other things, 'a fundamentally a-sentimental speculation' with regard to this passage from the state of virginity to the state of non-virginity, adding that one could qualify as 'extra-human' the person that would try to represent this process.

Consider the chariot, which 'is free of all gravity in the horizontal plane': in other words, this glider's chariot is the male sex surmounted by the bride. For the bachelor machine, which is not in direct contact with the bride, Duchamp used an intriguing device he spotted in a confectioner's window on rue Beauvoisine, while visiting his parents in Rouen. This device, which Duchamp titled *The Chocolate Grinder*, is the perfect metaphor for the bachelors' masturbatory attitude:

Their own complexity stuns them. The part that is desire turns into the motor. The chariot of emancipated metal recites the

litanies-refrains of the Bachelor Machine . . . The Bachelors'
desire solidifies, passes through a series of filtering cones. It falls
into the Louis xv footed chocolate grinder, which kneads it . . .[8]

Indeed, Duchamp flung *The Chocolate Grinder*, which he first painted
on canvas in two versions, one in 1913 and then another in 1914
that he later destined for his glass, into the heart of the bachelors'
domain. Sometime over the next several years he transposed this
figure onto glass,[9] using lead fuse wire to trace the contours and
draw the spokes of the machine's vibrating rollers, which evoke
delicacies, and therefore pleasure. 'The grinder is mounted on a
Louis xv nickeled chassis' and is essentially made up of rollers that
'grind the chocolate', just as the bachelor 'grinds his own chocolate'.
The Glider and the Grinder are two transmitting devices that cannot
transmit their 'metal' or their 'chocolate' to the bride, who ignores
them. This corresponds with Duchamp's bachelor existence at the
time. The 'conjunctive apparatus' linked to the bride is located
around this 'self-sufficient', even 'self-referential' device; it provokes,
one hopes, the 'collision' or explosion. This apparatus is made up
of the *Nine Malic Moulds* and their eighty *Capillary Tubes*, the seven
Sieves/Parasols of the *Oculist Witnesses* and the *Drainage Slopes*,
figured in the form of a dotted spiral. Whereas these tangible motifs,
devoid of all sentimentality, remain particularly enigmatic for the
viewer, Duchamp's writings on the subject are very enlightening.

Duchamp begins by describing the itinerary of the Illuminating
Gas by specifying that, 'from the top of each malic mould the gas
passes along the unit of length in a tube of elemental section and
by the phenomenon of stretching in the unit of length the gas finds
itself solidified in the form of elemental rods'. Then he explains,
again with surprising detail, the process of transformation of this
gas: 'Each of these rods under the pressure of the gas in the malic
moulds leaves its tube and breaks, through fragility, into unequal
spangles lighter than air (retail fog).' Finally, he explains how the

spangles, which have kept a 'malic tint', are filtered by the sieves that block their ascension through a mechanism regulated by the laws of chance:

> The spangles are stopped in their ascent by the 1st parasol (sieve) . . . the parasols thus straighten out the spangles which, on leaving the tubes were free and wished to rise . . . to the point that necessarily there is a change of condition in the spangles. They can no longer retain their individuality and they all join together at point в.

Now the dazed and separated spangles, having lost their sense of orientation – that is, their 'awareness of the situation' – get a hold of themselves and seem to reach the Bride's insides thanks to the Ventilator that 'forces the gas to attach itself at ab, cd, ef, etc, in a condition resembling glycerin mixed with water'.[10]

After nicely evoking the process of ejaculation through the figures of the Grinder and the Glider, Duchamp details here, with sketches as back-up, the sexual act and what happens beyond it: the meeting of two opposing, life-forming fluids. In other words, Duchamp described the most fundamental act of creation and, as such, his conception of the creative process, which is nothing else than going along with happenstance or accidents. We can also surmise that the unwanted birth of his daughter Yo in 1911 came as a shock, and that perhaps he overcame it by undertaking a process of mental reconstitution worked out and visualized in numerous studies between 1912 and 1915. This did not, however, prevent Duchamp from loading this 'hilarious' painting with humour, and from declaring, decades later, that 'my strategy had more to do with the need to introduce some "mirth" or at least some humour into such a "serious" subject.'[11]

When all the elements of the glass were already in place, as a drawing from 1913 and his handwritten notes attest, Duchamp

began the step by step formal assembly of this fascinating fable, as he wrote to Walter Pach on 12 March 1915: 'I am about to finish the bits of glass I started and am getting ready to work on the top of my painting. Most of all I'm happy to be finishing these few minor things before starting again on another part.'[12] He left for New York that summer, with the different elements of his glass, including the *Nine Malic Moulds*, which he referred to in his notes and correspondence as his 'red thing on glass' or 'red fellows'.[13] He did not spend much time working on his Bride during his first three years in New York. As one of the most sought-after members of a circle of friends that included many women drawn to his charm, he preferred to benefit from these lovely years of insouciance and camaraderie.

Only when he decided to move to Buenos Aires in 1918 did he start working on *The Large Glass* again: 'I have started the right side of the glass and hope that a few months will suffice to conclude my work on the drawings that I want to bring back one day to New York to finish the glass.'[14] Having promised *The Large Glass* to Walter Arensberg, who agreed to pay his rent in exchange, Duchamp updated him regularly on his progress. He also informed Walter Pach, who had introduced him to the Arensbergs several years before: 'I brought all of my notes for the glass with me so that I can carry on with it here and hope to finish the drawings for it in a few months.'[15]

Like an artisan, but without much enthusiasm since everything was already in place in his notes, he kept putting off finishing his great work:

I worked on it for eight years and that's not saying much! First I did sketches, then I transferred an outline onto the glass so that there was not much inspiration for the glass in itself, more a faithful execution. I did not want to make a decorative panel to decorate a room![16]

Beatrice Wood and Henri-Pierre Roché, whom Duchamp allowed in his New York studio as long as he was not there, were the first to see the panels. Their descriptions are delightful:

> Very large plates of glass were resting on trestles. Parts of them were covered with metal forms that had been cut and painted slightly then attached to the glass with transparent varnish. This was: *The Bride Stripped Bare by her Bachelors.* Parts of it were cleared off. Others were covered with varying thicknesses of dust. A sign read: *Dust Breeding.* To be respected . . . It was Victor's famous room. Patricia [Beatrice Wood] was in seventh heaven. She was on a pilgrimage.[17]

Then he added: 'It is an epic of desire, a fairy tale, and a mechanical ballet. It was spray-washable on both sides. Contrary to the canvases, Victor [Duchamp] said, there isn't any dust behind it. And it will survive them.'[18]

Throughout the 1920s Man Ray, who visited Duchamp often, was the most familiar with *The Large Glass*, always awaiting its author, who wanted to finish it: 'In the far corner near the window stood a pair of trestles on which lay a large piece of heavy glass covered with intricate patterns laid out in fine lead wires. It was Duchamp's major opus: *The Bride Stripped Bare by her Bachelors, Even.*'[19] Duchamp confirmed in a letter to his friend in May 1922 that he was not working very seriously on the glass, 'What a drag!', he exclaimed. Rather than seeing it as a fable or a painting, Man Ray considered it a work in progress, an unapproachable monument. Man Ray advised Duchamp to use photography instead of under-taking laborious manual tasks. Duchamp reasserted, although his friend did not need convincing, that photography would end up dominating the arts.[20]

At the end of 1923 Duchamp gave the *Glass* to his patron. A black and white photograph taken by the American artist Charles

Sheeler, a friend of the Arensbergs since 1915, shows it installed in their New York apartment. The photograph is of a detail of the lower part of the glass, which allows the bureau and possibly a Cubist painting behind it to show through. This is when the rumour that Duchamp had 'abandoned' art began to circulate. The Arensbergs decided to leave New York for California and considered the panel too fragile to make the journey safely so, although they had waited eight years for it to arrive, they sold it to Katherine Dreier for $2,000. Duchamp supervised its transport to Dreier's Central Park apartment and decided then and there to leave it in its 'definitively unfinished' state and devote himself officially to chess and his research on optics.

Four years later, during the short months he spent with his first wife Lydie Fischer Sarazin-Levassor, he informed her of its existence, but with a certain indifference: 'I also painted a large glass in New York. It is not quite finished because it has ceased to amuse me. I've been working on it for almost eight years. Very few people know it exists; I have never shown it. But some have seen it at my place.'[21] Indeed, from 1923 to 1926 *The Large Glass* was almost unknown. Duchamp had returned to Europe, where he travelled between Paris, Rouen, Brussels, Nice and Monte Carlo to play in chess tournaments or play roulette at the Monte Carlo casino. 'I am not painting anymore, only chess amuses me', he told his new wife in 1927. During a brief stay in New York in 1926 he oversaw its first public presentation at the Brooklyn Museum, at Katherine Dreier's request, in the *International Exhibition of Modern Art Assembled by the Société Anonyme*.[22] Duchamp placed it at an angle in the centre of the exhibition space in view of Brancusi's sculpture *Leda*, probably another Bride! One of Piet Mondrian's Neo-Plastic compositions, as well as a painting by Léger, was visible through it. In keeping with Duchamp's wishes, *The Bride Stripped Bare by her Bachelors, Even* projected itself visually in the space and, like a temptress, absorbed everything in its immediate surroundings. After the

exhibition, the glass was returned to Katherine Dreier's, where it was stored in crates. When Dreier and Duchamp eventually opened them, they discovered that it had been cracked during transport. The random cracks went in two opposite directions: toward the upper region, in the bride's direction, and toward the lower region, in the direction of the bachelor machines. Duchamp liked the cracks and decided they should remain. He kept the cracks, just as he had kept all his handwritten notes, intending to gather them and make them accessible through a special edition. He told Roché, who was using his studio as a bachelor pad: 'Under my mattress at the foot of the bed you'll find the notes on my glass. You can look at them but don't change the order.' Roché was flattered that Duchamp let him read these bits of paper (Duchamp often referred to bits of glass), as he recounts in his novel *Victor*: 'There were bits of paper of all different sizes and colours; everything he had written, no matter what, no matter when, about his glass; his inner dialogue, pieces of matchbooks, corners of restaurant tablecloths.'[23]

In 1934 Duchamp decided to reproduce the ensemble of notes through the means of phototypography. He contacted the former owners, Walter and Lou Arensberg, who still had certain paintings that had been at the work's origin:

> I have just embarked on the task of compiling an edition of my notes and documents on my glass, 'The Bride Stripped Bare by her Bachelors, Even'. I would like to get together all of the notes I wrote on it in 1912, 13, 14 and 15 and have them reproduced in facsimile (using phototypography which gives a very good idea of the original especially for hand-written notes). I would also like to reproduce the main paintings and drawings which went into the composition of the 'Bride'. Would you therefore do me the great service of taking a good photo of *The Chocolate Grinder* (1914, the one with glued wires) and send it to me at once?[24]

Two views of *La Boîte verte*, 1934, Paris.

He brought these notes and images together in a green velvet box he entitled *La Boîte verte*.

When passing through New York for various business-related reasons, Duchamp stayed for two months in Katherine Dreier's country estate in Connecticut, where she kept *The Large Glass* and other works, including *Tu m'*. With a growing awareness of his work's value, he spent several hours every day repairing and stabilizing *The Large Glass*: 'My idea about repairing the glass is to put it between two other glasses framed by an iron frame. I would glue every piece broken on to one of the glasses with an invisible glue (which I am studying) and the whole thing although very heavy, would make a solid piece of furniture when in place.' [25] He inscribed 'Unfinished, Broken 1931, Repaired 1936' on the back of *The Large Glass*, behind the Grinder and next to the title and his name. Dreier

then installed it in her living room at her final residence, The Haven, not on an angle, as Duchamp had in the Société Anonyme exhibition in 1926, but frontally and slightly off-centre. *The Large Glass* was shown in a museum for a second time in 1944, on the occasion of *Art in Progress*, an exhibition celebrating the fifteenth anniversary of the Museum of Modern Art. That same year Dreier, assisted by Roberto Matta, published a text on the bride, which Dreier edited through the Société Anonyme. After this exhibition the glass remained in MOMA's permanent collection until Dreier donated it to the Philadelphia Museum of Art in 1954. It is presently housed there, in front of a window, in the company of many of the works from the Arensberg collection.

Duchamp attained worldwide recognition in the 1960s. Retrospective exhibitions were organized in Sweden, England and Japan, in which the Bride was to occupy a central place. Given its fragility, Duchamp allowed several extraordinarily faithful exhibition copies to be made of the *Glass*. Ulf Linde made the first for *Art in Motion*, which took place in 1961 at the Moderna Museet in Stockholm. The British artist Richard Hamilton made the second copy for the Duchamp retrospective *The Almost Complete Work of Marcel Duchamp*, which he curated at the Tate Gallery in London in 1966. Yoshiaki Tono made the third copy, after Duchamp's death, for the University of Tokyo Museum of Arts and Sciences. Duchamp approved and authenticated the first two copies, adding the phrase 'Pour copie conforme (Certified copy)'. With his legendary humour he added to Ulf Linde's version 'from one spitting image to another' as well as the enigmatic, but nevertheless appealing, play on words: 'The Bride stripped bare . . . this famished infamous female in family'.[26]

8

Duplicating Works instead of
Repeating Himself

Duchamp, who was quite familiar with printing techniques, especially
engraving, thanks to his grandfather Emile Nicolle, managed to
shorten the length of his military service in 1905 by working
as an apprentice at a printer's shop in Rouen. As early as 1914 he
began imagining how to compile his notes, which resulted in *La
Boîte de 1914*, a limited edition of five.[1] Less well known than the
boxes of notes he produced later, the *Box of 1914* is an ordinary box
containing Duchamp's photographed handwritten notes and a
drawing of a cyclist seen from behind, with the written inscription:
'Avoir l'apprenti dans le soleil' ('to have the apprentice in the sun').
At the same time that he was developing the ready-mades – and,
in a certain sense, this box is a ready-made – which question the
originality of the artwork, reproductions and hierarchies between
hand-making and conceptualizing an artwork (this accounts for his
unusual formula 'of or by Marcel Duchamp or Rrose Sélavy'), he
made two photographic reproductions of his notorious painting
Nude Descending a Staircase: a life-size retouched photograph
for Walter Arensberg, which he signed 'Duchamp fils' ('Son of
Duchamp'), and a postcard-sized version for the doll's house of
his friend and student Carrie Stettheimer.[2]

Expanding on the process he started with the *Boîte de 1914*,
Duchamp next produced *La Boîte verte* or *The Bride Stripped Bare by
her Bachelors, Even*. The order form he designed and printed reads
'Edition Rrose Sélavy, 18, rue de la Paix, Paris'.[3] Duchamp edited

300 ordinary examples of *La Boîte verte*, a box filled at random with 93 reproductions of different types and formats, and 20 de-luxe boxes that also contained an original work by him. Like *La Boîte de 1914*, this group of notes and preliminary works that lead up to *The Large Glass* serves as a companion to it: 'I wanted the box to be able to be consulted while looking at the Glass because I did not think it should be looked at aesthetically. Both of them should be seen together.'[4]

The care that Duchamp took in putting together this more elaborate *Boîte* reveals his almost obsessive concern with precision and diligence. He went to the printer's every day to oversee its fabrication. Because he wanted to reproduce all the notes, photographs and drawings related to *The Large Glass* as exactly as he could, Duchamp went as far as imitating the irregularity of a tear, the colour of an ink, or the trembling of a drawn line:

> I wanted to reproduce them as accurately as possible. So I had all of these thoughts lithographed in the same ink, which had been used for the originals. To find paper that was exactly the same, I had to ransack the most unlikely nooks and crannies of Paris. Then we cut out three hundred copies of each lithograph with the help of zinc patterns that I had cut out on the outlines of the original papers.[5]

One year after the edition of *La Boîte verte*, Duchamp decided to publish an 'album' reproducing most of his works.[6] Yet he needed to find a new form, something that was not a book, for housing his miniaturized works and facsimiles:

> Instead of painting something, I wanted to reproduce the paintings I liked so much in miniature and as a smaller package. I thought about doing a book, but I did not like the idea. So then I had the idea to make a box in which all of my works would be

housed like in a miniature museum, a portable museum. And that's why I put it in a valise.[7]

That same year, in 1935, he set up a stand at the Concours Lépine industrial fair, as the 'benevolent technician' of twelve optical discs, the *Rotoreliefs*, in an edition of 500. He described them to Katherine Dreier: 'I am going to make a play toy with the discs and spirals I used for my film. The designs will be printed on heavy paper and collected in a round box . . . Please don't speak of this as simple ideas are easily stolen.'[8]

These optical discs were to be placed on a turntable so that the viewer could observe the effects of volume and depth produced by the slowly moving forms. The rotoreliefs enable the viewer to see fragments of reality in three dimensions and to pass into the fourth dimension through a quasi-hypnotic effect. Duchamp had been fascinated by the fourth dimension for decades. In choosing to exhibit his rotoreliefs at the Concours Lépine he demonstrated a true desire to convince a large audience to look at the world through different eyes. In a second letter to Katherine Dreier he recognized without regret that his experiment had failed:

My counter at the 'Concours Lépine' is installed and since it was opened I have sold 2 boxes. This is a complete failure commercially speaking. That is why I can write in peace. I have sent the toy two or 3 days ago . . . Anyway I am having it copyrighted in USA hoping still to sell a few there.[9]

This relative disappointment did not deter him from the ambitious project of circulating his works through the valises, which he pursued up until his death in 1968. Despite the lack of encouragement that the Concours Lépine and his 'artistic career' were providing, from 1935 Duchamp intensified, methodically and with resolve, his research into procedures used to create the de-luxe version of *La*

View of the exhibition 'De ou par Marcel Duchamp or Rrose Sélavy', at the Musée des Beaux-Arts, Rouen, October 1998 – January 1999.

Boîte-en-valise,[10] of which he produced 20 signed copies accompanied by an original artwork. It took him no less than six years to perfect and complete the edition, which then went through six successive versions made between 1952 and 1971.[11]

Even though Duchamp was completely up to date on methods of reproduction, this new project was far more elaborate than the previous ones and the development and fabrication of *La Boîte-en-valise* turned out to be a long-term venture. He wanted to bring together almost everything he had ever produced and put it in this box: not just the notes, but 69 images and five miniaturized ready-mades. The order form for the 'de-luxe' version contained a detailed description of this novel object: 'A fold-out leather box containing exact replicas in colour, cut-out, printed or reduced objects of glass, painting, watercolours, drawings, readymades, the ensemble of which (69 items) represents the almost complete works of Marcel Duchamp between 1910 and 1937.'[12] For the internal workings of this 'miniature museum' Duchamp took inspiration

from cabinets of curiosity, toolboxes and suitcases. The central section, made up of seventeen fixed elements, opens out into space like a polyptych, with *The Large Glass* printed on celluloid film stretched onto thin strips of wood sitting at its centre.[13]

Duchamp surrounded *The Large Glass* with earlier paintings: to the left *Bride, The King and Queen Surrounded by Swift Nudes, Nude Descending a Staircase, N°2*, and, to its right, *Tu m'*, *Comb, Nine Malic Moulds* and *Glider*. He placed three ready-mades (*Air de Paris, Pliant de voyage* and *Fountain*) in a vertical row to the left of *The Large Glass*. On the bottom of this vertical section, as if on a museum wall, Duchamp installed two other ready-mades, *Why Not Sneeze Rrose Sélavy* and *3 Standard Stoppages*. The latter is situated to the left of the section containing thirteen 'loose sheets'[14] of black paper onto which he carefully attached black and white or colour reproductions of the two-dimensional works. Arranged in no particular order, these were placed in a small, lidded box, with reproductions of *Sonata* and *The Chocolate Grinder* on either side. These sheets could be taken out and rearranged as one saw fit; Duchamp did not establish any hierarchy of values between the reproductions and the originals. In the 1950s and '60s he even used some of these printed reproductions in his exhibitions. He labelled each of the 69 elements with the title, dimensions, place of origin and name of the collector who owned the original. In order to be able to put together 300 valises successfully Duchamp had to make a considerable number of reproductions. Since his financial resources did not permit him to use a printer for all of them, he devised other solutions, such as obtaining images at no cost when articles and books were published about him. For the miniature ready-mades, he had no other solution but to make them himself. He created the replica of *Fountain*[15] in papier mâché, using Stieglitz's photograph[16] of the lost original as his reference. He then asked a craftsman to reproduce it in porcelain. During the Second World War Mary Reynolds sewed *Pliant de voyage* by hand from a pattern

View of the exhibition 'De ou par Marcel Duchamp ou Rrose Sélavy', at the Musée des Beaux-Arts, Rouen, October 1998 – January 1999. The exhibition featured one *Rotorelief* (1935), on the left; *Cast Shadows* (1918); *Hat Rack* and *In Advance of the Broken Arm*, suspended; and *3 Standard Stoppages* (1913–14).

cut out of black oilcloth.[17] Duchamp managed to collect nearly all the reproductions and miniature replicas between 1936 and 1941, when he put the first example of *La Boîte-en-valise* up for sale.

During this period he began the sizeable task of inventorying his works in the collections of Lou and Walter Arensberg and Katherine Dreier, and asked his collectors to have photographs made of them.[18] Then, still driven by this demand for resemblance, he realized that he would have to see the works in order to record their original colours as precisely as possible. In 1936 Duchamp returned to the United States and immediately went to Katherine Dreier's estate, West Redding. With his new enterprise in mind, he supervised the photography sessions and accurately noted the dimensions, and the intensity of the colours, of *Tu m'*, *3 Standard Stoppages* and *The Large Glass*, installed in the library. Then he went to California, where the Arensbergs had been living since 1921. With the same exactitude, he verified formats, titles, dates and colours. He drew sketches and made technical notes on the

fronts and backs of each black and white photograph. Next, he travelled to Cleveland, Ohio,[19] where *Nude Descending a Staircase*[20] was on display. Again, Duchamp noted the nuances of the colours used in the original on a black and white photograph,[21] which served as a guide for the replica.

In addition to these preliminary measures, he dealt with technical issues and researched methods of reproduction that would produce the most faithful rendering of the original. He relied on the numerous methods available at the time – phototypography, stencilling, engraving and silkscreen – to account for the material diversity of the originals. In an effort to push their resemblance as far as possible, he applied varnish to certain images or made cardboard frames for the reproductions of his oil paintings. He used a stencilling method called *pochoir* on celluloid[22] for the replicas of *The Large Glass*, *Glider* and *Nine Malic Moulds*. For the 'original colouring', signed by the artist, in the deluxe editions, he made stencils,[23] then enhanced the images by applying touches of watercolour or gouache onto the reproduction. After six years of preparing and perfecting, Duchamp finally brought his project to a close.

In 1941, during the Nazi occupation of France, he launched his commercial mail-order operation, offering a special price for the initial de-luxe versions of *La Boîte-en-valise*: 'The price of 5,000 francs has been reduced to 4,000 francs until 1 March 1941.'[24] Peggy Guggenheim immediately purchased the first de-luxe box, which contained a hand-retouched reproduction of his 1912 painting *The King and Queen Surrounded by Swift Nudes*[25] as well as a note reading: 'for Peggy Guggenheim this 1 number of twenty *Boîtes-en-valises*, each containing 69 items and an original by Marcel Duchamp, Paris January 1941'.[26]

Through his friend Gustave Candel, Duchamp had managed to acquire a cheese merchant's pass, which enabled him to cross the demarcation line that separated German-occupied France from the free zone under the Vichy regime, carrying 'spare parts' for his

boxes, some of which he entrusted to Peggy Guggenheim, who was leaving for New York. Given how events were unfolding, Duchamp also decided to return to the United States.[27] Before setting sail he spent some time in Marseilles and offered a de-luxe version of the valise to Henriette Gomez,[28] who had also taken refuge there, along with the Surrealists. In July 1942 he arrived in New York, recovered his materials and started up business again. Assembling a single box took an entire month, and the fabrication of the de-luxe versions would be spread out over approximately nine years; they were finally finished in the early 1950s.[29] Duchamp took advantage of his standing in America, much higher than he enjoyed in France, and quickly publicized his 'miniature museum'.

In 1942 Peggy Guggenheim put her *Boîte-en-valise* on display in the inaugural exhibition at her gallery Art of this Century. Frederick Kiesler, who designed the interior and the furnishings, created a special showcase for its presentation. By cranking a handle, the circular movement of which echoed the gyrating movements of Duchamp's spiral optical discs, the visitor could move the loose sheets, which were attached to a structure that turned, while looking through a spyhole. The exhibition catalogue, with an introduction by André Breton, Jean Arp and Mondrian, illustrated *La Boîte-en-valise*[30] and asserted that Duchamp had been 'preoccupied with reproducing the very original documentation of his work' for many years.[31] Several magazines, including *Time* in 1942 and *Life Magazine* in 1952, also published images of *La Boîte-en-valise*.[32]

Having finished the first series, Duchamp intended to pursue his edition in order to attain the initial objective of 300 copies.[33] No longer entitled *Boîtes-en-valise*, but simply *Boîtes*, they did not contain the 'original' artwork of the de-luxe version, nor did they have its leather case. The miniature reproductions were placed in small boxes with linen or green, beige or red leather covers. Duchamp worked on what he called the 'B Series' between 1942 and 1950.[34] There were 75 boxes in all and they included 68 rather than

69 items, placed in a beige linen box without a protective cover.[35] For technical reasons, Duchamp also gave up the celluloid copy of the *Glider Containing a Watermill in Neighbouring Metals*,[36] originally installed next to *Tu m'*. With the exception of these changes, this new edition, as well as the others to follow, resembles the de-luxe version. Now Duchamp simply had to delegate their manufacture to fastidious collaborators, to choose their 'commercialization' date and to supervise the updating of their contents.

Between 1949 and 1950, while he was busy with the 'B Series' edition, the Arensbergs began thinking about donating their collection to an American museum and asked Duchamp for his assistance. The couple, who spoke fluent French and were passionate about art and literature, had collected most of Duchamp's works, with his complicity. So Duchamp used his sharp negotiating talents to help find an American museum prepared to accept their exceptional collection of modern art, as well as a group of Pre-Columbian works. After unsuccessful negotiations with museums in California, with the Art Institute of Chicago and the Metropolitan Museum of Art in New York, they finally donated their collection to the Philadelphia Museum of Art in 1950.[37] Duchamp oversaw the installation of the collection, which opened to the public in 1954. In other words, during the early 1950s, immediately after working on the de-luxe *Boîte-en-valise*, Duchamp was very involved in installing his works in a museum. Henri-Pierre Roché underscored this happy coincidence in his *Souvenirs sur Marcel Duchamp*: 'Duchamp was as concerned to reunite all of the reproductions of his works in a suitcase as he was to reunite the works themselves in a single museum.'[38] Duchamp felt intensely satisfied with the permanent presentation of most of his œuvre, which was later complemented by Katherine Dreier's donation of *The Large Glass*: 'Walter and Lou, I am sure, will be as pleased as I am to see the final grouping of my things take actual shape in Philadelphia.'[39]

In 1954 Duchamp began work on the third edition of the box, the c series, which was assembled by an editor, graphic designer and typographist named Ilia Zdanevitch.[40] This edition was a turning point in the history of the 'ordinary' versions of *La Boîte-en-valise*. Indeed, he sent the 30 copies of this new series, prepared for sale in 1958, to Paris to be sold by an art supplies dealer, Lebebvre-Foinet.[41] This box also contained 68 elements in a natural linen box that had an interior lined with blue Ingres paper, but it was unsigned. Duchamp updated the 'labels', with his usual precise attention to the subtlest details. He printed a single label that read: 'The works from the Arensberg collection are now in the Philadelphia Museum of Art, donated by Louise and Walter Arensberg in 1954.'[42] The date of sale of this edition corresponded with the date of the first monograph devoted to Duchamp.[43] He designed the layout for a de-luxe version of that book, entitled *Eau et Gaz à tous les étages* ('Water and Gas on Every Floor'). Duchamp thus continued to establish a veritable coherence between his life – his exhibitions, publications, encounters, family ties – and the new versions of the box, as he tirelessly continued to ameliorate each subsequent version of his personal museum.

In 1961, when he finished the 30 copies of the D series, Duchamp authorized the first life-size replica of *The Large Glass*, onto which he wrote 'Pour copie conforme' ('Certified Copy').[44] In 1963, the year he produced the E series, his first retrospective opened in Pasadena, California.[45] Again, he established a link between this event and the creation of another *Boîte*. On the one hand, the title of the exhibition '*de ou par Marcel Duchamp ou Rrose Sélavy*'[46] corresponded exactly with that of the *Box in a Valise*. On the other, Duchamp's proposal for hanging the works imitated the vertical disposition of the three ready-mades (*50 cc Air de Paris*, *Pliant de voyage* and *Fountain*) included in the original boxes.[47]

At this time he decided to increase the number of reproductions initially included in *La Boîte-en-valise*. The last two editions – the F

and G series, produced in 1966 and 1977 respectively – were to contain 80 items, according to the note Duchamp included in the box, and were supplemented with three 'loose sheets' or twelve new reproductions of earlier and recent works.[48] Duchamp added five works recently acquired by Mary Sisler: *Laundry Barge* (1910) and *Red Nude* (1910) as well as *Sieves or Parasols* (1914), *Network of Standard Stoppages* (1914) and *Female Fig-leaf* (1951). Duchamp met this American collector, a new 'disciple', in 1964. Over the course of several years, and with his aid, she managed to acquire 90 works belonging to two distinct periods: before 1915 and after 1923.[49] These periods correspond to the not yet 'liberated' Duchamp, the 'sad young man in a train', the Duchamp who 'had officially abandoned art for chess', and the silent Duchamp with his tongue in his cheek. The other reproductions Duchamp chose include three charcoal studies for the *Portrait of Chess Players* (1911), which were recovered at his sister's home, and the erotic objects – *Dart Object* (1951) and *Wedge of Chastity* (1954) – that he offered to Teeny Duchamp as a wedding present.[50]

Duchamp remained true to his principles and used the catalogues from his retrospective in Pasadena to obtain his reproductions, including a colour image of the *Network of Standard Stoppages*. Then in 1967, when the Musée des Beaux-Arts in Rouen and the Musée National d'Art Moderne in Paris organized an exhibition entitled *Les Duchamps*,[51] he cut up several copies of the catalogue cover, which reproduced his *Portrait of Chess Players* of 1911 (*Jacques Villon and Raymond Duchamp*). Until the end of his life Duchamp sought to complete his 'miniature museum' by adding recent works and earlier ones that call to mind his family circle, such as the three studies for the *Chess Players* portraying his two brothers.

La Boîte-en-valise testifies to Duchamp's genuine passion for printing and publishing, but it also makes evident his concern to realize his own museum and first *catalogue raisonné*, rather than letting history, which he considered to be as random as a lottery,

be the judge. With its 69 or 80 reproductions, all made using various techniques and with innumerable details, *La Boîte-en-valise* consumed more time and called for more effort than many of his original works. The meticulous research entailed in the completely innovative *Boîte-en-valise* was Duchamp's most original accomplishment. Instead of repeating himself, Duchamp opted for a more subtle and complex solution: he decided to reproduce with slight nuances and on a smaller scale most of his works and some of his writings. This was a new form of expression, or as Arensberg put it, a 'new form of autobiography'.[52] It revealed the paradoxical, yet none the less fascinating aspects of Duchamp's personality: an undeniable obsession with the painstaking manual craftsmanship of handicraft or even children's games, his lifelong taste for scaled-down gestures, and a critical distance with regard to accumulation, memory and definitive statements. Anyone with Duchamp's awareness and lucidity knows that 'the known must always be completed by the addition of the unknown'.[53] Above all *La Boîte-en-valise* revealed a 'utopian Duchamp' who was absolutely pragmatic and realistic, but driven by a desire to convince as many as possible that art and life are indissociable. And, as Francis M. Naumann has noted, *La Boîte-en-valise* might be interpreted as a visual metaphor for Duchamp's ongoing preoccupation with the philosophical notion of the 'Infra-thin'. The seven ordinary versions of *La Boîte-en-valise*, as well as the de-luxe versions, are productive allegories of this notion, which Duchamp defined as a 'conductor' that eases the natural and infinite passage from one dimension to another. The 'Infra-thin' can be of the order of the senses, vision, hearing, touch and smell: mist on polished surfaces, tobacco smoke, the rubbing of corduroy trousers, reflections on shiny surfaces, caresses. According to Duchamp:

> Possibility is infra-thin . . . possibility implying becoming – the passage from one to another takes place in the infra-thin . . . in

Time the same object is not the same after a 1 second interval. The (dimensional) difference between two serial objects is infra-thin when the maximum precision is obtained.[54]

As he wrote to Breton in 1954, 'For me there is something other than yes, no and indifferent – the absence of investigations of this sort, for example.'[55]

9

Counselling

As soon as Duchamp arrived in New York he put to use his keen
knowledge of Cubism, Abstraction and Futurism in the Society of
Independent Artists exhibition and the publication of magazines,
and began counselling New York friends, especially his French-
language students, most of whom were collectors and considered
him enlightened and hung on his every recommendation.

He advised the Arensbergs, who mostly purchased his works
but still liked to have his opinion on their other acquisitions. They
trusted him wholeheartedly and in the early 1950s asked him to
approach about twenty American museums potentially capable of
accepting their collection and to negotiate the terms of their
donation. The major museums in Chicago, New York and
Washington, DC, turned down their offer. Thanks to Duchamp's
diplomatic intervention, however, the Philadelphia Museum of Art
agreed to house their collection, which was inaugurated in 1954.
This was also the period when Duchamp translated into English
Jean Dubuffet's first lecture at the Arts Club in Chicago; he had
organized a Brancusi exhibition there in the 1930s.[1]

Katherine Dreier, who met Duchamp at the Arensbergs', was
also sensitive to the artist and eager for his pertinent advice; she
considered him an unmatched historian capable of initiating them
into the world of contemporary art. Dreier was a writer, public
speaker and sharp-eyed collector who considered Duchamp as her
'other half'; she consulted him on all her projects. Her establishment

Marcel Duchamp and *The Large Glass* (1915–23) at the Museum of Fine Art in Philadelphia in 1955.

of the first American museum of modern art, with the help of Duchamp and Man Ray, was probably the most important project she undertook to promote contemporary art. After asking her bold and talented friends to come up with a name for the private institution, to design and fit out the rooms, arrange the lighting

and photograph the works, she asked Duchamp to design the Société Anonyme 'logo'. She then named him 'head of exhibitions' and asked him to gather documentation on the most innovative European artists of the time.[2] To facilitate their task, they used Fernand Léger as their go-between in Paris and Kurt Schwitters in Germany.

Duchamp became seriously involved in Dreier's foundation and the activities of the Société Anonyme. Like Dreier, he thought it was the artist's role to make the work of his or her contemporaries known and that the artist, not the art historian, should recount the history of the present. Both were convinced that the future of art lay in the United States, that the mixture of individual freedom, the modernity of the architecture and the confrontation with an enduring melting pot implied that if America could see that European art was 'finished' or 'dead', it would have a real chance for the future.[3]

In order to encourage an American art that had still to emerge and to facilitate the exchange between continents, Dreier and Duchamp knew they had to import the most experimental European production from the 1920s. They decided to put on an international exhibition every six weeks[4] and to publish catalogues. They would organize conferences, publicized with slogans such as 'Do you want to know what a Dada is? You can hear all about it at the Société Anonyme Inc. on Friday evening, April the First, Admission Fifty Cents',[5] and give readings, for example 'The First Birthday Party, An Evening With Gertrude Stein, Readings from her unpublished works'.[6] They would also bring together a broad range of documents on European artworks, artists' writings and the most cutting-edge reviews, such as *Valori Plastici*, from Rome, *The Blind Man*, edited by Duchamp, Roché and Wood, or the *Coq parisien*, from France. Several decades later Duchamp recalled that their actions contributed to the understanding of contemporary European art and credited the artists: 'the resolutely modern attitude America has toward art today originated from their efforts'.[7]

One of Duchamp's exhibitions for the newly opened Société Anonyme was a first solo show by the Russian sculptor Alexander Archipenko, held in 1921. Duchamp had introduced Dreier to Archipenko during a trip to Paris two years before. Duchamp considered that his 'most important contribution to sculpture will have been to do away with volume'.[8] He designed the exhibition poster, separating out the different syllables of the artist's name: AR CHI PEN. He also proposed Kandinsky's first American show,[9] as well as a show of Léger's work in 1925, not to mention the group shows including works by Kurt Schwitters, Paul Klee and Duchamp-Villon, among others.

The Société Anonyme anticipated the future activities of the Museum of Modern Art, which opened in 1929 with much greater resources, by more than a decade, as well as those of the Musée National d'Art Moderne in Paris, founded in 1947. Nevertheless, the efforts of Dreier, Duchamp and Man Ray were time-consuming and did not reach a wide audience. Around 1928 Katherine Dreier announced that the Société Anonyme would have to come to an end. Duchamp replied to the news:

Your 2 letters announcing the possible stop of activities in the S. A. did not surprise me – The more I live among artists, the more I am convinced that they are fakes from the minute they get successful in the smallest way. This means that all the dogs around the artists are crooks – if you see the combination fakes and crooks – how have you been able to keep some kind of a faith (and in what?). Don't name a few exceptions to justify a milder opinion about the whole 'Art game' . . . Please come back to the ground and if you like some paintings, some painters, look at their work, but don't try to change a crook into an honest man, or a fake into a fakir . . . I have lost so much interest (all) in the question that I don't suffer from it – You still do.[10]

Despite the bitterness, the two founders of the Société Anonyme did not abandon their convictions. In 1929 Dreier asked the Carnegie Corporation for special funds to create a five-year exhibition programme, with Duchamp as 'salaried manager', but her request was unfortunately denied.

Dreier and Duchamp officially announced the end of their association on 30 April 1950, at the ceremony celebrating their donation of the collection they had amassed, of more than 600 works by 68 male and female artists from 23 different countries, to the Yale University Art Gallery. Between 1943 and 1949 Duchamp wrote 32 biographical notes for the collection's catalogue raisonné, demonstrating talents as an art historian akin to those of Félix Fénéon.[11] He wrote about Picasso, Braque, Léger, Klee, Matisse, Calder, Gris, Picabia, Miró and Kandinsky, as well as his old detractors Gleizes and Metzinger. Then, in 1952, Dreier charged Duchamp with the task of placing her personal collection in different American museums: MOMA and the Guggenheim in New York, the Phillips Collection in Washington, DC, the Art Institute of Chicago, and, of course, the Philadelphia Museum of Art, for *The Large Glass*.[12]

Following the adventures with the Société Anonyme, Duchamp started advising Peggy Guggenheim, the wealthy, eccentric heiress and spouse of Laurence Vail and, later, of Max Ernst. Peggy Guggenheim was familiar with the Parisian artistic circles of Montparnasse, where she had spent time with the photographer Berenice Abbott. Guggenheim and the writer Mina Loy opened a small gallery there and met Duchamp through Mary Reynolds. In his memoirs, Man Ray praised Mary's qualities, in particular her generosity with artists, whom she often invited to stay at her Paris home:

There was a charming young widow of World War I who fell in love with Duchamp and with his usual sang-froid and amiability he accepted the homage . . . We met often for lunch or at Mary Reynolds's, the widow, for dinner. She was a sort of fairy

godmother, receiving all who came to her, both of the French and American intellectual colonies. She was imposed on a good deal and solicited for aid. She worshipped Duchamp but understood that he was determined to live alone . . . Mary Reynolds had a little house with a garden in a quiet part of Paris; she kept an open house as usual and many evenings were spent sitting around in the garden with others who had been invited to dinner. Duchamp took an interest in fixing up the place, papering the walls with maps and putting up curtains of closely hung strings, all of which was carried out in his usual meticulous manner, without regard to the amount of work it involved.[13]

Peggy Guggenheim moved to London in 1931, after her first divorce, where she soon opened another gallery in Cork Street and asked Duchamp to be in charge of the exhibitions. Duchamp suggested she call her gallery Guggenheim Jeune, in reference to the Paris gallery Bernheim Jeune, and then gradually became her mentor. Later Beckett, Tanguy, Ernst and even Mondrian would play a similar role in New York, where she opened her third gallery, Art of this Century. For the moment Duchamp, whom she greatly admired and to whom she felt strongly in debt, played a different role:

I don't know what I would have done without him. He had to educate me completely. I could not distinguish one modern work of art from another, but he taught me the difference between Surrealism, Cubism and Abstract art. Then he introduced me to all of the artists. He organized exhibitions for my gallery and always gave me the best advice.[14]

Marcel Duchamp suggested that she specialize in two crucial areas: Surrealism and Abstraction. He compiled a list of the most important contemporary artists and made several suggestions for exhibitions in her London gallery. These included the inaugural

Duchamp in Hollywood in 1936.

show of Jean Cocteau's drawings and furniture designs, then, in
1938, a Kandinsky show, accompanied by a catalogue with texts by
Breton, Diego Rivera and the critic and editor Christian Zervos.
But above all, Duchamp organized an important exhibition of
sculpture for the Guggenheim Jeune gallery in March–April 1938.
The *Exhibition of Contemporary Sculpture* included works by seven
living sculptors: Brancusi, Arp, Calder, Laurens, Antoine Pevsner,
Sophie Tauber-Arp, Henry Moore and Duchamp's brother
Raymond Duchamp-Villon, considered as a precursor. In order
to bring certain of the pieces onto British soil Duchamp needed
a guarantee from the director of the Tate Gallery, but refused to
attribute the label 'work of art' to certain of the sculptures. Despite
Duchamp's assistance, the London gallery made very few sales and
Peggy Guggenheim was obliged to purchase the works she exhibited,
thus establishing the collection that is visible today at the Peggy
Guggenheim Collection in Venice.[15]

Peggy Guggenheim returned to the United States because of
the worsening situation caused by the Second World War. Before

departing for New York she left her collection for safekeeping at the Musée de Peinture et de Sculpture, Grenoble, in the care of the museum director Pierre Andry-Farcy, who knew its inestimable value and agreed owing to the historical circumstances. As a show of gratitude, and upon Duchamp's urging, she then donated to the museum Raymond Duchamp-Villon's original plaster cast for the *Cheval Majeur* (1914).

When she arrived in New York she opened Art of this Century, which functioned like a museum and became the fief of the Surrealists in exile in New York. Simone de Beauvoir went to the gallery during a trip to New York and compared it to a Surrealist 'church'; she described the exhibition in the following, lukewarm terms:

> This gallery is like no other; the décor is more important than the objects, even the religious ones . . . There are all sorts of baroque objects near the sculptures and paintings: bottles incrusted with seashells, a large captain's wheel that, when rotated, sparks the appearance of a series of reproductions by Duchamp. It's a miniature Surrealist exhibition with the same assorted tricks and minor thrills.[16]

Duchamp shared other exhibition ideas with Peggy: a show of Cornell boxes or a group show dedicated exclusively to female artists, *Exhibition by 31 Women*, which brought together Valentine Hugo, Meret Oppenheim, Sophie Tauber-Arp, Louise Nevelson, Frida Kahlo and others.

In 1943, at the insistence of Alfred Barr, the first director of the Museum of Modern Art, she decided to organize a Salon devoted to young American talent.[17] She put together a jury of curators and two artists, Duchamp and Mondrian. According to legend, it was Mondrian, perplexed in front of a canvas by Jackson Pollock, who insisted that his works be included in the Salon, claiming that he

Duchamp with Man Ray in New Jersey, 1965.

found it to be one of the most interesting pictorial modes of expression around. Peggy Guggenheim, who initially thought Pollock's work was not painting and that it lacked 'discipline', would eventually become his first dealer. And so Jackson Pollock's first works were presented to the New York public, only to be recognized by critics as representative of the new American talent and as the keystone of Abstract Expressionism.

In 1964 Duchamp became acquainted with another American collector, Mary Sisler, who was close to Robert Rauschenberg and Jasper Johns, two young 'Neo-Dadaist' artists and fervent admirers of Duchamp,[18] who appreciated them too:

I like them a lot too because beyond the painting, where the artist's concerned, I look at the mind of the fellow who is painting. And I couldn't care less if the fellow paints amazing things if he is an imbecile and as stupid as a painter, which you understand, is often the case. But Rauschenberg and Johns are also remarkably intelligent.[19]

Mary Sisler wanted to purchase only works by Duchamp. With his help, she finally managed to collect 82 pieces,[20] which were shown in an exhibition entitled *Not Seen and/or less Seen of/ by Marcel Duchamp/Rrose Sélavy, 1904–1964*.[21]

Homme devant le miroir

Many a time the mirror imprisons them and holds
them firmly. Fascinated they stand in front. They
are absorbed, separated from reality and alone with
their dearest vice, vanity. However readily they
spread out all other vices for all, they keep this
one secret and disown it even before their most
intimate friends.

There they stand and stare at the landscape which
is themselves, the mountains of their noses, the
defiles and folds of their shoulders, hands and skin,
to which the years have already so accustomed them
that they no longer know how they evolved; and the
multiple primeval forests of their hair. They med-
itate, they are content, they try to take themselves
in as a whole. Certain traits appear too small, and
it is well so, but others are too large and it is
magnificent so. Women have taught them that power
does not succeed. Women have told them what is
attractive in them, they have forgotten; but now
they put themselves together like a mosaic out of
what is attractive about them. Only handsome men are
sure of themselves, but handsome men are not fitted
for love: they wonder even at the last moment
whether it suits them. Fitted for love are the
great ugly things that carry their faces with
pride before them like a mask. The great taciturns,
who behind their silence hide much or nothing.

Slim hands with long fingers or short, that grasp
forth. The nape of a neck that rises steeply to
lose itself in the forest's edge of the hair, the
tender curve of the skin behind an ear, the myster-
ious mussel of the navel, the flat pebbles of the
knee-caps, the joints of their ankles, which a hand
envelops to hold them back from a leap — and beyond
the farther and still unknown region of the body,
much older than it, much more worn, open to all
happenings: this face, always this face which they
know so well. For they have a body only at night
and most only in the arms of a woman. But with them
goes always, ever present their face.

The mirror looks at them. They collect themselves.
Carefully, as if tying a cravat, they compose their
features. Insolent, serious and conscious of their
looks they turn around to face the world.

Rrose Sélavy[22]

Art as Love / Eros for All

Duchamp built his life and his work as a series of passages or even ruptures: from Cubist painter to independent artist and *individu*, from Paris to New York and vice versa, from *The Large Glass* to *Etant donnés*, from his identity as Marcel Duchamp to that of Rrose Sélavy, and from one double to another through his 'certified copies'. Consistently and with passion, he aimed to lay bare the multiple facets of his individuality, in sum, the 'ready-made', as expressed in 'Pensée-cadeau: vers un ami' ('Thought Gift: for a friend'), a poem Ettie Stettheimer sent to him in 1922:

> I would like to be made to measure
> For you, for you
> but I am readymade by nature,
> for what for what?
> since I do not know I have made adjustments
> for me—[1]

For Duchamp, the artist's true investment in his creation is this life-time commitment: 'The artist of tomorrow will go underground.' Duchamp sought to satisfy his 'appetite' for self-understanding, the sort that arises from rites of passage and is necessary for initiation, which he rarely commented on. He understood the liberating effects of an independence of mind, freedom and repudiation, all of which are possible through detachment and indifference. This

The Duchamp exhibition of 1986 held at Moderna Museet in Stockholm. The ceiling is a reconstruction of *Sixteen Miles of String*, the *mise-en-scène* for the exhibition 'First Papers of Surrealism'.

range of available existential choices gradually led him down the road to self-knowledge, which he followed with patience and humility. His humanist attitude led him to recognize the liberating power of humour and eroticism:

> Eroticism is a subject very dear to me and I certainly applied this taste, or this love, to my Glass. In fact, I thought the only excuse for doing anything was to introduce eroticism into life. Eroticism is close to life, closer to life than philosophy or anything like it; it's an animal thing that has many facets and is pleasing to use, as you would use a tube of paint.[2]

That said, Duchamp did set up a hierarchy between humour and eroticism. He considered humour fundamental; it prevents one from ever taking oneself too seriously and, therefore, allows for self-contradiction and mental flexibility. It is a process that inevitably leads to what Robert Filliou, one of Duchamp's artistic heirs, called 'permanent creation' or, in the more theoretical words of Duchamp's frequent reference, Gaston de Pawlowski: 'Humour is the strict sense of the relativity of things; it is the ongoing critique of what we believe to be definitive; it is the door open to new possibilities without which mental progress would be impossible.'[3]

In contrast, Duchamp considered eroticism to be a very serious, even 'quite dangerous' notion. For him 'eroticism is the only serious thing I could consider . . . Now that is serious, and I tried to use it as a platform, if you will, for building things, like *Bride*, for example.'[4] By bringing eroticism to the same level as creative acts like drawing, painting, sculpture, thinking or writing, Duchamp removed the sacred aura from art, which was sometimes considered as a religion or a dogma, and brought it much closer to life; artists have carried on doing this since the 1960s.

Two years before his death he reiterated his position: 'I believe in eroticism a lot, because it is truly a rather widespread thing

throughout the world, a thing that everyone understands. It replaces, if you wish, what other literary schools call Symbolism, Romanticism. It could be another "ism", so to speak.'[5] Here, Duchamp admits two wishes: on the one hand, that his position will be understood outside artistic circles, which corresponds with Apollinaire's prediction in 1913 that 'It will perhaps be reserved for an artist as disengaged from aesthetic preoccupations, as occupied with energy as Marcel Duchamp, to reconcile Art and the People';[6] and on the other, that he will establish a new 'ism' that has strictly nothing to do with style and forms.

For Duchamp, as for Picabia, Brancusi, Man Ray, Breton and the Surrealists, and Jeff Koons today, eroticism has been the basis for all reflection, the infallible means for revealing hidden things, in other words, an act towards self-awareness and knowledge of others:

> it is really a way to try to bring out in the daylight things that are constantly hidden – and that are not necessarily erotic – because of the Catholic religion, because of social rules. To be able to reveal them, and to place them at everyone's disposal – I think this is important because it's the basis for everything and no one talks about it.[7]

Again, he could not have said it more clearly than in 1961:

> The erotic act is the perfect four-dimensional situation. This idea is important to me: a fixed idea, stemming from a tactile apprehension of all of the facets of an object, provides a tactile sensation of the fourth dimension. Because, naturally, none of our senses have any application in the fourth dimension, except, perhaps, for touch. As a result, the act of love as tactile sublimation can be envisaged or rather felt like a physical apprehension of the fourth dimension.[8]

Eroticism was central to Duchamp's most mysterious paintings, made during his trip to Munich in 1912: *The Virgin, Bride, The Passage from the Virgin to the Bride*, which were surpassed by the esotericism of *The Large Glass*. Picabia, who was as preoccupied with these questions in his work as he was in his life, reaffirmed these initial pictorial translations of eroticism. 'I wish my penis had an eye so that one day I could say I saw love up close', he wrote in his novel *Jésus-Christ Rastoquère*, published by Au Sans Pareil in 1912. Decades later, Duchamp came up with a similar formula: 'I want to grasp things with the mind the way the penis is grasped by the vagina.'[9] Duchamp gave *Bride* to Picabia, whom he described as a 'half-Auvergnat, half-Norman Don Juan'. From 1913 to 1915 Duchamp and Picabia held an ongoing dialogue on the theme of the 'girl born without a mother', or the machine as a sexual metaphor. Duchamp constantly asserted that eroticism was the principal subject of his painting on glass, which was a combination of several earlier works as well as his writing. He considered eroticism one of the 'great cogs of the bachelor machine'.[10]

Although Duchamp was preoccupied with the description of sexual mechanics (one of the driving themes of hundreds of hand-written notes for *The Large Glass*), his language remains cryptic. It was only after his total liberation between 1915 and 1918 in the Arensbergs' Neo-Dadaist circle that his position became more expli-cit, or more mundane, in certain cases. Duchamp's friends practically raised sexuality to the level of an artistic gesture. It was flaunted as an anti-bourgeois position that could erase social prejudice. Over the course of those three years Man Ray, Duchamp and others intensified their production of games, plays on words and erotic objects. In 1918 Man Ray made reference to Duchamp's ready-mades in his photo-graphs *Woman* and *Man*, images of cooking utensils that appear as sado-masochistic metaphors for male and female sexual organs.

Several women linked to the New York Dada scene participated in these quite racy games of seduction. Beatrice Wood, Lou

Arensberg, who became Roché's lover, Sophie Treadwell and, above all, the German baroness and author Elsa von Freytag-Loringhoven, who had left Europe for New York, had their own roles to play in Marcel's masterful erotic rituals. Elsa and David Bomberg made several erotically charged symbolic objects, including a phallic assemblage of plumbing materials that she entitled *God* in 1917. Man Ray and Duchamp made a film, now lost, named explicitly after its subject matter, *The Baroness Shaves her Pubic Hair*. Beatrice Wood, who was mistress to both Roché and Duchamp, captured their parties in anecdotal sketches that are as evocative as the objects mentioned or as Mina Loy's memories:

> Marcel was as clever as a prestidigitator; he could slip a corsage into a woman's hand with absolute grace and say, 'Madame, you have a 'joli caleçon en satin' (you have lovely satin panties) and leave her with a fanciful kiss and a 'Madame, you have 'un sale con de satin' (a dirty satin cunt).[11]

It was in this frivolous and libertine context that Duchamp submitted his urinal to the Society of Independent Artists; he was aware of its phallic and erotic dimension, as was Alfred Stieglitz, who photographed it after the committee rejected it. A closer look at the interior of Stieglitz's 1917 photograph reveals a shadow, the outline of which clearly evokes an erect male organ. This shadow, emphasized by Stieglitz's lighting of the object, is echoed in certain of Brancusi's sculptures, such as *Princess x* (1916), which represents a female bust shaped like an erect phallus, also exhibited at the Independent Artists exhibition.

When Duchamp 'androgynized' the *Mona Lisa* by drawing a moustache and goatee on her, he implied that this straight-faced image concealed Leonardo da Vinci's homosexuality, but also a 'hot' woman. Shortly after he gave birth to his female alter-ego, Rose Sélavy, this 'impudent widow', this 'intellectual woman', who

became 'Eros, c'est la vie' one year later when Duchamp added a second 'r' to her name. When asked about Rose's birth in New York in 1920, Duchamp said:

> . . . I wanted to change my identity, and the first idea that came to me was to take a Jewish name. I was Catholic, and it was a change to go from one religion to another! I didn't find a Jewish name that I especially liked, or that tempted me, and suddenly I had an idea: why not change sex? . . . The double R comes from Picabia's painting, you know, the *Oeil cacodylate*, which is at the Boeuf sur le Toit cabaret.[12]

Duchamp used Rrose, alias Eros, to get his erotic messages across through particularly colourful and daring plays on words and puns. In 1939 he published his writings as *Occultisme de précision, Rrose Sélavy New-York Paris Poils et coups de pieds en tous genres*. In slang, Rrose/Eros, this mistress of the art of transforming 'storks into swans', or into signs (*cygnes*, in French), utters rather unusual words for a woman. Consider this 'intimate' question: *Faut-il mettre la moelle de l'épee dans le poil de l'aimée?*; or these nice turns of phrase: *abominables fourrures abdominales* ('abominable abdominal furs'), *A charge de revanche/à verge de rechange, un mot de reine/des mots de reins*; and finally, *quand on a un corps étranger entre les jambes, il ne faut pas mettre son coude près des siennes*. Hadn't Duchamp declared upon his arrival in New York that female modesty was no longer *de rigueur*? Duchamp, alias Rrose, transformed other puns into images in his silent film *Anemic Cinema*. The slow, continuously gyrating, white spirals expressed even more trivial spoonerisms, such as: *l'aspirant habite Javel et moi j'avais l'habite en spirale*.[13]

Having first chosen the path of veiled eroticism, using a mechanistic language formed into a sophisticated treatise to evoke the sexual act and the collision of flows, Duchamp next put sexually

suggestive words in Rrose's mouth and later became even more explicit in his erotic objects from the 1950s, as well as the series of engravings entitled *Lovers* (1968). Then he produced his final work, *Etant donnés*, which openly displays the female slit, the 'source or spring' from which 'these fluids, you know, that love is made of' spurt. This *tableau vivant* can be seen as a metaphor for the 'woman as fountain', as an indirect way to express the 'original revolutionary faucet' that stops 'running when we stop listening to it'. This work is a relevant and unforeseen reference to images by Courbet, such as the landscapes of the Lou and the waterfalls, Ingres (*The Spring*, 1856) and Picasso (*The Pissing Woman*, 1965), which portray the 'woman as fountain' and 'waterfalls' that splash and 'spray' life. Through this work, Duchamp offers us a particularly sanguine message that sums up all of his 'infamies' or 'litanies': *Sélavy, C'est la vie*! And in rose, naturally!

11

'Maria, (you have) finally arrived'

When Duchamp returned to New York in 1942, many of his friends from before the war had already left. The Arensbergs had moved to Los Angeles in the 1920s and Man Ray had taken up residence in nearby Hollywood; Beatrice Wood was also living in California. Roché had returned to Paris decades before and Duchamp's 'other half', Katherine Dreier, retired to her country home in Connecticut, where she remained until her death in 1951. Duchamp's female companion, Mary Reynolds, joined him in New York in 1943, but soon went back to Paris, where she died in 1951. Duchamp visited her just before she passed away and wrote to Man Ray from the return ship to New York: 'Nothing like the death of one person to bring home to you the senselessness of all the rest of the bloody human race.'[1]

New York in the 1940s was a new context for Duchamp. He had been the central figure of the small New York Dada group, but now Breton, who was joined in exile by the main Surrealist painters, took over the role of charismatic leader. In addition, before long an emerging generation of American painters, including Jackson Pollock, Mark Rothko and Robert Motherwell, would come to occupy centre stage, thanks to the support of the art critic Clement Greenberg. Duchamp's early arrival in New York, and the presence of other French artists during the early part of the century, are at the origin of this historical evolution. Nevertheless, such changes did not prevent Marcel from pursuing his projects, such as his

European artists in New York at Pierre Matisse's apartment in 1945. We can see in this group portrait André Breton on the left, Mme Suzanne Césaire, just next to him, Jackie Matisse, Marcel Duchamp standing by the door with Yves Tanguy to his left and Teeny Duchamp seated next to Aimé Césaire.

presentation of the *Boîte-en-valise*, or from quietly working on other, more secret, artworks. His new circle of friends included Peggy Guggenheim, whose home, Hale House, and her gallery Art of this Century served as a link between the United States and Europe. She welcomed such new arrivals as Yves Tanguy, Max Ernst, André Masson, Frederick Kiesler and Piet Mondrian, as well as younger figures, such as John Cage and his wife, or the new American generation, in particular Pollock, who had his first solo exhibition in her space in 1942.

Duchamp felt more isolated in this new environment, with no great public recognition and no American artists claiming his legacy. The next generation of artists, however, which included the founders of American Pop Art, Robert Rauschenberg and Jasper Johns, would cite his influence.

It was at this time and in this America, which had so widely opened its arms to him decades earlier, that he met Maria Martins, a renowned sculptor, jewellery designer and the wife of the Brazilian ambassador to the United States. She had studied sculpture in Brussels, then in New York with Jacques Lipchitz, and owned a studio in the city. Despite the considerable difference between her expressive and symbolic, Surrealist-influenced sculpture and Mondrian's Neo-Plasticist painting, Maria exhibited with him at the Valentine Gallery in 1943. It is likely that Breton, who admired her work and wrote a preface for one of her exhibition catalogues, introduced Duchamp to her. Maria Martins was known for her exceptional talents as hostess of her husband's diplomatic receptions, and as a savvy collector: she purchased Mondrian's *Broadway Boogie Woogie*, then offered it to the Museum of Modern Art, which collected some of her sculptures in turn. She also took Duchamp's advice and purchased his *Coffee Grinder* from 1911.

Photographs and accounts from the time attest to Maria's seductive, fascinating beauty and magnetic femininity. She was a dark brunette with softly wavy hair and perfect oval face, whose gaze emanated a deep sensuality and a spiritual dimension. Duchamp, known for his own power of attraction, was captivated. Although it is difficult to pinpoint the beginning of their affair, it seems to have started in 1944, at around the same time that Duchamp took up art-making again. Since 1923 he had been claiming that he had abandoned art for chess, but he found himself ensnared by a married woman who became his secret muse and the central figure in his final work, *Etant donnés*, which was only revealed to the public posthumously. As was the case with *The Large Glass*, which occupied him from 1912 to 1923 and then again in 1936, Duchamp worked on *Etant donnés* for roughly two decades.

From 1946 onwards, several hand-painted colour images made for the de-luxe editions of *La Boîte-en-Valise* hint that Duchamp had undertaken a project, as significant as *The Large Glass*, that was

Duchamp at boules with Yves Tanguy in Connecticut, 1948.

also linked to his private life. These include a unique 'drawing', *Faulty Landscape*, which he offered to Maria in the de-luxe valise number 12.[2] This quasi-abstract work comprising a central, flowing form on a neutral ground, a sort of starry sky suggestive of the 'Milky Way', was used for the cover of the special issue of *View* magazine dedicated to Duchamp in 1945. The contours of this stain recall a female body with outstretched legs and arms. At the time only Maria knew the meaning of Duchamp's abstract form, which

historians may find similar to Pollock's 'drippings' or Tachist painting, both contemporary with this work. However, in 1988, 20 years after Duchamp's death, specialists examined it with the help of the FBI and discovered that the peculiar image is, in fact, composed of ejaculated seminal fluid.

While the connotation of the adjective 'faulty' requires little explanation, the noun *Landscape* brings us back to *Pharmacy*, the ready-made Duchamp offered to his sister Suzanne, and to a note on *The Large Glass*: 'Watermill (landscape—). Given the waterfall' ('*Etant donné la chute d'eau Moulin à eau [paysage]*').[3] When Duchamp offered *La Boîte-en-Valise* to Maria, he also gave her a de-luxe version of the *Boîte verte* dedicated to 'Maria, enfin arrivée', or to 'Maria, (you have) finally arrived'. In a sense, it was as if Duchamp was establishing a link, even a tenuous one, between his 'finally arrived' Maria and *The Bride Stripped Bare by her Bachelors, Even*. His most enigmatic and epic work, which he left unfinished in 1923, took on a most unexpected significance and demonstrated, as if it needed to be reiterated, that Duchamp's life and work formed a single entity. Duchamp considered the creative process as part of an existential mission deeply anchored in life and in reality. Suddenly, in 1946, he touched on what he had no doubt been anticipating his entire life, and had expressed in an 'unsentimental' way, as Breton said, in a fable like *The Large Glass*. His secret and loving passion for an inaccessible woman provided him with an occasion for reconciling two separate episodes in his life, both of which seem to have genuinely influenced his artistic practice.

Other clues to the repercussions this love affair had on his future works include an academic pencil drawing that Duchamp made in 1947, entitled *Etant donnés: Maria, la chute d'eau et le gaz d'éclairage* (*Given: Maria, the Waterfall and the Illuminating Gas*). The female body is no longer represented in an abstract or mechanistic way, as in the *Nude Descending a Staircase* or the *Pendu femelle* of *Bride*, but in a naturalistic, even studied way. The nude is faceless

Etant- Donnés
interior view
(1946–66),
mixed media.
Philadelphia
Museum of Art.

and the positions of her arms and legs outlined on a neutral
background resemble the form of the sperm stain on *Faulty
Landscape*. It was surely a study for Duchamp's secret work as
well as a portrait of the woman that inspired it: Maria. He wrote
on the page: 'This lady belongs to Maria Martins/With all of my
love/Marcel Duchamp 1948–1949.'[4]

Duchamp provided another piece to the puzzle in an original
coloriage from 1948 for *La Boîte-en-Valise* he offered to some Swiss
friends he visited that year. Only Man Ray or the artist Enrico
Donati could have understood what it meant. The drawing,
Hand Reflection, is doubly enigmatic. First, the informed viewer
alone will know that its title makes reference to some of Duchamp's
notes for *The Large Glass*, namely his description of the 'mirror
reflection of the illuminating gas'. Secondly, its central figure, a
woman's hand clenched around a tube ending in a black circle,

could be a metaphor for a hand holding a mirror or a hand holding a male organ spurting the illuminating gas, symbolized by a source of light.

This second original drawing is another preparatory study for Duchamp's final work. It represents a fragment of the female figure's body: the hand that holds the Bec Auer lantern that Duchamp detailed in the instruction manual he wrote for it. There he specified that a 'small green bulb' should be placed in the mantle of the lamp and that the electrical wire should be 'hidden under the mannequin's arm'. While he was working out these fine points, he was also making the pink foam breast, *Please Touch*, with Donati's assistance, which he called 'my secret', for the catalogue of the 1947 Surrealist exhibition. Duchamp also made other erotic works between 1950 and 1951, such as *Objet-dard*, *Female Fig-leaf* and *Wedge of Chastity*.

We know that before the end of his affair with Maria in 1950 Duchamp had visualized the entire installation, which he entitled *Given: 1° The Waterfall, 2° The Illuminating Gas . . . , 1946–1966*.[5] Duchamp removed Maria's name from the title for the final version. In keeping with his wishes, this sculpture, which is also a *tableau vivant*, joined its 'siblings' – the forty or so works by Duchamp that the Arensbergs donated and *The Large Glass*, donated by Katherine Dreier – at the Philadelphia Museum of Art in 1968.

To access *Etant donnés*, the museum visitor crosses an unwelcoming dark space resembling a dead-end or an 'emergency exit'. Then, an old garage door framed by bricks built into the wall comes into view off to the side. The viewer approaches the battered door and looks into the two peepholes (Duchamp called them 'voyeur holes'), and discovers a pale, faceless, lifeless female body lying before them, with one arm cropped and the other holding a Bec Auer lantern aloft. The body is utterly smooth, except for 'the hair spread out between her breasts'; she is resting on a pile of branches that might catch fire if they were 'lit' by a source of heat.

Duchamp left explicit instructions that he wanted the body to appear to sink into its bed of branches: 'Important: before placing the nude, attach three aluminium bands onto which several single branches have been attached so as to give the effect that the nude is sinking into the bushes. 1, 2, 3, 4, 5, 6.'[6]

The eye is then drawn further back to a landscape with a waterfall, towards which the nude extends the lantern. In the background, the delicately lit vegetation seems to move, as in the kitschiest of decors, while the body in the foreground lies completely immobile, as if dead. Duchamp took great care with the realistic, even illusionistic, effects of this landscape, drawing variations in the sky with 'replaceable cotton clouds'.

Viewers faced with this particularly bold *tableau vivant* are inevitably frustrated by the inaccessibility of the space. There is no way of knowing what is going on in the hidden, invisible corners, and it is difficult to tear one's eyes away from the mutilated, inanimate nude bearing a lantern like a trophy. The whiteness and lifelessness of her body, which seems so close and yet so far, inexorably beckon the viewer. This paradox is incapacitating.

Duchamp had been working in a rented studio on 14th Street since 1943, and we now know that this was the theatre of his secret from 1946. According to his second wife, Teeny, Duchamp worked on assembling the installation in his studio for several hours every day, knowing that others would disassemble and reassemble it after his death. He did what he could to facilitate this task: he wrote an instruction booklet with guidelines and photographs.[7] In letters to Maria, after she had left New York, Duchamp refers to this sculpture as a collective work: he gives news of 'our sculpture', of the 'woman with open pussy', or 'Our Lady of Desires'. According to certain historians who have had access to Duchamp's correspondence with Maria,[8] Duchamp asked her not to leave for France and then for Brazil, but to stay with him in New York in a studio that had become available on his floor: 'You could isolate

yourself with me there and no one would know about this cage outside the world.'[9] She refused, and this small apartment on 14th Street became a kind of refuge for Duchamp. He worked there in secret on *Etant donnés*, perhaps while still harbouring the illusion that he might possess Maria's body. Duchamp referred to this apartment, which is not unlike the *Merzbau* that Kurt Schwitters built into his different homes, as the 'Cathedral of erotic misery', or 'the grotto'. It was a daily haven that surrounded him and protected him from isolation.

In 1947, when Schwitters's wife Helma told her husband she was frightened, he replied:

> But you really shouldn't be, I am building an imaginary house and we are going to live in it . . . I am calling it *Merzbau 7*. For seven years we were engaged, the war lasted seven years, and I was twenty-seven years old when I could at last hold her in my arms again and she came down from Seventh Heaven when I was dead.[10]

Perhaps Duchamp, in his quest to escape the unbearable reality of Maria's departure, found refuge in this 'fictive' and illusionistic space. In a poem dating from 1946, Maria wrote: 'I want the nostalgia of my presence to paralyze you.'

With his legendary restraint and discretion, Duchamp hid this work until his death in order to avoid having to explain its origin and meaning. As such, its interpretation remains forever partial and hypothetical. Without seeking to counter his legitimate desire to guard the mystery, one could speculate on the meaning of *Etant donnés* by comparing it with Courbet's *Origin of the World*.[11] Duchamp saw the Barnes collection in Philadelphia in 1933, when he went to convince Albert Barnes to buy a sculpture by Brancusi. He was very impressed by another of Courbet's paintings, *The Woman with White Stockings* (1861). The radical

cropping of the model's legs in both works caught Duchamp's attention. It is easy to imagine that Courbet's suggestive titles also appealed to Duchamp; they do not describe the painting but 'bring the mind elsewhere', towards a much broader notion that stimulated his imagination. In the mid-1880s Courbet had already asserted what Duchamp analysed in the mechanical language of the *Bride* in 1915, and what he reaffirmed a century after Courbet, in 1966: that all of humanity is sooner or later confronted with the mystery of this probable or improbable encounter, through an irrepressible alchemy between the waterfall, or the female fluid, and the illuminating gas, or the male seminal fluid, a source of energy. This 'extra-rapid exposure' between these 'liquids that love are made of' remained a fundamental question for Duchamp, serving as a metaphor for his vision of creation.

12

Parting Deeds and Words

Marcel Duchamp's life became increasingly public from the 1950s.
Now recognized worldwide, the artist who had always avoided pub-
lic appearances, interviews, exhibitions and the commercial aspects
of art began to take part in them with amusement and detachment.
He returned to his roots (to his family and France) and to an appar-
ent conformity, only to surprise his audience when it was least
expected, by posthumously revealing *Etant donnés*, thus calling into
question a number of assumptions about the man and his work.

It is clear that Duchamp, like most great artists, was playing the
game of posterity, knowing all the while that he was just buying
time. When Jean Crotti asked his opinion of painting in 1952, he
responded as follows:

> Artists throughout the ages are like Monte Carlo gamblers and
> the blind lottery pulls some of them through and ruins others.
> To my mind neither the winners nor the losers are worth both-
> ering about. It's a good business deal for the winner and a bad
> one for the loser.[1]

During this period he officially gave up his bachelorhood, for the
second time, and married Teeny Matisse, the former wife of the art
dealer Pierre Matisse, on 16 January 1954. As was his custom, he
announced the news to his friends and family as if it were a mere for-
mality, though he added a touch of humour: 'I have been married,

Marcel Duchamp and Teeny in Naples *c.* 1962–3. With them was Gianfranco Baruchello.

since 16 January to Teeny Matisse', he wrote to Suzanne Duchamp and Jean Crotti, 'No children yet, except the three readymades.'[2] To Walter Arensberg he wrote: 'In growing old the hermit would be monk.'[3]

This was the year for accomplishments: the Philadelphia Museum of Art inaugurated the exhibition spaces dedicated to Duchamp's work. He proudly sent invitations to his old friends Breton and Henri-Pierre Roché, who could not attend the festivities: 'The Philadelphia Museum will open its rooms containing the Arensberg Collection around the 15th of October and they've included my *Large Glass* so I'll be all right for the next 25 years.' He commented on its placement: 'Katherine Dreier's *Large Glass* is right in the middle of an enormous room at the Arensberg collection . . . I'm really touched by how kind the directors have been who have consulted me about every slightest detail.'[4] Duchamp was even more satisfied because the 30 or so of his

Duchamp posing for Villon in 1950. Note the French Championship poster of 1925 and *The Lovers*, a relief by Raymond Duchamp-Villon.

works included in the Arensberg collection were joined by 20 works by Brancusi grouped together in a separate space.

Then, curiously, although he had always refused commemorative exhibitions, associations and groups, Duchamp agreed to participate in and even contribute to two exhibitions devoted to him and his family. He curated and wrote the catalogue for the first: *Duchamp Frères et Soeur: Oeuvres d'art*, which took place at the Rose Fried Gallery in New York. The Musée des Beaux-Arts in Rouen, the seat of his family, organized the next in 1967, a year before his death. It was entitled *Les Duchamps: Jacques Villon, Raymond Duchamp-Villon, Marcel Duchamp, Suzanne Duchamp*.[5] Despite his fame, Duchamp situated himself on exactly the same level as his brothers and sister – as the third son and Suzanne's accomplice. And while he had managed to distance himself from the family clan, he made it here into a 'label', a family 'firm', to which he lent

Duchamp and *The Large Glass* exhibited at Pasadena, 1963.

his notoriety. He left aside any past differences or misunderstandings and relinquished the aura surrounding the notion of the author and the artist's ego. In 1964 he transformed a portrait photograph of the family, taken in 1899, by likening it to his 1917 urinal. Was Duchamp trying to patch up old family disputes or was he perhaps referring to the phrase Rrose wrote in the 1920s: 'Incest or familial passion?'

In addition to these family exhibitions, Duchamp also contributed to the organization of his first retrospectives. The first took place in 1963 at the Pasadena Art Museum in California ('Life starts at 76 with my one-man show in Pasadena', he wrote to Breton)[6] and the second Richard Hamilton put together at the Tate Gallery in London in 1966. Teeny used her ample talents to draw Marcel from the shadows and from the reserve he had been revelling in throughout the years.

While living in the public eye and travelling between Paris, New York, London, Stockholm and Cadaquès, where he spent his summers, Duchamp continued to correspond with friends and made

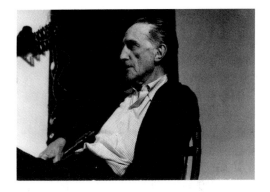

Duchamp in 1967–8 at Cadaquès.

several new works, thus demonstrating that the 'hermit' did not let the official recognition go to his head. Besides authorizing the replicas of his ready-mades and *The Large Glass*, Duchamp also made the erotic objects *Female Fig-leaf*, *Objet-dard*, *Not a Shoe* and *Wedge of Chastity*, as well as two other assemblages based on plays on the French word for still-life (*Nature morte*): *Sculpture-morte* and *Torture-morte*, which he produced in Cadaquès in 1959. These two works, conceived as visual puns or holiday 'homework', and his portrait in profile *With my Tongue in my Cheek* symbolically and ironically evoke withering, pain, the dematerialization of the flesh and, inevitably, death, whose approach Duchcamp was probably waiting, if not preparing, for!

On the evening before he died, on 1 October 1968, Duchamp and Teeny had dinner in Paris with Man Ray, his wife Juliet, and Robert and Nina Lebel. Man Ray and Duchamp, who had been friends for fifty years and collaborators for thirty, exchanged gifts. Shortly after, Duchamp decided to leave this game for another one taking place elsewhere. Man Ray recalled these final moments, and left room for speculation as to his friend's avowed or unspoken intentions: 'Toward midnight on October 1, Marcel slumped over with his eyes closed and a slight smile on his lips. His heart had obeyed him and had stopped (like his work before it). Oh, it is

Duchamp and
Teeny in August
1961 with Timothy
Philipps, Salvador
Dalí and others at
the Café Meliton
in Cadaquès.

Duchamp at his
first home *c*. 1960
in Cadaquès.
The fireplace was
designed by
Duchamp (see the
small seahorse at
the centre).

tragic like the end of a chess game. I will not say any more about it.'[7] Teeny sent a telegram to Richard Hamilton: 'Marcel died last night peacefully', adding, 'He had the most calm, pleased expression on his face.'[8] Had it all been finely orchestrated? He had, after all, asked that the epitaph on his tombstone in Rouen read: 'D'ailleurs, c'est toujours les autres qui meurent' ('By the way, it's always the others who die').

Yet Duchamp still had things he wanted to express before the end of the game, and Breton gave him the opportunity to do so in two Surrealist exhibitions. Presenting themselves as 'daters' or anti-historicists, they conceived of the 1959 International Surrealist Exhibition (*Exposition inteRnatiOnale du Surréalisme*), held at the Galerie Daniel Cordier in Paris, as a 'return to eroticism'.[9] Duchamp's intervention, made under the sign of Eros, was a room of pink satin walls and a breathing ceiling that visitors entered through a vaginal form. This installation, as well as the catalogue he co-designed with Mimi Parent, a mailbox titled *Boîte alerte!*,[10] were playful versions of the erotic sculptures and a nod to the still secret *Etant donnés*.

Duchamp and Breton also introduced works by Duchamp's Dadaist heirs Robert Rauschenberg and Jasper Johns (a combine painting and a target, respectively) to the French public. Duchamp, naturally, did not attend the opening, but sent a telegram: 'Je purule, tu purules, la chaise purule, grâce à un rable de vénérien qui n'a rien de vénérable', which roughly translates as 'I ooze pus, you ooze pus, the chair oozes pus, thanks to a heavy-set guy with venereal disease, who has nothing venerable about him.'[11]

The following year Duchamp became involved in a lesser-known exhibition held at the d'Arcy Gallery in New York. He suggested the title, *Surrealist Intrusion in the Enchanter's Domain*, to Breton, and then conceived of the show in its entirety, assisted by the poet Claude Tarnaud. He updated Breton: 'Tarnaud, Bonnefoy and I have been working hard for ten days on setting

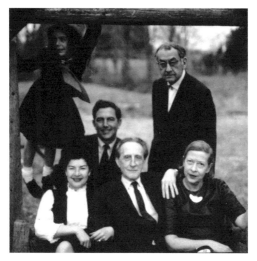

Duchamp, Teeny
and Man Ray and
Juliet with Man
Ray's niece,
Naomie Savage, in
New Jersey, 1965.

Duchamp with
family at Villiers
sous Grez,
October 1967.

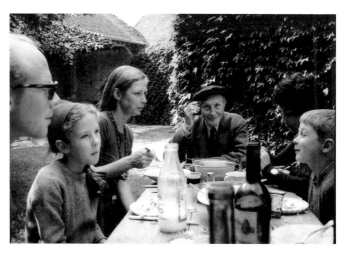

up rooms with one or two small "inventions" which have to remain rather shy but at the least the general formula doesn't duplicate that of previous Surrealist events.'[12] A few weeks later, Duchamp described the installation, which resembled a 'happening' or fair, in detail:

> Opening only: a fortune-teller (professional who was taken up the whole evening). Permanently: 3 white hens (alive) in a cupboard made into a hen house, a ray of sunshine at sunrise (or sunset); a reel of tape specially recorded with a little girl doing painful exercises on the piano in the house next door; a tarot card (Arcane 17) projected onto the ceiling . . . a mirror between practically all the paintings . . . a large pharmacy jar (green, red, yellow); the tobacconist's sign (carrot) outside . . . clock-in machine like at a factory entrance.[13]

In addition to participating in these exhibitions and overseeing the permanent installation of his work in one of the most important American museums, Duchamp followed Teeny's advice and agreed to the publication of two monographs and his writings, which appeared in 1958 as *Marchand du sel*.[14]

As such, Duchamp, who had managed to reconcile the different aspects of his life story, was granted a great gift: the possibility to leave behind tranquilly the image of a peaceful and contented man. Since the shock of 1912, which irrevocably traced out his exceptional destiny, he had untiringly worked on a new morality and a form of ethics that enabled him to achieve the liberty and independence essential to any creative impulse. According to Henri-Pierre Roché's quasi-fictional account of Duchamp: 'He must be alone, he is a loner, a beggar, a thinker. He is a preacher, in his own way. He is working towards a new morality.'[15]

Indeed, Duchamp's fairness, his subtle and agile mind, his pedagogical talents, his steadfastness and feeling for appeasement in

Duchamp in Florida in 1962.

the guise of his tremendous courtesy, never cease to amaze. His lack of interest in recognition and in financial gain provided him with the courage to follow uncharted paths with the singular aim of broadening the artist's, and the viewer's, spheres of activity. As a result, he systematically reversed the relationship between the artist, the artwork and the public, completely transforming the hierarchy of roles. By considerably broadening the definition of the work of art and of the role of the artist, he turned the 'passive' viewer into an 'adult, healthy and active being'[16] capable of 'jumping from one promontory to the next'[17] – in other words an individual capable of never conforming to a predefined rule, image or dogma, and of inventing his or her own 'formulae'. Duchamp's trajectory

and the importance of his 'new morality' for generations of artists cannot be underestimated: 'The art community feels Duchamp's presence and his absence. He has changed the condition of being here', wrote Jasper Johns.[18]

Although France did not grant Duchamp the same consideration it granted Picasso and Matisse (Duchamp's first major exhibition in France took place in 1977 at the Centre Georges Pompidou), on his death the critic Raymond Cogniat did make mention of Duchamp's ongoing quest: 'In fact, in this curious mirage, his works are of lesser functional importance than his acts, or rather, one must consider his acts as artworks because everything in him worked in harmony, even if one considers his provocative contradictions alone.'[19]

It is to hoped that Duchamp's acts will continue to inspire artists, as it has scores of individuals taken, as he was, with liberty and with noble wisdom.

References

1 Introduction

1 Letter to Walter Arensberg, June 1919. Marcel Duchamp, *Affectionately, Marcel: The Selected Correspondence of Marcel Duchamp*, ed. Francis M. Naumann and Hector Obalk (Amsterdam, 2000), p. 86.
2 Ibid., p. 106.
3 For details on Duchamp's professional chess competitions, see Vlastimil Fiala, *The Chess Biography of Marcel Duchamp (1887–1968)*, 2 vols (Olomouc, 2004).
4 Duchamp, *Selected Correspondence*, p. 239.
5 Pierre Cabanne, *Dialogues with Marcel Duchamp* (New York, 1971), pp. 77–8.
6 Duchamp, *Selected Correspondence*, p. 239.
7 Rudolf Steiner had a strong influence on the artists of the Puteaux group, with whom Duchamp was associated before leaving for New York. Around 1912 Duchamp was an avid reader in French translation of his text *Die vierte Dimension*. In addition, works like Duchamp's roto-reliefs are undeniably hypnotic.

2 Marcel, this Sad Young Man on a Train

1 According to Duchamp, Apollinaire gave this painting another title in 1914: *Melancholy on a Train*. Pierre Cabanne, *Dialogues with Marcel Duchamp* (New York, 1971), p. 29, and Michèle Humbert, 'Duchamp et les avatars du silence', *Etant Donné*, 1 (1999), p. 94.
2 'It *is* necessary to know that the Municipal Museum of Art in Rouen

owns *Les Enervées de Jumièges*, and that Joan of Arc was roasted at Rouen.' See 'Preface by Salvador Dalí', in Cabanne, *Dialogues*, p. 14.

3 When M. Duchamp passed away, the civilian hospice in Rouen issued a statement that recalled his commitment, 'perfect courtesy' and 'his disinterestedness and modesty'. Excerpt from a speech given by M. Albert May, Duchamp Estate Archives, Villiers-sous-Crez, France.

4 Duchamp and Lydie Fischer Sarazin-Levassor were married from 8 June 1927 to 25 January 1928.

5 Lydie Fischer Sarazin-Levassor, *Un échec matrimonial: le coeur de la mariée mise à nu par son célibataire, même* (Dijon, 2004), p. 131.

6 Ibid., p. 132.

7 Ibid., p. 133.

8 Marcel Duchamp, 'Catalogue de la Société Anonyme', in his *Duchamp du signe: écrits*, ed. Michel Sanouillet (Paris, 1994), p. 209. See *The Société Anonyme and the Dreier Bequest at Yale University: A Catalogue Raisonné*, ed. Robert L. Herbert, Eleanor S. Apter and Elise K. Kenney (New Haven, 1984), pp. 739–40.

9 Published in French by the Editions de la Revue Blanche (1899) and the Editions P. V. Stock (1900). Duchamp purchased a later edition during the 1960s.

10 Sarazin-Levassor, *Un échec matrimonial*, p. 131.

11 *Comb* is the title of a ready-made from 1916.

12 Marcel Duchamp, *Affectionately, Marcel: The Selected Correspondence of Marcel Duchamp,* ed. Francis M. Naumann and Hector Obalk (Amsterdam, 2000), p. 28. Pach also translated texts by the French art historian Elie Faure.

13 See especially the series of chronophotographs entitled *Descending Stairs*, plate 125, published in Eadweard Muybridge, *Animal Locomotion* (London, 1887).

14 Marey's photographic work was published in the magazines *Nature* and *L'Illustration*, which Marcel said he consulted at the time.

15 Several years before his death, the city mounted a plaque in honour of the presence of the Duchamp family in Rouen: 'Between 1905 and 1925, a family of Norman artists lived here: Jacques Villon, Raymond Duchamp-Villon, Marcel Duchamp and Suzanne Duchamp.'

16 Cabanne, *Dialogues*, p. 29.

17 Sarazin-Levassor, *Un échec matrimonial*, p. 88.

18 Calvin Tomkins, *Duchamp: A Biography* (New York, 1996), p. 111.

19 Duchamp, *Selected Correspondence*, letter to Jean Suquet, December 1949, p. 283.

20 Grasset and Fasquelle reissued this novel in 1923 along with a 'critical examination' by the author.

21 Duchamp, *Selected Correspondence*, p. 26.

22 The date 21 June 1912 is also mentioned.

23 Arturo Schwarz, *The Complete Works of Marcel Duchamp*, 3rd edn (New York, 1977), vol. I, p. 567.

24 Duchamp, *Selected Correspondence*, p. 26.

25 This journey took them to Etival, the home of Gabrielle Picabia's parents, on 26 October 1912.

26 *Deux personnages et une auto (étude)*, 1912, lead pencil on paper, Neuilly. Former collection of Alexina Duchamp, France.

27 Duchamp, *Selected Correspondence*, p. 29.

28 Duchamp, 'A propos de moi-même', in *Duchamp du signe*, p. 224.

29 He gave him *The Passage from the Virgin to the Bride*.

30 Duchamp, *Selected Correspondence*, p. 34.

31 Ibid., p. 36.

3 All Aboard for New York, 1915–18

1 He sold this work to Henri-Pierre Roché before leaving for Buenos Aires in 1918.

2 Marcel Duchamp, *Affectionately, Marcel: The Selected Correspondence of Marcel Duchamp*, ed. Francis M. Naumann and Hector Obalk (Amsterdam, 2000), p. 66.

3 Peyton Boswell, writing in the *New York Herald*, 17 February 1913.

4 *Arts and Decoration, Tribune, Vanity Fair*.

5 Man Ray, *Self-Portrait* (Boston, MA, 1962, repr. New York, 1998), p. 56.

6 Henri-Pierre Roché, *Victor* (Paris, 1977), pp. 28–9.

7 Duchamp, *Selected Correspondence*, p. 68.

8 Ibid., p. 118.

9 Ibid., p. 141.

10 *La Fête à Duchamp (Duchamp's Party)*, 1917, John Gordan collection. Albert and Juliette Gleizes, Henri-Pierre Roché and the Marquis de

Buenavisita are represented as guests.

11 *Portrait of Marcel Duchamp*, 1923, oil on canvas, William Kelly Simpson collection, and *Portrait of Marcel Duchamp*, 1923, Museum of Fine Arts, Springfield, MA.

12 Roché, *Victor*, p. 16.

13 Ibid.

14 Ibid., p. 17.

15 Man Ray, *Self-Portrait*, p. 62.

16 Roché, *Victor*, p. 57.

17 'Dee as Leonardo – What was it?', Katherine Dreier Manuscript, 13 October 1920, Dreier Archives, Beinecke Library, Yale University, New Haven, CT.

18 Duchamp, *Selected Correspondence*, p. 47.

19 Ibid., p. 47.

20 Private collection, United States.

21 Duchamp, *Selected Correspondence*, p. 52.

22 Ibid., p. 59. According to Francis M. Naumann, Duchamp did know one person: a French friend who ran a bordello!

23 Ibid., p. 57.

24 Duchamp stayed in Buenos Aires for only ten months.

25 Ibid., p. 73.

4 Ready-mades, 1914–64

1 Bernard Dorival, *Les Duchamps: Jacques Villon, Raymond Duchamp-Villon, Marcel Duchamp, Suzanne Duchamp*, exh. cat., Musée des Beaux-Arts de Rouen (Rouen, 1967), p. 79

2 'Marcel Duchamp parle des readymades. Entretien avec Philippe Collin', in *Marcel Duchamp*, exh. cat., Tinguely Museum (Basel, 2002), p. 37. This interview was held on the occasion of an exhibition devoted to Duchamp's ready-mades, held at the Galerie Givaudan in Paris on 21 June 1967, one year before Duchamp's death.

3 'Marcel Duchamp parle des readymades', p. 38.

4 Marcel Duchamp, *Affectionately, Marcel: The Selected Correspondence of Marcel Duchamp*, ed. Francis M. Naumann and Hector Obalk (Amsterdam, 2000), p. 44.

5 William C. Camfield, exhibition on the *Urinal* of 1917, The Menil Collection, Houston, 1989.

6 Duchamp, *Selected Correspondence*, p. 44.

7 Ibid., p. 45.

8 Pierre Cabanne, *Dialogues with Marcel Duchamp* (New York, 1971), p. 48.

9 Man Ray, *Self-Portrait* (Boston, MA, 1962, repr. New York, 1998), p. 62.

10 Duchamp, *Selected Correspondence*, p. 346.

11 Ibid.

12 Duchamp's sister Suzanne married Charles Desmares, a pharmacist from Rouen, in 1911. She remarried in 1919, this time to Jean Crotti. Duchamp gave her one of the first 'rectified' ready-mades, titled *Pharmacy* (see chapter One).

13 A lost ready-made that Duchamp never reproduced. Richard Hamilton made the only replica in 1966 and 1977 for the Duchamp retrospective, the first exhibition held at the Centre Pompidou in Paris.

14 Duchamp, *Selected Correspondence*, p. 44. He added a sketch of the sculpture in question, indicating the colours: red, green, blue.

15 Unpublished interview with Sidney Janis, Carroll Janis collection, New York.

16 Henri-Pierre Roché, *Victor* (Paris, 1977), p. 65.

17 *Fountain* reappeared as a replica in an exhibition held at the Sidney Janis Gallery in New York in 1950.

18 See chapter Two.

19 Duchamp, letter to Henri-Pierre Roché, 9 May 1949, *Selected Correspondence*, p. 273.

20 Marc Partouche, *Marcel Duchamp: J'ai eu une vie absolument merveilleuse: biographie, 1887–1968* (Paris, 1992), p. 51.

21 Marcel Duchamp, 'A propos des "Ready-mades"', in his *Duchamp du signe: écrits*, ed. Michel Sanouillet (Paris, 1994), p. 191. Duchamp gave this short talk on his ready-mades at the Museum of Modern Art, New York, on 19 October, 1961, in conjunction with the exhibition *The Art of Assemblage*.

22 The Arensbergs owned two fox terriers and Duchamp might have found this object in their apartment.

23 Duchamp, 'A propos des "Ready-Mades"', in *Duchamp du signe*, p. 192.

24 Francis M. Naumann, *Marcel Duchamp: The Art of Making Art in the Age of Mechanical Reproduction* (New York, 1999), p. 34.

25 Cabanne, *Dialogues*, p. 47.

26 Partouche, *Marcel Duchamp*, p. 64.

27 Duchamp, *Selected Correspondence*, p. 75.

28 There are many possible verbs one can use to complete the phrase that starts with *Tu m'* : tu m'aimes (you love me), tu m'amuses (you're funny), tu m'inquiètes (I'm worried about you), tu m'interpelles (you puzzle me), tu m'excuses (you forgive me?) . . .

29 When Duchamp left for Argentina he took the ready-mades with him.

30 Cabanne, *Dialogues*, p. 60.

31 Marcel Duchamp, 'La mariée mise à nu par ses célibataires, même ("la boîte verte")' in *Duchamp du signe*, p. 50. See Marcel Duchamp, *Notes from the Green Box (*1934); typographic version published as Richard Hamilton, ed., *The Bride Stripped Bare by her Bachelors, Even*, trans. George Heard Hamilton (London, 1960), unpaginated.

32 Dreier arrived in Buenos Aires on 14 September 1918.

33 Duchamp, *Selected Correspondence*, p. 66.

34 Duchamp presented *A bruit secret* (1916) at the third exhibition of the Société Anonyme, held in 1920.

35 André Breton or Marcel Duchamp, *Dictionnaire abregé du surréalisme* (Paris, 1938).

36 *Entretiens avec Pierre Cabanne* (Paris, 1995).

5 Collaborations

1 Pierre Cabanne, *Dialogues with Marcel Duchamp* (New York, 1971), p. 61.

2 Marcel Duchamp, *Affectionately, Marcel: The Selected Correspondence of Marcel Duchamp*, ed. Francis M. Naumann and Hector Obalk (Amsterdam, 2000), p. 94.

3 Musée National d'Art Moderne, Centre Pompidou, Paris.

4 Man Ray, *Self-Portrait* (Boston, MA, 1962, repr. New York, 1998), p. 62.

5 Ibid.

6 Marcel Duchamp, 'Catalogue de la Société Anonyme', in his *Duchamp du signe: écrits*, ed. Michel Sanouillet (Paris, 1994), p. 212. See Robert L. Herbert, Eleanor S. Apter and Elise K. Kenney, eds, *The Société Anonyme and the Dreier Bequest at Yale University: A Catalogue Raisonné* (New Haven, CT, 1984), p. 547.

7 Duchamp, *Selected Correspondence*, p. 94.

8 Here again, Duchamp traced a new path for contemporary art that became widespread in the 1960s. Harald Szeemann's 1969 exhibition *When Attitudes Become Forms*, held in Bern, Switzerland, provides a broad overview of this production.

9 The hands cupped around Duchamp's made-up face belong to Picabia's female companion, Germaine Everling.

10 Duchamp, *Selected Correspondence*, p. 96.

11 Man Ray, *Self-Portrait*, p. 88.

12 Duchamp, 'Catalogue de la Société Anonyme', in *Duchamp du signe*, p. 212, and in *Société Anonyme and the Dreier Bequest at Yale University*, p. 547.

13 André Breton, 'Les visages de la femme', in *Man Ray: Photographies 1920–1924 Paris* (Paris, 1934); also as *Photographs by Man Ray 1920 Paris 1934* (Hartford, CT, 1934; repr. New York, 1979, as *Photographs by Man Ray: 105 Works, 1920–1934*).

14 Metropolitan Museum of Art, New York.

15 Duchamp, *Selected Correspondence*, p. 140.

16 Ibid., p. 149.

17 Man Ray, *Self-Portrait*, p. 188.

18 Duchamp, *Selected Correspondence*, p. 149.

19 Duchamp added a second 'r' to Rose (Rrose) after the infamous evening at the Boeuf sur le toit cabaret, making it possible to read the name as 'Rrose Sélavy' or 'Eros Sélavy!' (Eros is life!).

20 Man Ray, *Self-Portrait*, p. 188.

21 Duchamp, *Selected Correspondence*, p. 156.

22 Man Ray, *Self-Portrait*, p.75

23 Ibid., p. 77.

24 Duchamp shared his last meal in Paris with Man Ray, his wife Juliet, Teeny Duchamp, and Robert Lebel and his wife Nina (see chapter Eleven).

25 Duchamp, *Selected Correspondence*, p. 248.

26 *Joseph Cornell/Marcel Duchamp . . . in resonance*, exh. cat., Philadelphia Museum of Art and The Menil Collection, Houston (Ostfildern, 1998).

27 'Objects by Cornell: Minutiae, Glass Bells, Shadow Boxes, Coups d'oeil, Jouets Surréalistes', Julien Levy Gallery, New York, 26 November–30 December 1932.

28 Deborah Solomon, *Utopia Parkway: The Life and Work of Joseph Cornell* (New York, 1997), p. 135.

29 Ibid.

30 From here Duchamp asked Patricia Matta Kane to assemble and distribute the *Boîtes-en-valise*.

31 'Joseph Cornell and Marcel Duchamp', Duchamp folder, 1942–1953, in the holdings of the Philadelphia Museum of Art, Gift of the Joseph and Robert Cornell Memorial Foundation. This folder contains 118 items. Walter Hopps found it in 1973.

6 'Exhibiting – it's like getting married'

1 Daniel Dezeuze, *Textes et Notes, 1967–1988* (Paris, 1991), p. 20.

2 He managed to collect almost $10,000. The exhibition took place in New York's Grand Central Station, which meant high rental fees.

3 Cited by Scarlett and Philippe Reliquet in *Henri-Pierre Roché, l'enchanteur collectionneur* (Paris, 1999), p. 90.

4 Marcel Duchamp, *Affectionately, Marcel: The Selected Correspondence of Marcel Duchamp*, ed. Francis M. Naumann and Hector Obalk (Amsterdam, 2000), p. 66.

5 Ibid., p. 66.

6 Ibid., p. 98.

7 The Surrealist exhibition at the Galerie Pierre in Paris opened on 13 November 1925. In accordance with Duchamp's wishes, *Rotary Demisphere* was not shown in the exhibition.

8 Duchamp, *Selected Correspondence*, p. 152.

9 Ibid., p. 103.

10 Ibid., p. 117.

11 Ibid., p. 113.

12 Ibid., p. 117.

13 Ibid., p. 116.

14 Ibid., p. 121.

15 Ibid., p. 150. A year later he agreed to get married to Lydie, although he was always opposed to marriage. One might interpret this union as a response to these tragic events.

16 Ibid., p. 154.

17 Francis M. Naumann, *Marcel Duchamp: l'argent sans objet* (Paris, 2004), p. 80.

18 Laurie Eglinton, 'Marcel Duchamp, Back in America, Gives Interview', *Art News*, 32 (18 November 1933), pp. 3, 11.

19 The two different spellings, 'Maurice' and 'Morice', appear in the sources and in the correspondence.

20 This definition recalls Duchamp's description of the ready-mades as 'rendez-vous'.

21 Lydie Fischer Sarazin-Levassor, *Un échec matrimonial: le coeur de la mariée mise à nu par son célibataire, même* (Dijon, 2004), p. 53.

22 Ibid., p. 52.

23 Duchamp, *Selected Correspondence*, p. 170.

24 Held 5 January–9 February 1929.

25 Duchamp, *Selected Correspondence*, p. 180.

26 Ibid., p. 181.

27 Ibid.

28 Eglinton, 'Marcel Duchamp', pp. 3, 1.

29 Duchamp, *Selected Correspondence*, p. 173.

30 Duchamp joined the editorial committee in 1937, with André Breton, Paul Eluard, Maurice Heine and Pierre Mabille.

31 Duchamp, *Selected Correspondence*, p. 194.

32 Charles Duits, *André Breton, a-t-il dit passe* (Paris, 1969), p. 108.

33 Man Ray, *Self-Portrait* (Boston, MA, 1962, repr. New York, 1998), p. 233.

34 Elaine Sturtevant reconstructed Duchamp's installation *1,200 Coal Sacks* in her retrospective exhibition of 2004, *The Brutal Truth*, at the Museum für Moderne Kunst in Frankfurt am Main.

35 See the exhibition invitation: 'Opening signal at 10 o'clock sounded by André Breton/Getting out of be in hydrophilic flanks/The most beautiful streets in Paris/Rainy Taxi/Sky of Rousettes.'

36 Pierre Cabanne, *Dialogues with Marcel Duchamp* (New York, 1971), p. 81.

37 According to Marcel Jean and Man Ray.

38 Duchamp, *Selected Correspondence*, p. 232.

39 Ibid., p. 231.

40 Susanna Perkins Hare assisted Duchamp.

41 According to certain accounts, Calder proposed placing thousands of small folded-paper birds on the string, but Breton vetoed this idea.

42 See Lewis Kachur, *Displaying the Marvelous: Marcel Duchamp, Salvador*

Dalí, and Surrealist Exhibition Installations (Cambridge, MA, 2001), p. 196. The introduction to the catalogue reads: 'Children's opening reception, playing with the smell of cedar'.

43 Marcel Duchamp, 'Infra-mince' in his *Duchamp du signe: écrits,* ed. Michel Sanouillet (Paris, 1994), p. 274.

44 Duchamp, *Selected Correspondence,* p. 257.

45 *La Planète affolée: surréalisme, dispersion et influences, 1938–1947,* exh. cat., Museums of Marseilles (Marseilles, 1986), p. 284.

7 *La Mariée mise à nu par ses célibataires, même*

1 In 1946 Duchamp started working on the equally mysterious *Etant donnés: 1° La chute d'eau, 2° Le gaz d'éclairage,* which was revealed to the public only after his death in 1968. A fragment of the title for this work appears in his notes on the Bride from 1913–14.

2 Yo Sermayer (1911–2000), artist. Duchamp organized an exhibition of her works in 1967, at the Bodely Gallery in New York, and wrote a play on words, signed Rrose Sélavy (alias Marcel Duchamp), for the catalogue: 'Voici Peinture d'ameublement de Yo Savy (Alias Yo Sermayer)'. See Marcel Duchamp, *Duchamp du signe: écrits,* ed. Michel Sanouillet (Paris, 1994), p. 251.

3 Interview with Marcel Duchamp conducted by Tristram Powell for the BBC. See Francis M. Naumann, *Marcel Duchamp: The Art of Making Art in the Age of Mechanical Reproduction* (New York, 1999), p. 269.

4 Marcel Duchamp, 'Transcription of *La Boîte verte',* in *Duchamp du signe,* p. 66. See Marcel Duchamp, *Notes from the Green Box* (1934); typographic version published as Richard Hamilton, ed., *The Bride Stripped Bare by her Bachelors, Even,* trans. George Heard Hamilton (London, 1960), unpaginated.

5 Pierre Cabanne, *Dialogues with Marcel Duchamp* (New York, 1971), p. 37.

6 Ibid. pp. 48–9.

7 Duchamp, 'Transcription of *La Boîte Verte',* in *Duchamp du signe,* p. 87. See Marcel Duchamp, *Notes from the Green Box* (1934).

8 Henri-Pierre Roché, *Victor* (Paris, 1977), p. 65.

9 Duchamp had the image appear on the cover of the second issue of the Dada magazine, *The Blind Man,* which he co-edited with Roché and

Wood in New York in May 1917.

10 Duchamp, *Notes from the Green Box* (1934).

11 Marcel Duchamp, *Affectionately, Marcel: The Selected Correspondence of Marcel Duchamp*, ed. Francis M. Naumann and Hector Obalk, (Amsterdam, 2000) p. 342.

12 Ibid., p. 32.

13 Ibid., p. 30.

14 Ibid., p. 65.

15 Ibid., p. 69.

16 Duchamp, cited in *Marcel Duchamp*, exh. cat., Tinguely Museum (Basel, 2002), p. 76.

17 Roché, *Victor*, p. 65.

18 Ibid.

19 Man Ray, *Self-Portrait* (Boston, MA, 1962, repr. New York, 1998), p. 73.

20 Ibid., p. 187.

21 Lydie Fischer Sarazin-Levassor, *Un échec matrimonial: Le coeur de la mariée mise à nu par son célibataire, même* (Dijon, 2004), p. 89.

22 The exhibition was held from 19 November 1926 to 1 January 1927. It was also presented at the Anderson Galleries in Manhattan, in Buffalo and then in Toronto. Since *The Large Glass* was too fragile to travel it was not included in these later venues.

23 Roché, *Victor*, p. 69.

24 Duchamp, *Selected Correspondence*, p. 188.

25 Ibid., p. 207.

26 In Francis M. Naumann, *Marcel Duchamp: L'art à l'ere de la reproduction mécanisée* (Paris, 1999), p. 222.

8 Duplicating Works instead of Repeating Himself

1 There are five versions of *La Boîte de 1914*. The one that contains the original notes and the drawing is in the collection of the Philadelphia Museum of Art.

2 *Nude Descending a Staircase, N°3*, 1916, watercolour, pen, pencil and pastel on a photograph, Philadelphia Museum of Art, and *Nude Descending a Staircase, N° 4*, 23 July 1918, pencil, ink and distemper on paper, 9.5 × 5.5 cm, Museum of the City of New York.

3 Rrose Sélavy was Duchamp's female alter ego, 'born' in New York in 1921. Duchamp associated Rrose in the signature of certain works, editions and films (*Anemic Cinema*). The Société Anonyme published the first edition copyrighted in Rrose Sélavy's name in 1922: *Some French Moderns Says McBride*, a collection of critical essays by the American art critic Henry McBride.

4 Marcel Duchamp, cited in Marc Partouche, *Marcel Duchamp: J'ai eu une vie absolument merveilleuse: biographie, 1887–1968* (Marseilles, 1992), p. 88.

5 Ibid.

6 Letter to Katherine Dreier, 5 March 1935.

7 Marcel Duchamp, 'Interview with James Johnson Sweeney' (NBC television, 1955), in *Duchamp du signe: écrits*, ed. Michel Sanouillet (Paris, 1994), p. 184. Marcel Duchamp, interview with James Johnson Sweeney, in Marcel Jean, ed., *Autobiographie du surrealism* (Paris, 1978; Eng. trans., New York, 1980), pp. 412–14.

8 Marcel Duchamp, *Affectionately, Marcel: The Selected Correspondence of Marcel Duchamp*, ed. Francis M. Naumann and Hector Obalk (Amsterdam, 2000), pp. 197–8.

9 Ibid., p. 204.

10 Series A.

11 Ecke Bonk, who has written a reference book on the *Box in a Valise*, established the classification system in series, from A to G. See *Marcel Duchamp: The Box in a Valise, de ou par Marcel Duchamp ou Rrose Sélavy: Inventory of an Edition* (New York, 1989).

12 Marcel Duchamp, subscription bulletin for the deluxe series of the *Box in a Valise*, Paris, 1940.

13 *The Bride Stripped Bare by her Bachelors, Even*, 1915–23, Philadelphia Museum of Art.

14 This is how Duchamp referred to these elements.

15 1917, New York, signed Richard Mutt, sent to the Salon of Independent Artists in New York. Original lost, replica produced in 1964.

16 Reproduced in the second issue of the magazine *The Blind Man*, edited in New York by Duchamp, Roché and Wood in 1917.

17 1917, New York, original lost, replicas produced in 1962 and 1964.

18 Sam Little took most of the photographs.

19 *Twentieth Anniversary Exhibition*, Cleveland Museum of Art, 26 June–

4 October 1936.

20 This is the second version of the *Nude Descending a Staircase*, 1912, oil on canvas, 149 × 89 cm, Philadelphia Museum of Art.

21 Reproduction no. 7 in *De ou par Marcel Duchamp ou Rrose Sélavy*, exh. cat., curated by Ronny and Jessy Van de Velde, with an introduction by Francis M. Naumann (London, 1996). Cited in Bonk, *Marcel Duchamp: The Box in a Valise*, p. 212. The photograph belongs to the Duchamp archives.

22 The motif is printed on the back.

23 Duchamp provides a very precise description of this printing technique in a note in *The Green Box*.

24 Subscription bulletin, Paris, 1940. Reprinted in *De ou par Marcel Duchamp ou Rrose Sélavy*.

25 Louise and Walter Arensberg Collection, Philadelphia Museum of Art.

26 Bonk, *Marcel Duchamp: The Box in a Valise*, p. 164.

27 Arensberg helped Duchamp obtain a visa for the United States by naming him curator of their collection, called the 'Francis Bacon Library Art Collection' in Los Angeles. Duchamp gave them a de-luxe version (number 0) of the *Boîte-en-valise*, with an original *Virgin*. It is in the collection of the Philadelphia Museum of Art.

28 This copy (number IV/XX) does not have a leather case, but an original *Apolinère enameled*. It is in the collection of the Musée d'Art Moderne, Saint-Etienne.

29 In the end, Duchamp made 24 de-luxe versions, four of which were numbered 0/XX, and given to Mary Reynolds, Katherine Dreier, Lou and Walter Arensberg, and Kay Boyle.

30 The renowned photographer Berenice Abbott took the photographs.

31 Bonk, *The Box in a Valise*, p. 165.

32 'Artist Descending to America, Marcel Duchamp. The Trip was Perfectly Delicious', *Time* (7 September 1942). An article appeared in *Life* (28 April 1952), with a photograph of the valise by Eliot Elisofon.

33 See chapter Five. The first five copies were assembled in France, while the nineteen to follow were finished in New York with the help of Joseph Cornell.

34 Musée National d'Art Moderne, Centre de Création Industrielle, Paris. Cornell and Xenia Cage helped put this box together. The Rose Fried Gallery in New York was in charge of selling them.

35 Bonk, *The Box in a Valise*, p. 172. Fifteen or so were presented in a valise.

36 1913–15; Lou and Walter Arensberg Collection.

37 From 20 October to 18 December 1949 the Art Institute of Chicago presented the exhibition *Twentieth Century Art from the Louise and Walter Arensberg Collection*. The exhibition included 30 works by Duchamp, who also helped Katherine Kuh with the organization. Louise Arensberg died on 25 November 1953 and her husband Walter died a year later. Their collection was inaugurated in October 1954, and was accompanied by a two-volume catalogue, *20th Century Art and Pre-Columbian Sculpture*.

38 Robert Lebel, *Sur Marcel Duchamp* (Paris, 1958), p. 83.

39 Duchamp, *Selected Correspondence*, p. 314.

40 Also known as Iliazd.

41 Bonk, *The Box in a Valise*, p. 179.

42 Lebel, in *Sur Marcel Duchamp*.

43 Jacqueline Matisse began assembling the boxes (series D to G) from this moment on.

44 Ulf Linde made this copy for the exhibition *Motion in Art*, at the Moderna Museet in Stockholm, from 17 May to 9 September 1961.

45 Organized by Walter Hopps, 8 October–8 November 1963.

46 Duchamp designed the poster and the catalogue.

47 Bonk, *The Box in a Valise*, p.186.

48 Richard Hamilton organized a retrospective *The Almost Complete Works of Marcel Duchamp* at the Tate Gallery in London, 18 June–31 July 1966. Jacqueline Matisse assembled these boxes. They were produced under the supervision of Arturo Schwarz in Milan. The F series, in a red box, contains 75 copies signed by Duchamp. The 47 copies of the G series, in an olive-green box, were edited in 1971 and signed by Teeny Duchamp.

49 They were purchased from two of Duchamp's friends: Henri-Pierre Roché and Gustave Candel. See the exhibition *Not Seen and/or Less Seen of/by Marcel Duchamp/Rrose Sélavy, 1904–64*, Cordier & Ekstrom Gallery, New York, 1965.

50 Offered to Teeny Duchamp as a wedding gift. Duchamp managed to get the images of the erotic objects from the publication of his catalogue raisonné by Arturo Schwarz in Milan in 1964.

51 *Les Duchamps: Jacques Villon, Raymond Duchamp-Villon, Marcel Duchamp, Suzanne Duchamp*, Musée des Beaux-Arts, Rouen, 15 April–

1 June 1967, and *Marcel Duchamp et Raymond Duchamp-Villon*, Musée National d'Art Moderne, Paris, 6 June–2 July 1967. Both museums used the same image of the *Chess Players* for the catalogues. The lithographed poster was a life-size version of the painting, the first work by Duchamp purchased by the museum.

52 Arensberg told Duchamp in 1943: 'You have invented a new kind of autobiography. It is a kind of autobiography in a performance of mari-onettes. You have become the puppeteer of your past.' See Bonk, *The Box in a Valise*, p. 167.

53 Gaston de Pawlowski, *Voyage au pays de la quatrième dimension* (Paris, 2004), p. 46.

54 Marcel Duchamp, *Notes* (Paris, 1999), pp. 18–46.

55 Duchamp, *Selected Correspondence*, p. 343.

9 Counselling

1 *Position Anti-Culturelle*, translated in 1951.

2 Duchamp is named 'chairman' of the exhibition committee in the 1920–21 activities report of the Société Anonyme. The committee also included Katherine Dreier, Joseph Stella and Man Ray.

3 Marcel Duchamp, *Deux interviews new-yorkaises, septembre 1915* (Paris, 1996), p. 19.

4 The *International Exhibition of Modern Art*, at the Brooklyn Museum in 1926 included works by 106 artists from 23 different countries.

5 1 April 1920.

6 30 April 1920. Henry McBride, Katherine Dreier, Mina Loy and Marsden Hartley read the texts.

7 Marcel Duchamp, 'Interview with James Johnson Sweeney', in Marcel Duchamp, *Duchamp du signe: écrits*, ed. Michel Sanouillet (Paris, 1994), p. 182. Transcript from a film produced in 1955 by the National Broadcasting Company.

8 Marcel Duchamp, 'Catalogue de la Société Anonyme', in *Duchamp du signe*. See Robert L. Herbert, Eleanor S. Apter and Elise K. Kenney, eds, *The Société Anonyme and the Dreier Bequest at Yale University: A Catalogue Raisonné*, (New Haven, CT, 1984), p. 43.

9 In 1923 Dreier named him Vice-President of the Société Anonyme.

10 Marcel Duchamp, *Affectionately, Marcel: The Selected Correspondence of Marcel Duchamp*, ed. Francis M. Naumann and Hector Obalk (Amsterdam, 2000), p. 169.

11 Duchamp, 'Catalogue de la Société Anonyme', in *Duchamp du signe*, pp. 193–215. See also Herbert, Apter and Kenney, *The Société Anonyme and the Dreier Bequest*. See Stéphanie Laudicinia, 'Marcel Duchamp critique d'art, les notices du catalogue de la Société Anonyme', *L'Histoire de l'Art*, 35/36 (1996), pp. 81–90.

12 When she died on 29 March 1952 she named Duchamp, Frederick Burgess and Albert C. Kelly as the executors of her will.

13 Man Ray, *Self-Portrait* (Boston, MA, 1962, repr. New York, 1998), pp. 189–91.

14 Peggy Guggenheim, *Confessions of an Art Addict* (London, 1960; repr. Hopewell, NJ, 1997), p. 47.

15 In 1949 Peggy bought a *palazzo* in Venice to house her personal collection and to create a sculpture garden. In 1951 the *palazzo* was transformed into a museum and opened to the public until her death in 1979. It is presently part of and run by the Guggenheim Foundation, based in New York.

16 Simone de Beauvoir, *L'Amérique au jour le jour* (Paris, 1948), p. 37.

17 Spring Salon for Young Artists.

18 Jasper Johns bought a de-luxe version of *The Green Box*, whereas Rauschenberg bought the *Bottle Rack*, which Duchamp inscribed 'Impossible to recall the original phrase'.

19 Marcel Duchamp, *Entretien avec Alain Jouffroy* (Paris, 1997), p. 22.

20 Purchased from his two friends, Henri-Pierre Roché (who died in 1959) and Gustave Candel.

21 Cordier & Ekstrom Gallery, New York, 1965. Duchamp, who came up with the title, designed the cover of the catalogue, written by Richard Hamilton. Mary Sisler would leave a part of her collection to the Museum of Modern Art, New York.

22 Originally written in German by an anonymous author (probably a woman), this text was translated into English, then signed by 'Rrose Sélavy' as a literary ready-made. It was published, together with texts by André Breton, Tristan Tzara and Paul Eluard, by Cahiers d'Art in the volume *Man Ray, Photographies 1920–1934* (Paris, 1934) and by James Thrall Soby in *Photographs by Man Ray 1920 Paris 1934* (Hartford, CT, 1934).

10 Art as Love / Eros for All

1 Calvin Tomkins, *Duchamp: A Biography* (New York, 1996), p. 242.
2 Marcel Duchamp in conversation with Richard Hamilton, BBC, London, 1959.
3 Gaston de Pawslowski, *Voyage au pays de la quatrième dimension* (Paris, 2004), p. 53.
4 Marcel Duchamp, *Entretien avec Alain Jouffroy* (Paris, 1997), p. 40.
5 Pierre Cabanne, *Dialogues with Marcel Duchamp* (New York, 1971), p. 88.
6 Guillaume Apollinaire, *Marcel Duchamp, 1910–1918* (Paris, 1994). See Cabanne, *Dialogues*, p. 37.
7 Cabanne, *Dialogues with Marcel Duchamp*, p. 88.
8 *Marcel Duchamp*, exh. cat., Palazzo Grassi (Venice, 1986), unpaginated.
9 See Lawrence D. Steefel, 'The Stylistic and Iconographic Development of the Art of Marcel Duchamp', PhD dissertation, Princeton University, 1960, p. 312.
10 Marcel Duchamp, 'La Mariée mise à nu par ses célibataires, même ("la boîte verte")', in *Duchamp du signe: Ecrits*, ed. Michel Sanouillet (Paris, 1994), p. 59. See Marcel Duchamp, *Notes from the Green Box* (1934); typographic version published as Richard Hamilton, ed., *The Bride Stripped Bare by her Bachelors, Even*, trans. George Heard Hamilton (London, 1960), unpaginated.
11 Michael R. Taylor, 'Rrose Sélavy, prostituée de la rue des Levres: levant le voile sur l'alter-égo érotique de Marcel Duchamp', in *Féminin Masculin*, exh. cat., Centre Georges Pompidou (Paris, 1995).
12 Cabanne, *Dialogues with Marcel Duchamp*, p. 64.
13 Marcel Duchamp, 'Morceaux Moisis' in *Duchamp du Signe: écrits*, ed. Michel Sanouillet (Paris, 1994), p. 161.

11 'Maria, (you have) finally arrived'

1 Marcel Duchamp, *Affectionately, Marcel: The Selected Correspondence of Marcel Duchamp*, ed. Francis M. Naumann and Hector Obalk (Amsterdam, 2000), p. 293.
2 This valise is in the collection of the Museum of Modern Art in Toyama, Japan.

3 Marcel Duchamp, 'La Mariée mise à nu par ses célibataires, même ("la boîte verte")', in *Duchamp du signe: écrits*, ed. Michel Sanouillet (Paris, 1994), p. 89. See Marcel Duchamp, *Notes from the Green Box (1934)*; typographic version published as Richard Hamilton, ed., *The Bride Stripped Bare by her Bachelors, Even*, trans. George Heard Hamilton (London, 1960), unpaginated.

4 Calvin Tomkins, *Duchamp: A Biography* (New York, 1996), p. 357.

5 Duchamp added the following note under the title: 'Approximation démontable exécutée entre 1946 et 1966 à New York' and explained: 'By approximation I mean a margin of *ad libitum* in the dismantling [dismounting] and remantling [remounting].' The Cassandra Foundation, directed by Duchamp's close friend William N. Copley, offered the work to the museum, as per Duchamp's wishes, in 1969. In 2004 the Osaka Museum in Japan presented a replica of *Etant donnés*, created using a stereoscopic procedure by Mr Fujimoto, with Jacqueline Monnier's kind authorization.

6 *Manual of Instructions of Marcel Duchamp Etant Donnés: 1° La chute d'eau, 2° Le gaz d'éclairage . . .*, (Philadelphia, 1987), unpaginated. See the preface by Anne d'Harnoncourt.

7 Ibid. The Philadelphia Museum of Art published this as a facsimile in 1987. Duchamp did not want these elements to be made public until fifteen years after the work was revealed in 1969.

8 See Tomkins, *Duchamp*, and Francis M. Naumann, *Etant donnés: 1° Maria Martins, 2° Marcel Duchamp* (Paris, 2004).

9 Tomkins, *Duchamp*, p. 366.

10 Cited in *L'Art de l'exposition, une documentation sur trente expositions exemplaires du xxème siècle* (Paris, 1991), p. 203.

11 1866, Musée d'Orsay, Paris.

12 Parting Deeds and Words

1 Marcel Duchamp, *Affectionately, Marcel: The Selected Correspondence of Marcel Duchamp*, ed. Francis M. Naumann and Hector Obalk (Amsterdam, 2000), p. 321.

2 Ibid., p. 336. Teeny Duchamp did have three children with Pierre Matisse: Jacqueline, Paul and Pierre-Noël.

3 Ibid., p. 337.

4 Ibid., p. 341.

5 Exhibition held 15 April–1 June 1967. A smaller version, *Marcel Duchamp: Raymond Duchamp Villon*, was shown from 7 June to 2 July 1967 at the Musée National d'Art Moderne. Duchamp designed the exhibition poster.

6 Letter to Breton.

7 Man Ray, *Ce que je suis et autres textes* (Paris, 1998), p. 90.

8 Duchamp, *Selected Correspondence*, p. 391. See also Calvin Tomkins, *Marcel Duchamp: A Biography* (New York, 1996), p. 450.

9 15 December 1959–26 February 1960. Duchamp exhibited *With my Tongue in my Cheek*, 1959.

10 Duchamp placed one of his last ready-mades, *Couple of Aprons, Male and Female* in the de-luxe versions of the *Boîte alerte!* (edition of 20).

11 Marcel Duchamp, *Duchamp du signe: écrits*, ed. Michel Sanouillet (Paris, 1994), p. 160.

12 Exhibition at the d'Arcy Gallery, 28 November 1960–14 January 1961. Duchamp, *Selected Correspondence*, p. 369.

13 Ibid., p. 370. He called the hen house a 'coin sale', or dirty corner, playing on the English words 'coin' and 'sale'.

14 William Copley commissioned Robert Lebel to write the first monograph *On Marcel Duchamp* (Paris, 1958), a biographical study. The second, a book of interviews, appeared in 1966, the year of André Breton's death. Michel Sanouillet first edited Duchamp's writings as *Marchand de Sel*.

15 Henri-Pierre Roché, *Victor* (Paris, 1977), p. 57.

16 Daniel Dezeuze, *Ecrits d'artistes: Textes et Notes, 1967–1988* (Paris, 1991), p. 20.

17 Marcel Duchamp, 1933, p. 19.

18 Jasper Johns in *Marcel Duchamp*, exh. cat., ed. Anne d'Harnoncourt and Kynaston McShine, Museum of Modern Art, New York, and Philadelphia Museum of Art (New York, 1973), p. 204.

19 Raymond Cogniat in *Le Figaro* (3 October 1968), not paginated.

Bibliography

Apollinaire, Guillaume, *Marcel Duchamp, 1910–1918* (Paris, 1994)

Bonk, Ecke, *Marcel Duchamp: The Box in a Valise, de ou par Marcel Duchamp ou Rrose Sélavy: Inventory of an Edition* (New York, 1989)

Cabanne, Pierre, *Dialogues with Marcel Duchamp* (New York, 1971)

De ou par Marcel Duchamp ou Rrose Sélavy, exh. cat., curated by Ronny and Jessy Van de Velde, intro. by Francis M. Naumann (London, 1996)

Dezeuze, Daniel, *Textes et Notes, 1967–1988* (Paris, 1991)

Dorival, Bernard, *Les Duchamps: Jacques Villon, Raymond Duchamp-Villon, Marcel Duchamp, Suzanne Duchamp*, exh. cat., Musée des Beaux-Arts, Rouen (1967)

Duchamp, Marcel, *Affectionately, Marcel: The Selected Correspondence of Marcel Duchamp,* ed. Francis M. Naumann and Hector Obalk (Amsterdam, 2000)

—, *Deux interviews new-yorkaises, septembre 1915* (Paris, 1996)

—, *Duchamp du signe: Ecrits*, ed. Michel Sanouillet (Paris, 1994)

—, *Entretien avec Alain Jouffroy* (Paris, 1997)

—, *Marchand de sel*, ed. Michel Sanouillet and E. Peterson (Paris 1958); English. trans. as *Salt Seller: The Writings of Marcel Duchamp* (New York, 1973) and *The Essential Writings of Marcel Duchamp* (London, 1975)

—, *Notes* (Paris, 1999)

Fiala, Vlastimil, *The Chess Biography of Marcel Duchamp (1887–1968)*, 2 vols (Olomouc, 2004)

Herbert, Robert L., Eleanor S. Apter and Elise K. Kenney, eds, *The Société Anonyme and the Dreier Bequest at Yale University: A Catalogue Raisonné* (New Haven, CT, 1984)

Humbert, Michèle, 'Duchamp et les avatars du silence', *Etant Donné*, I (1999)

Joseph Cornell/Marcel Duchamp . . . in resonance, exh. cat., Philadelphia

Museum of Art and The Menil Collection, Houston (Ostfildern, 1998)

Kachur, Lewis, *Displaying the Marvelous: Marcel Duchamp, Salvador Dalí and Surrealist Exhibition Installations* (Cambridge, MA, 2001)

Lebel, Robert, *Sur Marcel Duchamp* (Paris, 1958)

Man Ray, *Ce que je suis et autres textes* (Paris, 1998)

—, *Self Portrait* (Boston, MA, 1962; repr. New York, 1998)

Marcel Duchamp, exh. cat., Tinguely Museum, Basel (2002)

Naumann, Francis M., *Etant donnés: 1° Maria Martins, 2° Marcel Duchamp* (Paris, 2004)

—, *Marcel Duchamp*: *L'argent sans objet* (Paris, 2004)

—, *Marcel Duchamp: The Art of Making Art in the Age of Mechanical Reproduction* (New York, 1999)

Partouche, Marc, *Marcel Duchamp: J'ai eu une vie absolument merveilleuse: biographie 1887–1968* (Marseille, 1992)

La planète affolée: surréalisme, dispersion et influences, 1938–1947, exh. cat., Musées de Marseille (Marseilles, 1986)

Reliquet, Scarlett, and Philippe Reliquet, *Henri-Pierre Roché, l'enchanteur collectionneur* (Paris, 1999)

Roché, Henri-Pierre, *Victor* (Paris, 1977)

Sarazin-Levassor, Lydie Fischer, *Un échec matrimonial: le coeur de la mariée mise à nu par son célibataire, même* (Dijon, 2004)

Schwarz, Arturo, *The Complete Works of Marcel Duchamp*, 3rd edn, 2 vols (New York, 1977)

Solomon, Deborah, *Utopia Parkway: The Life and Work of Joseph Cornell* (New York, 1997)

Tomkins, Calvin, *Duchamp: A Biography* (New York, 1996)

Acknowledgements

With thanks to Jacqueline Matisse-Monnier, Donna Hochard, Valérie Villeglé, Michael Taylor, Vivian Rehberg, Harry Bellet, Sonia Saouma, Jeff Koons Studio, New York, Claude Pétry, Liam Gillick, Lara and Michael Fares, Chantal Helenbeck, and Laurent Le Bon.

Photographic Acknowledgements

The author and publishers wish to express their thanks to the following sources of illustrative material and/or permission to reproduce it.

Musée des Beaux-Arts de Rouen: pp. 22, 29, 33, 119 (all © Succession Marcel Duchamp / ADAGP, Paris, and DACS, London, 2006), 124, 126; Philadelphia Museum of Art (Louise and Walter Arensberg collection): pp. 26 (© Succession Marcel Duchamp / ADAGP, Paris, and DACS, London, 2006), 41 (photo Charles Sheeler), 158; photos Man Ray (© Man Ray Trust/ ADAGP, Paris, and DACS, London, 2006): 73, 74, 77; photo: Edward Steichen: p. 8; photos © Sucession Marcel Duchamp (for all uncredited photographs the photographer is unknown): pp. 11, 13, 19, 21, 24, 38 (photo Elias Elisophon), 46, 49 (authorised replica made by Arturo Schwarz), 84, 92 (foot), 94, 99 (photo Thérèse le Prat), 101 left, 101 right (photo Arnold Newman), 108, 135, 140 (photo Béatrice Wood), 142 (photo Naomi Savage), 146, 154, 164 (photo Gianfranco Baruchello), 165 (photo Gill Pax), 166 (photo Julian Wasser), 167, 168 top, 168 foot (photo Christer Strömholm), 170, 172.

27 Nado